DECONSTRUCTING
SAMMY

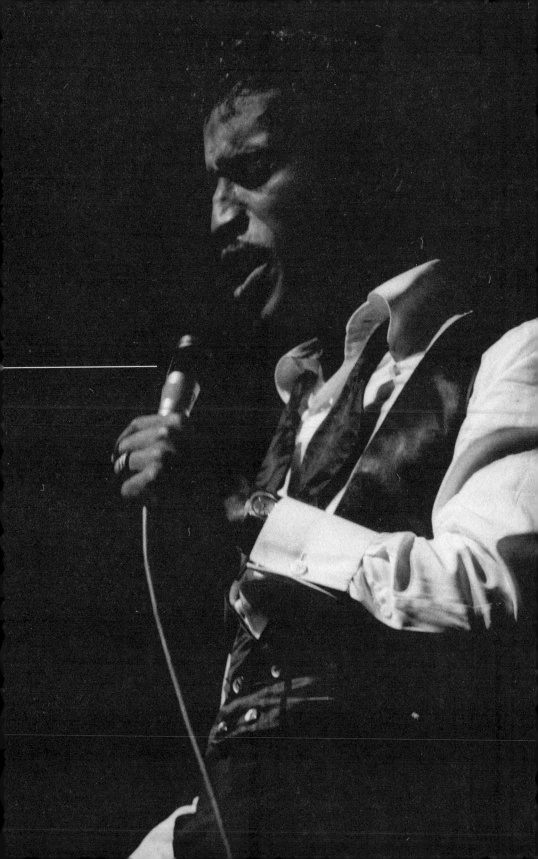

MUSIC, MONEY, MADNESS, AND THE MOB

DECONSTRUCTING
SAMMY

MATT BIRKBECK

Amistad

An Imprint of HarperCollinsPublishers

HarperCollins books may be purchased for educational, business, or sales promotional use. For information please write: Special Markets Department, HarperCollins Publishers, 10 East 53rd Street, New York, NY 10022.

FIRST EDITION

Designed by Timothy Shaner, nightanddaydesign.biz

Title page photograph © by Pierre Fourier/Corbis

Library of Congress Cataloging-in-Publication Data has been applied for.

ISBN 978-0-06-145066-2

08 09 10 11 12 OV/RRD 10 9 8 7 6 5 4 3 2 1

For Donna,
Matthew, and Christopher

DECONSTRUCTING
SAMMY

PROLOGUE

I t was near dawn when the pinging sound of a tiny bell resonated throughout the expansive bedroom, filtering down two short staircases to a small office, where Brian Dellow sat watching television.

The bell startled Brian, who was dozing following another all-night vigil. He jumped out of his chair and rushed up the stairs to the bedside of Sammy Davis Jr.

Racked with excruciating pain and pumped full of morphine, the great entertainer was mercifully near the end of a grueling nine-month battle with throat cancer. Months of chemotherapy and radiation treatment proved futile, and after a final stay at Cedars-Sinai Hospital in Los Angeles, Sammy returned to his Beverly Hills home to die. A recent tracheotomy stilled his voice, and his neck was visibly red and bloated from the hideous, festering tumor. Also stricken with pneumonia, Sammy remained mostly unconscious, but during brief moments of clarity, he'd ring his little bell.

For Brian, who was Sammy's chief bodyguard and, more important, his close friend, the ringing bell often meant Sammy's legs were on fire. Or so Sammy thought. It was the cancer, which spread throughout his body, and Brian gently rubbed coconut oil on legs that were now shriveled flesh on top of bone. The disease reduced Sammy, already small in stature, to a mere sixty pounds and left him nearly unrecognizable. Close friends gasped upon first sight of him during teary-eyed visits.

Outside, reporters maintained a twenty-four-hour death vigil by the

front gate of 1151 Summit Drive, television cameras at the ready once word filtered that Sammy had finally succumbed. On this final morning, with daylight approaching and the end near, Brian stood next to Sammy while a nurse watched from the foot of the bed.

"You need something, boss?" said Brian.

The great entertainer was in cardiac arrest, and he weakly raised his arm and pointed his thumb downward, toward his chest, while slowly shaking his head from side to side.

Brian knew what he was trying to say.

"No boss, you can't go, we've got to pack. We have a gig to play," said Brian.

Sammy smiled, reached out, and held Brian's hand tightly. He closed his eyes and took his final breaths.

At 5:59 A.M., Sammy Davis Jr. was gone.

His wife, Altovise, was awakened and brought to her husband's side, the ever-present scent of alcohol trailing behind. She held Sammy's hand, a million memories flashing all too quickly, moments in time that seemed so far away over a twenty-year marriage—the visits to the Nixon White House, the goodwill trip to Vietnam, the hundreds of shows in London, New York, Las Vegas, and all points in between, and of course, the never-ending parties. From private dinners with the Sinatras to the "Party of the Century" in 1980—a $100,000 royal feast the Davises hosted here, at their twenty-two-room home, attended by every political, sports, and entertainment star in Hollywood and beyond. But those were the good times, and now, it was all over.

During the months prior to Sammy's death, his employees looted his home of memorabilia, jewelry, and artwork while Altovise quietly squirreled away money, property, and possessions. She sent FedEx packages filled with cash, jewelry, and other valuables to friends and family throughout the country and overseas, placed thirteen fur coats in a local storage shop, and hid her Rolls-Royce in Las Vegas.

After kissing her dead husband on the cheek, Altovise quickly removed the remaining jewelry from his body.

Before Sammy was buried, she took his glass eye.

CHAPTER 1

Hundreds of people, many dressed in colorful clothing, slowly filled the vast auditorium at East Stroudsburg University to pay their last respects to Albert R. Murray Sr.

Affectionately known as "the Judge," he died the week before, following a short illness, and after a private burial, his friends, family, and admirers came to East Stroudsburg, Pennsylvania, not only to say goodbye, but to celebrate an extraordinary life.

The Judge and his wife, Odetta, were the founders and owners of the Hillside Inn in nearby Marshall's Creek. For fifty years, the Hillside catered to a predominantly African-American clientele, carving out an existence on a plot of land in northeastern Pennsylvania as a safe and quiet refuge for African-Americans routinely denied accommodations, especially during the tense racial times of the 1950s and 1960s. The Judge and Odetta personally felt that sting, and when Odetta vowed during a business trip to the Poconos in 1954 never to sleep in a car by the side of a road again, the Hillside was born. Odetta, whom everyone called Mama, died in 2002, and now, with the Judge gone, their only child, Albert Jr., was heir to their legacy.

Known by all as Sonny, he stood in front of the auditorium, dwarfed by a giant image of the Judge projected onto a big screen that hung over the stage. Sonny smiled as he shook hands and gave warm hugs to friends and family members, some of whom traveled from as far as Georgia. Welcoming his guests, he proudly pointed to a framed letter

from Pennsylvania governor Edward Rendell. It was a congratulatory letter written the year before, addressed to "Judge Murray," recognizing him not only for his great service to the Commonwealth, but for providing a "model hospitality facility in the Pocono Mountains" and his "courageous vision in a time of considerable discrimination."

"I have no doubt," wrote Rendell, "that the importance of the Hillside Inn Resort Hotel—and its founders—will continue to be felt for lifetimes to come."

Distant aunts and cousins cried after reading the letter, and all offered stern admonishments to Sonny to keep the legacy alive. At fifty-six, with specks of gray hair the only signs of age on a solid, stout body, he nodded his head, placating the well-wishers. Sonny knew the Hillside was a legacy he didn't want. An attorney by trade, Sonny had taken over the daily operation of the Hillside a year before Mama died, which prompted heated arguments with the Judge over its future. The Judge firmly believed the Hillside, a thirty-three-room resort, should remain as it always was through the decades—a last bastion of black pride, a place to rest and to heal the soul. But Sonny thought that time had come and passed. This wasn't the 1950s, he reasoned, and blacks now were accepted everywhere, from large destinations like Disney World to small bed-and-breakfast hotels in Vermont. The Hillside, he argued, was an anachronism that would not, and could not, survive.

He had seen too many times the reaction from a white couple or family who unknowingly booked a stay at the black resort only to leave quickly after arriving. Sonny also knew the strong feelings of the black guests, who didn't want to share their "home" with whites. But Sonny believed that for the Hillside to survive he needed to broaden its clientele, and after taking over the day-to-day operation in 2001 he gave the resort a facelift. He purchased new beds, hired painters, and conceived a marketing plan that touted the Hillside as a multicultural home for jazz and a place of respite for all races and ethnicities.

The Judge was irate.

The grandson of slaves, the Judge was a man of purpose and steadfast resolve. As a child growing up near Augusta, Georgia, he picked

cotton and rode his bike ten miles a day, each way, to attend a better high school. He later joined the army, married Mama, and served in England during World War II. After the war, they followed the postwar migration north and settled in Brooklyn, where Mama worked as a nurse while studying for a master's degree in elementary education. The Judge earned his law degree at Brooklyn College and became partners with Abe Kaufman, a Jewish accountant. Together, the unlikely pair began buying up homes and properties in Brooklyn and selling to black buyers who, like the Murrays, left the South to find better homes and jobs. The racial makeup of Brooklyn slowly changed as the steadily rising black population served as the impetus for the white flight to the suburbs of Long Island and New Jersey.

Sonny was born in 1949. When he was one, his parents, working to complete their educations, sent him to live with relatives in Georgia, where he later learned to roll tobacco, pick cotton, and slaughter cows. He also experienced racial prejudice, particularly when he unknowingly attempted to drink from a "whites only" water fountain in Augusta.

"Hey, nigger. You don't drink from there, ever. That's for white people only. You use that one over there. And don't forget that."

Even at a tender age, Sonny never forgot those hurtful words, or the confusion he felt trying to understand why he couldn't share a fountain with anyone else. It was, after all, just water. But Sonny learned the ways of the South before eventually returning to New York. Mama had a nickname ready for him—Sammy—after her beloved father, Sam Sanders, and she'd whisper "How's my little Sammy" into her son's ear while cradling him in her arms.

Mama and the Judge bought the worn-down Hillside Inn in 1954, following a visit to the Poconos. What was a business trip for the young, hardworking couple turned into an unsuccessful quest to find a room, any room. But no hotel or resort would accept them, and they slept in their car. Upon their return to Brooklyn, Mama vowed to open a hotel accepting of minorities, and the Hillside was born. It had only two floors, two bathrooms, and eight rooms, and needed a fresh coat of paint, but together with Kaufman, the Murrays bought what had

been a boardinghouse and commuted the seventy-five miles from their home in Brooklyn to oversee what they hoped would be a vacation retreat for blacks. When Kaufman died in 1955, the Murrays gained full ownership. But they were treated poorly and forced to endure numerous indignities from a rural Pennsylvania community that expressed its unhappiness with their new black neighbors in a variety of ways, from suppliers refusing to deliver goods and supplies to local banks declining to even consider business loans.

Local residents and the business community remained hostile to the black intrusion, yet the Murrays quietly persevered. The Judge, through the force of his will, kept the struggling Hillside alive by bringing in daily food and supplies from Brooklyn. The Judge always viewed racism as an obstacle he'd overcome, no matter what the cost, and anything other than remaining stoic was not an option.

The Judge and Mama struggled to keep the Hillside alive those first few years, but back in New York the Judge's strong will, legal abilities, and growing political connections earned him an appointment in 1966 to serve on the criminal court bench in Brooklyn. The Judge was an astute politician, and he aligned himself with Bertram Baker, the first black to be elected as a state assemblyman from Brooklyn in 1948. By 1966 Baker had become a powerful figure in New York politics, and when a judgeship opened, Baker lobbied then New York mayor Robert Wagner to nominate Albert R. Murray Sr. to serve as the first black criminal court judge in Brooklyn. It was a tremendous achievement for the Judge, one he accomplished by following a simple credo: "Don't buck the system, be a part of it."

The Judge quickly earned a reputation as fair but tough and nononsense, particularly with minorities, whom he would lecture from the bench. Some thought the Judge was harder on blacks than he was on whites, but the Judge thought he was simply doing his part to instill strength into people who exhibited little. Mayor John Lindsay reappointed the Judge to another term, and his legal skills earned him a special appointment to serve as a judge with the New York State criminal court.

Despite his great success in New York, the Judge privately grew angry and bitter about his situation in Pennsylvania. He saw himself simply as a man working to succeed in America, yet he was also acutely aware that his skin color meant that his success would depend entirely on his ability to control his comments and actions, particularly in his new environment.

While remaining in Brooklyn during the week, he joined Mama at the Hillside on weekends and, from instances when his tall frame and deep voice were subtly ignored at local township and community meetings, to overt racist comments from people unaware of his position and social standing, the Judge quietly endured his Pennsylvania neighbors. Mama soothed his growing anger, always reminding the Judge to "be calm, remember what we worked for . . ." But the daily indignities and slurs took their toll and the Judge seethed, releasing his anger in sudden, loud but private outbursts. Sonny never understood his father's rage or violent behavior, and by the time he left home to attend college in the late 1960s, his relationship with the Judge had grown distant.

Sonny returned to Pennsylvania after graduating from Syracuse University and Brooklyn Law School. With the Judge away during the week, Sonny opened his own law practice in nearby Stroudsburg and helped Mama with the hotel, washing dishes, bartending, and performing regular maintenance. He was her "Sammy," and mother and son remained close, her nurturing and warm Southern demeanor a welcome respite from the difficult relationship Sonny had with his demanding father. The older Murray and his namesake never saw eye to eye, and they argued over everything, even something as noncontroversial as golf. The Judge believed golf was a business opportunity masked as a game, and he pushed his son to play. Sonny saw it as yet another avenue for the Judge to inflict his will on his son, and whenever the subject came up, Sonny didn't hide his dislike for golf. He simply hated it because the Judge liked it, and whenever the Judge asked his son to play, Sonny's response was to the point:

"I don't play golf!"

Instead, Sonny devoted himself to making his own way, and he

took a job as a public defender and then an assistant district attorney with the Monroe County district attorney's office. Along with his early success came the first love of his life, a young woman whose humor and kindness won Sonny's heart and made him think of marriage. But the Judge inserted himself into the relationship, immediately laying out plans for the couple to live on the grounds of the Hillside. His controlling manner proved too much for the burgeoning relationship, which ended abruptly. In 1980 Sonny accepted an appointment to serve as an assistant U.S. attorney for the Middle District of Pennsylvania and he remained a federal prosecutor for eight years, carving a niche prosecuting mobsters and white-collar crime. He left the Justice Department in 1988, much to the chagrin of the Judge, whose shadow continued to loom large over his son. After Mama died, their relationship hit rock bottom. Between bitter arguments over the direction of the Hillside there were long periods of silence and separation.

Now the Judge was gone, and Sonny was faced with a decision. He had devoted the last five years of his life to the Hillside, shutting down a thriving law practice, abandoning his investments, and pouring in $1 million of his own money to make it work. But it wasn't working. The hotel was mired in debt and behind on its taxes and bills. Worst of all, Sonny believed, its mainly black clientele failed to appreciate the Hillside, its fifty-year history as the longest-operating black-owned hotel in the nation, and most important, all that his family went through to keep their dream alive.

Guests were often demanding and rude while their children cursed at will and showed little respect for their elders. Their attention was clearly focused not on individual improvement but on the cultural amenities of the day, from video games to music to high-end sneakers, which infuriated the Judge until the end. He was a black man's black man, strong and proud, but he hated what he was seeing from his guests and their children. Blacks remained consumers, not owners, he argued, and for years before his passing he'd lecture his guests on the benefits and necessity of ownership to improve their condition in America. He implored his guests, especially their children, to finish

their educations, and his words were forceful and had meaning. But they were lost in translation, and Sonny could only shake his head in resignation, knowing that a simple lecture from his father couldn't change years of ingrained behavior.

Following the poignant memorial at East Stroudsburg University, Sonny said good-bye to his many guests and visitors, his aunts and uncles, his distant cousins, and he returned alone to the Hillside and walked slowly to his parents' empty home. The red two-story colonial Sonny built for them in 1977 was situated on one of the 109 acres of pristine property they had come to own nestled in a green valley. Deer regularly grazed on the grass during the summer, while the fall brought a burst of color from fading leaves that provided a spectacular sight for visitors from the city. But the home was empty, the hotel business was fading, and Sonny was ready to finally make the decision to give it all up, to sell the Hillside, its 109 bucolic acres and everything with it. No one cared anyway, he thought.

He opened the door to his parents' home and stood in the foyer, closing his eyes, hoping to hear Mama's welcoming voice.

"You hungry? You sick? You need to talk?"

Mama was a rock, even during that year with the cancer, and she was sorely missed. Sonny walked into the first-floor bedroom where she died and he gazed at the empty bed. He could see her smile and he could feel her soft hand. Pictures of the Judge and Mama ringed the bedroom, along with photos of Sonny accepting an award during his days as a federal prosecutor. One photo, of Sonny and the Judge playing golf, caught his attention. It was one of the handful of times Sonny gave in to his father when it came to golf, and the color picture of Sonny holding the flag while his father readied a putt memorialized the rare moment. Sonny reached for the picture, turned it over with its frame facedown, and sat on the bed. He closed his eyes and dug deep into his memory, and long forgotten and disturbing images of his father surfaced. Sonny remembered the Judge suddenly appearing in his bedroom door with fire in his eyes after returning from some local meeting, and he recalled the beatings and how senseless they were.

"I brought you in this world," the Judge screamed, "and I can take you out!"

Sonny cried as the leather belt whipped across his bare back. The Judge often forced Sonny to take his clothes off to keep them from getting ruined, and each time Sonny screamed, the Judge hit him harder.

As Sonny contemplated his painful past and challenges ahead, his eyes drifted slowly across the bedroom. Along with the many photos, there on the walls were numerous framed newspaper and magazine articles honoring his parents and the Hillside. Sonny continued to pan the room but stopped when his eyes fixed on boxes in the open closet, stacked six feet high. On the sides, in black ink, each box was inscribed: ESTATE OF SAMMY DAVIS JR.

Sonny reached over and dragged one of the white boxes to the side of the bed. He blew off the dust, pulled out a file, and opened it. Memories rushed to the surface as his thoughts traveled back in time to Sammy, Altovise, Frank Sinatra, and the Rat Pack, to another day, another time, and another troubled black legacy.

CHAPTER 2

The early spring sun cast an unusually warm embrace on the Hillside Inn. The weather in the Poconos was always tricky. One year could provide a final, heavy, wet snow in April or warm, suitable for golf, temperatures in December. For more than a hundred years, the Pocono Mountains, or what the locals called "rolling hills," tucked behind the Delaware River, provided a peaceful retreat for the not-too-distant city dwellers in New York and Philadelphia.

The train stopped running here twenty years earlier, but people still came by the carloads, following Interstate 80 west across New Jersey or north on the Pennsylvania Turnpike, and filled up all the local hotels and motels each weekend from fall through spring, and then every day during the summer.

The cold winter months provided plenty of snow for skiing at Camelback Mountain, Jack Frost/Big Boulder, and Shawnee-on-the-Delaware. And when the snows finally melted, there was golf, hiking, fishing, and other outdoor activities in the spring, summer, and fall. Once upon a time, celebrities often came to the Poconos to play and to entertain. Jackie Gleason enjoyed a game of golf at the Shawnee Inn. Mount Airy Lodge, a sprawling resort known for its tacky, red, heart-shaped tubs, drew blue-collar honeymooners willing to plunk down big money to bathe in overpriced, overgrown champagne glasses, and watch the likes of Tony Bennett, Alan King, Julio Iglesias, and Dionne Warwick perform in the Crystal Room. Other resorts, like the Tamiment,

once hosted Woody Allen, Mel Brooks, Danny Kaye, and Carol Burnett. Sid Caesar and Imogene Coca perfected their act at the Tamiment before they became a national sensation on *Your Show of Shows* in the 1950s. Two decades later, Pocono Raceway hosted performances by Bob Hope, the Osmond Brothers, and the Jackson Five, while in the 1980s Jay Leno and Jerry Seinfeld entertained audiences at the Caesar's resorts long before they became national celebrities.

But the circuit that drew the performers, which included stops in New York's Catskill Mountains and Atlantic City, New Jersey, soon vanished, after casino gambling was introduced in Atlantic City in 1980. Instead of performing for fees as low as $5,000 a night, the same top-name entertainers could bypass the Poconos and Catskills and earn $25,000 and more in one shot in Atlantic City. There was talk of bringing casino gambling to Pennsylvania, even a $50 million investment in a new resort by Jilly Rizzo, a restaurateur known for his close friendship with Frank Sinatra. But gambling never came, and as the talent pool evaporated, the resorts began to close. Only those with a dedicated clientele survived, such as the Hillside Inn.

The upcoming weekend was the first of the new season to welcome a full house for the thirty-three-room resort, and Sonny decided it was time to remove the dead weeds, trim bushes browned by winter snowmold, and cut the emerging grass. Sonny had no problem with manual labor, something he learned as a child. A football player in high school, Sonny was muscular, his five-feet, ten-inch frame chiseled and hard. He worked out regularly, lifting weights, running, and playing tennis. Sonny pulled the rope to start the lawn mower and he proceeded to cut the grass in straight, horizontal lines in front of the indoor pool area when he noticed a woman and three men standing in a circle in the parking lot next door.

The woman was tall, thin, and black. She appeared somewhat disoriented, her head bobbing softly back and forth. Two of the men were white, one tall and large while the other much smaller, perhaps Hispanic. The third was a light-skinned black man, who appeared to be controlling the conversation. There was something odd about the men,

but Sonny focused his attention on the woman. She wasn't talking. She just stood and listened as the animated black man continued to lead the conversation, which grew louder, then stopped, with the foursome entering a car and driving away.

Minutes later the car returned and it bypassed the parking lot and drove up the road and into the driveway of one of the thirty-six privately owned homes on the Murray property. The bi-level home belonged to Calvin Douglas, a retired New York City transit worker who settled here years earlier. Sonny could see the rear of the car hanging out from the driveway. His curiosity piqued, he turned off the mower and watched as a man exited the driveway onto the road, heading toward the Hillside. It was Calvin. A Jamaican immigrant who became fast friends with the Judge and Mama soon after moving to the Poconos in 1987, Calvin was a sprightly seventy-year-old and walked with a quick step. Sonny saw him waving, and then heard him yell out, "Sonny!"

Sonny pulled a handkerchief out of his back pocket, wiped his brow, and then walked up the road.

"Mr. Douglas. How are you?"

"Oh, I've had better days," he replied, his voice punctuated by his Jamaican accent.

"I saw those people drive into your driveway. Is anything wrong?"

"Well, that's what I want to talk to you about. That woman," Calvin said, pointing toward his driveway. "That's Mrs. Sammy Davis Jr."

Sonny smiled.

He heard whispers that Altovise Davis was living on the Murrays' property. No one knew why, and no one thought to ask Calvin about it, figuring if he wanted to tell people, he would have.

"Sonny, I didn't want to do this, but we need you. I can't take this anymore," said Calvin, desperation in his voice. "She's sick, very sick, and needs legal help."

Calvin told the story of how Altovise arrived at his home. Her father, Joe Gore, and Calvin became best friends working together for the New York City Transit Authority, and after Calvin moved to Pennsylvania, they remained in close contact. Whenever Calvin visited the city, Joe

Gore and his wife, also named Altovise, provided him with a place to stay in their Queens home. During one visit in 1992, Calvin saw the Gores had another guest—their only daughter.

The Gores said Altovise was broke, their home the last stop before a homeless shelter. She lost all her possessions following Sammy's death in May 1990, including their Beverly Hills mansion, to pay off massive and unexpected debts. But the fire sale didn't come close to resolving the situation and the IRS was after her for back taxes, said Calvin.

Depressed and despondent, Altovise spent most of her waking hours in an alcohol-induced daze. Her preferred drink was vodka, and her drinking incensed her father, who threatened to kill her if she didn't leave. When Calvin arrived for one of his regular visits, Mrs. Gore tearfully begged him to take her daughter to live with him in Pennsylvania. Calvin agreed and he informed his wife a guest was arriving. When he returned home with Altovise, he brought her to an upstairs bedroom, where she remained hidden for days, venturing out only for trips to the liquor store to buy more vodka, which she stored in small mayonnaise jars that fit in her purse, and to answer phone calls from old friends.

"She asked Bill Cosby for help but he said he's not going to give her any money to buy liquor," said Calvin. "I've been trying to get her to go into rehab, but she won't go. She was in the Betty Ford clinic once before, but it didn't work," said Calvin.

"Does she have any money?" said Sonny.

"I don't know. She uses my car when she has to get around, and I have to give her five or ten dollars every now and then," said Calvin, nodding toward the men in the driveway. "She said she had jewelry, furs, a Rolls-Royce. That one guy, Al Carter, used to come by with some money in bags. He'd also bring her alcohol. Now they fly in from California and take money from her parents to pay for their bus ticket here. It's ridiculous."

Sonny looked over at the men.

"Who are those guys?" he said.

"That's her advisor, Al Carter, and his bodyguards. They were supposed to be taking care of her money after Sammy died. He calls every

day and keeps telling her everything is going to be fine and not to worry, because it's only a matter of time before she gets her money back," said Calvin, "but I don't like them."

Sonny could see that Calvin was frustrated and couldn't do anything more.

"I don't know where the money is going to come from, but we need you, and we need to put her in rehab," Calvin said.

Sonny looked over at Altovise, who stood in the driveway, staring into the woods. She was thin and bony.

"How much does she owe?"

"I'm not sure. I know it's a lot. She often mumbles about having money hidden here, and personal items hidden there. Then she drinks more vodka and stumbles back into her room. Sometimes she stays there for days. I put my ear to the door and I can hear her groaning and gasping for breath."

"So there's no income from her estate?" said Sonny.

"There is no estate. Whatever she makes the IRS takes," said Calvin.

Sonny was alternately shocked and saddened. Sammy Davis Jr. was an international celebrity, a cultural hero adored by white America for his talent and loathed by a generation of black America for being just another Uncle Tom, a minstrel who forgot his roots. He even married a white woman, May Britt, to validate himself. Sonny shared this view, and like many other blacks he couldn't stand Sammy's music or his politics. "The Candy Man"? Awful song. Embracing Richard Nixon? Absolutely traitorous.

Sonny's parents, on the other hand, loved Sammy.

Sammy was, in the words of the Judge, a black man who learned how to "make it" in this white world, and the Judge respected any black man that could rise to the top of his profession. Sonny didn't agree, but he couldn't help but admit that Sammy was arguably the greatest entertainer of the twentieth century. He appreciated Sammy's immense talent, a polished triple threat of singing, dancing, and acting. Through his genius, the man became an entertainment icon, regularly mingling

with presidents, kings, and queens. And Altovise, who Calvin said had been married to Sammy for twenty years, was right there with him, at his side, a living part of history.

It was a shattering, almost inconceivable fall, thought Sonny.

Sammy Davis Jr.'s wife living here, in poverty, in the Poconos?

"You can help her. You know this kind of stuff, working with finances and numbers," Calvin pleaded. "Sonny, you did it with Hutton."

The prosecution of E. F. Hutton led to the fall of one of the nation's largest financial institutions. And Sonny was at the center of the investigation.

In December 1981, an auditor at the Genesee County Bank near Buffalo, New York, was presented a check for $8.1 million from E. F. Hutton. The financial services giant, known for its catchy advertising slogan—"When E. F. Hutton Talks, People Listen"—intended to cash the check against two other checks totaling $8 million drawn by other Hutton offices and deposited at the same bank. Only one check was good. The other had yet to clear.

Genesee Bank was one of hundreds of local banks used by E. F. Hutton's four hundred branch offices across the country. Some $200 to $400 million in customer funds was deposited daily, and the money was then sent to regional accounts, one of which was at the United Penn Bank in Wilkes-Barre, Pennsylvania. Officials there, notified of the overdraft at the Genesee Bank, looked at their Hutton account and were astonished to find they had $23 million in uncollected funds outstanding. Hutton had already removed the money, but the checks had yet to clear, which was a violation of U.S. banking law. United Penn Bank contacted the U.S. attorney's office in Scranton, and the case was pursued by a young prosecutor, Albert R. Murray Jr.

Sonny was thirty-one years old when, full of energy and resolve, he joined the U.S. attorney's office for the Middle District of Pennsylvania. His appointment was greeted with great pride by his parents, especially the Judge, whose son was now a U.S. prosecutor. There wasn't any more honorable or noble profession, the Judge believed.

Sonny, too, was proud and happy, particularly that he was able to finally please his demanding father. And, like his father, who was the first black judge appointed to serve on the bench in Brooklyn, Sonny was the first black prosecutor appointed to serve in the U.S. attorney's office stationed in Scranton, a depressed, former coal-mining town that was predominantly white and Catholic, a blue-collar community populated by Irish and Italian immigrants and their descendants, who spent generations underground. The mines had long closed and the city suffered a downturn, but the federal prosecutorial district, one of three in Pennsylvania, remained busy, covering a vast area that reached from northeast Pennsylvania, including Scranton, Wilkes-Barre, and the Poconos, down through the center of the state to Harrisburg, the state capital.

It took some time, but Sonny discovered that E. F. Hutton was "kiting," or taking money from the bank accounts before the checks cleared, in effect receiving daily interest-free loans. Given that it was kiting at only two small banks, it wasn't much of a case. But as Sonny followed the trail, he found that Hutton was kiting checks at other banks in the region. The scheme was complicated and illegal, and the abuse, he discovered, was more widespread, leaving the banks in vulnerable positions, even if only for a day. Sonny opened a federal grand jury investigation in 1982 and, to fully understand the depth and scope of Hutton's cash-concentration system, the workings of the Federal Reserve, and bank check-collection systems, Sonny moved his prosecution to Harrisburg.

Since the investigation appeared to involve mail fraud, Sonny was given space in a basement at the postal headquarters building and together with more than two dozen inspectors from the U.S. Postal Service, the young prosecutor spent three years probing Hutton, issuing hundreds of subpoenas and amassing more than 7 million documents. Sonny spent whole months, often eighteen to twenty hours a day, seven days a week, hunkered down in his bunker, reviewing each document, which was placed in a filing system kept in a large, specially constructed and locked area next to Sonny's small office. Review meetings with postal inspectors would sometimes begin at four A.M., and new words

such as "insufficient funds on deposit," "drawer of check," and "bank float" became part of Sonny's vocabulary. His personal life was nonexistent, and he lived in a cheap hotel and ate at an even cheaper diner next door, both to spare U.S. taxpayers. During his rare free time, Sonny, a devotee of the Chinese art of Tai Chi, worked out on the banks of the Susquehanna River, where he'd watch the rats scramble up from the water and into the hotel, which he dubbed the "River Rat" hotel.

By 1984, Sonny presented his case to the attorney general. E. F. Hutton, he said, was unlawfully floating their own deposits daily, not just in the Middle District of Pennsylvania but across the country, earning tens of millions' of dollars in "free interest" from banks coast to coast by overdrafting as much as $250 million each day. Even in New York, where Hutton had a relationship with Manufacturers Hanover Trust and Chemical Bank, as much as $20 million would be deposited into Manufacturers Hanover drawn on the Chemical Bank account. Chemical covered the overdraft while Hutton, in effect, "played the float," earning interest on checks that had yet to clear. The U.S. attorney's office in New York was alerted in 1983, but the prosecutor in charge, Rudolph Giuliani, had his eyes on bigger, high-profile white-collar investigations and organized crime, and declined to prosecute. No harm, no foul, said Giuliani, especially since it involved only one bank and Hutton covered the money the following day anyway. But the Federal Reserve prohibited withdrawing money from checks that had yet to clear, and if Giuliani had probed further, he would have seen that the scheme extended throughout the country.

As Sonny discovered, E. F. Hutton's enterprise was remarkable if only for its complexity, and it reached the top echelons of Hutton's corporate structure. In May 1985, a federal grand jury was preparing to charge E. F. Hutton when officials there agreed to plead guilty to two thousand counts of mail and wire fraud and pay a $2.7 million fine. There were no individual indictments, which caused outrage in Washington. Word had leaked that E. F. Hutton chairman Robert Fomon met with U.S. Attorney General William French Smith at a Washington restaurant and sought an end to the investigation. Smith instead

immediately reported the contact to the FBI. Sonny was elated. Other financial institutions were doing the same thing as E. F. Hutton, and though there were no individual sacrificial lambs, the inner workings of an entire company, and thus the industry, were laid bare.

The politically sensitive prosecution brought Sonny before Congress later that year for hearings in Washington, DC. Senators Strom Thurmond of South Carolina and Joseph Biden of Delaware, among others, feted Sonny for his steadfast aggressiveness in exposing one of the worst cases of white-collar crime in U.S. history. But during his testimony, Sonny was quizzed about rumors that, because there were no individual indictments, his Hutton investigation had been compromised by the attorney general. Sonny scoffed, saying no one, not even the attorney general of the United States, could prevent him from following a true course.

"The only two people I answer to are God and the man back there," said Sonny, who turned around and pointed toward his father.

The Judge, sitting with Mama in the back of the vast and packed congressional hearing room, beamed with pride. This was his son, sitting before Congress, testifying about an investigation he led. It was a great personal accomplishment, and if there was one thing the Judge respected, it was great individual accomplishments.

Sonny's prosecution reverberated in headlines throughout the country and internationally, earned him a prestigious award from the Justice Department, and forced Congress to pass major changes in banking law. The sting and public humiliation of the guilty plea eventually forced E. F. Hutton to close its doors, and Sonny, who would testify several times before Congress, became known as the man who took down E. F. Hutton.

He was later asked to take a lead role in the federal investigation into the savings and loan industry, in which loose or nonexistent regulations led to the loss of billions. Sonny declined, and left the Justice Department.

Sonny thought about his Hutton experience, and it remained in the back of his mind when he turned to Calvin.

"Okay, Mr. D. Let me say hello."

The two men walked up the road to Calvin's driveway, where Altovise stood along with her three "advisors"—Al, Tiny, and Cheech.

"Altovise, this is Sonny Murray, the man I've been telling you about," said Calvin.

Altovise smiled slightly, then extended her hand. Sonny shook it. He could smell the alcohol on her breath.

"Nice to meet you, Mrs. Davis," he said. "Would you mind if we talked a bit, privately?"

They walked onto a large grass field, but Altovise didn't have much to say other than her life, as she knew it, was over, ripped away, she said, by people her husband had trusted. Lawyers and managers who mismanaged their financial affairs and left them broke. Now, even her own family didn't want her, and none of her old Hollywood friends would come to her aid.

Sonny changed the direction of the conversation, telling Altovise about some of his new entertainment clients and his association with the People for the American Way, a left-wing advocacy group formed in the 1980s by Norman Lear.

"You know Norman?" said Altovise, who appeared surprised.

"Sure, we're working together on a project," said Sonny.

Sonny and Norman were producing a movie together for Universal, about inner city kids jumping rope, or Double Dutch. Altovise was impressed and she listened intently as Sonny told her about several film and music projects in various stages of development.

"You do this here, from Pennsylvania?" she said.

"I'm close enough to New York to make meetings, and if I'm needed in Los Angeles I'll jump a plane. It's not that difficult," he said.

They exchanged more small talk before returning to the driveway. Sonny promised they would talk again, said good-bye, and he walked with Calvin back down the winding road. Along the way Sonny turned around to look at Altovise.

"You're right," Sonny whispered to Calvin. "It's tragic. Can you tell me more?"

DECONSTRUCTING SAMMY 21

They walked slowly as Calvin described how Sammy's daughter, Tracey, was trying hard to convince Altovise to sign away her rights to Sammy's estate. Quincy Jones planned to produce a Broadway musical about Sammy's life and Tracey needed Altovise's cooperation. But Quincy couldn't do business with Altovise, given that Sammy's name and likeness was owned by the IRS. Because of the debt, specifically the money owed to the government, no one wanted to do business with the Sammy Davis Jr. estate, knowing the IRS was watching. Hence, since Sammy's death, there were no movies, records, or videos, and very few business deals involving the name, likeness, or voice of Sammy Davis Jr.

It was as if Sammy never existed.

Sonny had never seen, before Altovise, a human being so hurt, angry, and near death, physically and emotionally. And he didn't understand how someone as successful as Sammy Davis Jr. could lose his fortune, property, and possessions. Sammy, in death, should be like Elvis, Sonny thought, a brand name that simply printed dollars.

"Does she have any financial records, books, receipts?" said Sonny.

"Nothing that I know of," said Calvin. "She just mumbles that she is a victim and hides in her room."

Sonny was intrigued. "Okay, Mr. D.," he said. "Let's set up a meeting."

The two men shook hands and Sonny walked back to the Hillside. Inside, the Judge and Mama stood behind the reservation desk, fumbling through some papers.

"You gonna help that poor lady?" said Mama, her eyes fixed on her work.

"How did you know?" said Sonny.

"What you think, I'm just some fly on the wall who doesn't know anything? The Judge and I knew she was livin' here. Wasn't much to be said about it, the poor woman."

The Judge looked up, holding his papers high in his hand.

"We're going to have a full house this weekend," he said.

"That's good," said Sonny, and turned to walk away.

But the Judge wasn't finished.

"So?" his voice boomed.

Sonny smiled.

"Mrs. Davis? Well, we'll see, Dad. We'll see."

The meeting on the elevated wooden deck in Calvin's backyard began at dusk. Sonny wanted to meet Mr. and Mrs. Gore, who drove up from Queens, and gauge their interest in participating in their daughter's recovery.

Joe Gore made it clear where he stood.

"I'm embarrassed to be here," said Joe, looking disapprovingly at his daughter, who sat on the opposite end of the table, the smell of alcohol wafting into the early evening air.

"She needs to stop drinking, then she'd be all right," said Joe, his anger fueled by frustration over his, or anyone's, inability to help his daughter.

Altovise didn't respond, and she didn't say much throughout the two-hour meeting, aside from the fact that she didn't create her situation and it wasn't her fault that the estate was insolvent. The blame, she said, lay with the people who ran Sammy's business affairs. Sonny didn't want to hear about blame and fault. Not yet. He'd get to those people later. For now, he had to start from scratch, and needed the cooperation of Mr. and Mrs. Gore. Their daughter was clearly damaged, physically and emotionally, and it was painfully clear that Altovise needed treatment.

Sonny believed her parents would have to play a key role in her recovery, particularly the emotional support. Joe Gore put his anger aside and agreed to help, as did his wife, who made a deep impression on Sonny. Like her daughter, Mrs. Altovise Gore was tall and thin. She had a sweet disposition, her voice halting and demure. Altovise was an only child, and Mrs. Gore said she doted on her daughter, buying her the best clothes and dressing her like a little lady, often in white socks and Mary Janes, which drew snickers from schoolmates. A loner at school, Altovise was nonetheless a good, respectful girl who took a liking to dance and dutifully attended dance classes as she grew into a beautiful young woman, statuesque, with a pleasant personality. Her impressive

dancing skills led to her selection to perform with the prestigious Alvin Ailey dance troupe in the 1960s. She later appeared on Broadway, and then in London, playing the role of Sammy's sister in *Golden Boy*. Altovise married Sammy in 1970 at City Hall in Philadelphia and they remained together for twenty years. Mrs. Gore wanted to say more, but didn't. Opening old wounds was not on the agenda, even though the sum result was clearly visible for all to see.

"We'll do whatever we have to do to help you, Mr. Murray," said Mrs. Gore. "She's been abandoned by everyone. She's called Sinatra, Michael Jackson, Gregory Hines, all her old friends. But no one will help."

"Please, call me Sonny," he said.

With the parents on board, along with Calvin Douglas, Sonny turned to Altovise.

"Do you want me to help you?"

Altovise nodded.

"If you agree to get straight, I will solve this problem, but you must, you must get treatment. I can't help you if you don't help yourself."

Altovise nodded again.

"No, don't shake your head. I need to hear you say you will go for treatment."

"Okay," said Altovise. "I will."

Altovise was clearly troubled but Sonny sensed an innocence, like a lost little girl looking for her way home. Sonny felt emboldened, just like he did when he was an assistant U.S. attorney representing the United States of America. This was an injustice, he believed, and not just to Altovise but to the memory of Sammy Davis Jr. Sonny may not have liked him, but he agreed with the Judge, who argued that Sammy was a black man who made it to the top of his profession and he deserved to be honored.

But all Sonny had was a broken woman and pieces of a story. He knew none of the specifics of her downfall, and that of Sammy's. The debt appeared to be large, and with little information at hand Sonny knew he'd be taking on a gargantuan task that would require an incred-

ible amount of his time and effort. He'd first have to resolve the IRS debt and then attempt to restore Sammy's name, image, and likeness to make it a profitable enterprise and, more important, bring it back to its rightful place in American entertainment history. And to understand how someone of such great wealth and celebrity could have lost everything, Sonny knew he'd have to dig into every facet of Sammy's life, including every deal, every show, every dollar he earned. It would be, in a sense, the E. F. Hutton investigation all over again. Knowing the difficulty he had with that probe, Sonny had his doubts about reconstructing the financial affairs of a dead entertainer, and a famous one at that.

But Calvin Douglas and the Gores begged Sonny to help, and his empathy for Altovise, for her plight, and for Sammy melted whatever reservations he had. So Sonny agreed to represent Altovise and laid out a plan he hoped would eventually settle the IRS debt and restore the right to use Sammy's name and likeness, which in turn would give Sammy Davis Jr. back to the world. He waived his usual $25,000 retainer and agreed to charge a discounted $200 hourly fee, payable when the debt was settled and the estate was once again producing income.

Mr. and Mrs. Gore were ecstatic, and everyone, Altovise included, shared a group hug.

"I can help you," Sonny said.

CHAPTER
3

Tracey Davis was the only daughter of Sammy Davis Jr., born in 1961, during his marriage to Swedish actress May Britt. Two other children, Mark and Jeff, were later adopted before the marriage imploded and ended in divorce in 1968.

Tracey had a family of her own and lived in Los Angeles, working as a freelance producer of television commercials. She had watched in recent years, first with sadness and then a growing anger, as her father's legacy crumbled and disappeared, and she desperately wanted to take control away from Altovise and revive it. Tracey had already moved forward on several projects, the most important of which was reaching agreement with famed music producer Quincy Jones to produce a musical about Sammy's life, based on his 1965 book *Yes I Can,* which Sammy cowrote with Burt and Jane Boyar. The Boyars retained 50 percent of the rights to the book, while Sammy's half went 25 percent to Altovise and the remaining 25 percent divided among Sammy's four children. Another son, Manny, had been adopted by Sammy and Altovise in 1988. Quincy paid a $50,000 advance for an eighteen-month option, and agreed to pay another $50,000 payment to option a second eighteen-month term.

Quincy had been one of Sammy's best friends and he wanted to celebrate Sammy's extraordinary life. But it was impossible, given the condition of the estate and the ever-present shadow of the IRS looming over Altovise, which prevented Tracey from moving ahead. Tracey believed that Altovise could assign her rights to the estate to Tracey, who would

then collect Altovise's share of the income. Tracey planned to form a corporation protecting her from any potential lawsuits or litigation, and once Altovise improved her health and reached a settlement with the IRS, she would receive her money and have her rights reassigned back to her. Should the IRS protest the plan, Tracey figured she'd cut them in for a percentage.

But Altovise and Tracey had personal issues that dated back over twenty years, to that very first day when Sammy invited his young children to his home in 1969 to meet the new woman in his life. Still raw and hurt from their parents' divorce, Tracey and her two brothers were in no mood to meet someone new. Their mother, May, who thought the dinner was an attempt by Sammy to spend some time with his children, insisted they attend. And so they went, three children, none older than nine, sitting in the dining room in a house they used to call home. It was weird and uncomfortable, especially when Sammy walked into the room with a younger, much taller woman by his side.

"Kids, I want you to meet Altovise," he announced.

The children were polite, and all said hello. Altovise returned the greeting, and they sat down for dinner, with Sammy at the head of the table, Altovise on the other end, and the children in between. The dinner conversation was strained. The children were happy to see their father, which was a rare occasion, given his heavy touring schedule. But the presence of this new woman dampened their enthusiasm, especially when Sammy broke the news.

"Children, I wanted to have dinner with you tonight to tell you something. I've asked Altovise to marry me."

Sammy beamed, as did Altovise. The children were stunned, and sat quietly picking at their food. Tracey finally broke the uncomfortable silence, looking over to her father and asking a question only a child could ask.

"Why?"

Sammy didn't have an answer.

When they returned home and told May, she was irate that Sammy told the children such important news without allowing her to prepare

them. The immediate ill will placed Altovise in the position of an inter-
loper, and it remained so during a tense relationship that often became
adversarial, particularly following Sammy's death. So, when Tracey re-
ceived a call on April 9, 1994, from someone named Al Murray Jr.,
claiming to be Altovise's new attorney, she was leery.

"Who are you? And are you really an attorney or just one of those
Al Carter guys?" she said.

Sonny said he had been retained by Altovise Davis to represent her
interests in her and her husband's estate.

"She's living in a home on the property of the Hillside Inn in Penn-
sylvania, which my parents own," said Sonny.

"Is that near Philadelphia?" said Tracey.

Sonny explained it was north of Philadelphia and about seventy-five
miles west of New York City.

"Oh, that's the place with the heart-shaped bathtubs. You're from
there?" she said, clearly unimpressed with Altovise's new attorney.

Geography aside, Tracey was hostile. Along with the Quincy Jones
musical, Tracey said, she'd been trying to complete several other busi-
ness deals since her father's death. But the estate's insolvency and Trac-
ey's lack of legal standing prevented her from moving forward.

"Altovise won't cooperate," Tracey said. "She's not a good person.
You don't know her like I do. She's a drunk. Quincy wants to do a
musical and the only way we're going to get this done is for me to be in
control of the estate."

Tracey said she hired Frank Sinatra's longtime attorney, Robert Fin-
kelstein, to represent her, and together they devised a plan that would
compensate Altovise handsomely. But due to her IRS issues, the deal
hinged on Altovise transferring her rights to Tracey.

"This is the only way," Tracey said.

Sonny had questions; chief among them, who represented the
estate?

Tracey said it was under control of the executors, Shirley Rhodes
and John Climaco. Rhodes was Sammy's manager and the widow of
Sammy's longtime conductor, George Rhodes, who died in 1985. Cli-

maco was an attorney from Cleveland and had worked with her father for many years.

"Cleveland?" said Sonny.

"Yeah," said Tracey. "Isn't that interesting."

"What does that mean?" said Sonny.

Tracey paused. "You'll find out."

Sonny said he'd immediately fax Tracey a letter introducing himself, and Tracey said she'd fax the names and contact numbers of all the important people who were involved in Sammy's life and in the disposition of his estate, including Rhodes, Climaco, Finkelstein, Sammy's accountant George Louis, Herb Sturman, the attorney who represented the executors, and Richard Ferko and Bill Choulos, who served as Altovise's attorneys prior to Sonny. True to her word, Tracey faxed twenty-two pages of phone numbers and addresses. Sonny walked over to Calvin's with the faxed papers in hand to go over the names with Altovise, who sat on the bed in her cramped, cluttered room, dressed in a T-shirt and robe and surrounded by papers and envelopes, many unopened.

Calvin stood in the doorway, watching and listening.

"I'm just finishing off a letter to Liza," Altovise said.

Sonny looked at the unopened envelopes. Many were from the Screen Actors Guild.

"What are those?" he said.

"Checks. Every month I get checks, some for pennies, others for hundreds of dollars."

"You're not cashing those, are you? The IRS would have a fit."

"No," said Altovise. "I cashed a couple a while back but none since."

Altovise finished her letter, folded it, and put it into an envelope.

"Can you mail this for me?" she said.

Sonny took the letter. It was addressed to Liza Minnelli in Beverly Hills, California. He placed it in his briefcase and took out the multipage fax from Tracey.

Altovise looked at the names.

"They all plotted against me," she said as she wrote "Michael Jackson" on another envelope.

Sonny explained Tracey's strategy, but he could see Altovise was equally leery of her stepdaughter. The musical, as proposed, would not work, Altovise said, and she maintained that she alone controlled Sammy's 50 percent of his books, which, along with *Yes I Can,* also included *Hollywood in a Suitcase* in 1980 and *Why Me?* in 1989. Besides, Altovise said, she didn't want to sign over her rights to anyone, especially Tracey.

"I don't trust any of them," said Altovise.

Sonny agreed. He had much more to learn and wasn't about to negotiate a major agreement right out of the box without knowing more details.

"You know," he said, looking around the room. "You should clean up a bit. You'd feel better."

Altovise looked up and away from her letter and panned the bedroom, which was filled with opened and unopened boxes, strewn clothing, photos of her and Sammy dressed formally at some regal events, and several empty mayonnaise jars.

"I need to finish my letter. Michael hasn't heard from me in a while," she said.

"Okay," said Sonny, moving toward the bedroom door. "When you can, you should get some rest. We need to start getting you well."

"Oh, Calvin," said Altovise. "Please close the door."

Calvin did as he was asked but he lingered and, with his ear pressed against the door, he heard the bed squeak, feet walking on the floor, the bed squeak again, and then the opening of a jar. Calvin had heard this before.

"That's what she does," Calvin told Sonny. "She stays in her room, writes letters to people who never answer, and sips vodka."

The two men walked into the kitchen and Calvin reached into a drawer and pulled out a notebook.

"She used to get a lot of phone calls when she first came here," said Calvin, looking at a list that included Michael Jackson, Liza Minnelli, and Donald Rumsfeld, who Altovise said was an old friend who worked for President Nixon.

Bill Cosby also called, but infrequently, said Calvin, just to check on Altovise out of loyalty to Sammy.

"Now the only people who call are her parents and Al Carter," said Calvin.

Sonny returned to his office at the Hillside and contacted the IRS in Los Angeles. The call was quick. He learned that Sammy's estate was declared insolvent and in collection in 1992, meaning all litigation was over. Sonny was also informed that in order to gain access to the estate tax returns and any additional information, he had to file the appropriate paperwork to be recognized as Altovise's representative, and that could take months.

Sonny hired a local accounting firm, Weseloh & Company, to prepare the paperwork, along with Altovise's most recent tax returns. She hadn't filed any since Sammy's death, and the IRS wanted them from 1990 through 1993. He also wrote introduction letters to those on the list provided by Tracey, informing them that he'd been "formally and exclusively retained" by Altovise Davis, her parents, and others—the "others" being Calvin Douglas.

It took several weeks, but Sonny eventually received responses from all on the list. Some, like Rhodes and Climaco, declined to cooperate, directing Sonny instead to contact Herb Sturman, the Beverly Hills attorney who represented the executors. George Louis, Sammy's long-time accountant, also declined to help, saying he was retired and that any queries also had to go through Sturman. When Sonny approached Sturman, he, too, declined any cooperation.

Robert Finkelstein was somewhat more cooperative, especially after Sonny wrote in his letter that Altovise expressed a "strong desire" to reconcile any past differences with Tracey Davis. To Finkelstein, a polished Hollywood veteran, that opened the door just enough to try to get a deal done for the Quincy Jones musical and convince Altovise to assign her rights.

Sonny also sent a letter to Leonard "Bud" Isenberg, Sammy's life insurance agent. Tracey said upon her father's death his life insurance policies totaled over $5 million. Of that, a little more than $1.5 million

was divided between three of his children, Tracey, Mark, and Jeff, while Altovise was the beneficiary of nearly a dozen policies Tracey believed totaled over $1 million. That left $2.5 million remaining, and Tracey said it went to her father's company, Transamerican Entertainment.

But Tracey contended that it didn't make any sense for Transamerican to receive such a large sum. And it made even less sense that several people who were close to her father, such as his longtime road manager Murphy Bennett, chief bodyguard Brian Dellow, and former manager Sy Marsh didn't receive a dime. Murphy, for one, had worked for Sammy in various capacities for more than thirty years. He was from Chicago and served in World War II before relocating to Los Angeles in 1950. He gave up a job with United Airlines to join Sammy in 1959 as his road manager. There wasn't anyone closer, said Tracey, yet a promised $1 million benefit never materialized. Sy Marsh, the former manager whose business relationship with Sammy ended in 1981, was also excluded from a promised $1 million payout, said Tracey.

Sonny didn't really care. Perhaps Sammy changed his mind. It didn't matter, at least not now. Altovise was his client, and as far as he was concerned, he wanted to find out what happened to her $1 million. But before even broaching that subject, Sonny scheduled an appointment for Altovise to see a Stroudsburg psychologist, Dr. William Van Meter. Her longstanding problems with alcohol required immediate treatment, and Sonny wanted a comprehensive diagnosis.

Van Meter agreed to treat Altovise at least twice a week, though it would take several months to get to the root cause of her problems, he said. That was fine, said Sonny. It would take that long to get legal standing with the IRS, to figure out Altovise's current financial situation, to gauge the current status of her late husband's estate, and to meet with Tracey Davis.

Sonny also realized that, aside from what he saw on television or read here and there, he knew absolutely nothing about Sammy Davis Jr., and he had some homework to do.

CHAPTER
4

When Sammy Davis Jr. was only eight years old, he saw his name on a billboard, which read WILL MASTIN'S GANG FEATURING LITTLE SAMMY. When he asked what "featuring" meant, his father explained that he was so talented, they had to tell the audience they were going to see something special.

Sammy was a natural talent, one of those rare people touched by the hand of God. Even at a tender age Sammy's dancing skills were noticeable, as was his ability to mimic people in song and spoken word.

He was born in Harlem, in 1925, to Sam, an African-American dancer, and Elvera Sanchez, a Puerto Rican chorus girl. Sam and Elvera appeared together in Will Mastin's *Holiday in Dixieland* as part of a vaudeville troupe that spent nearly every waking—and sleeping—hour on the road. After he was born, Sammy was sent to live in Brooklyn with friends of his parents, but soon after he was under the care of his grandmother Rosa B. Davis, whom Sammy called Mama. A sister, Ramona, came along two years later, but his parents divorced, and Sam, fearing he'd lose custody, took his three-year-old son on the road with him. When Sammy asked where they were going, Sam replied, "We're goin' into show business, son."

Sammy's education took place not in schools but in the vaudeville halls throughout New York and on the road. He watched intently from the side of the stage during rehearsals and performances, studying his father and the man he called his uncle, Will Mastin. They were old-time dancers, and Sammy quickly copied their steps, and created some

of his own. He could place his hand on the floor, the other in the air, and kick his feet out in front of him. Sam bought him a pair of tap shoes, and Sammy took off like he was born in them. Little Sammy was so good his father and uncle incorporated him into their act and they watched as his skills blossomed before appreciative audiences, which threw money at the talented little boy, as was the custom of the day. Following most performances, Sammy walked off the stage with his pockets filled with coins.

Sam and Will knew what they had in little Sammy, and, as he was growing up on the road, they nurtured and protected him from the harshness of the outside world. But since much of America was segregated, there wasn't a lot Sam and Will could do to protect Sammy from hearing the word "nigger." The first time it happened was at a restaurant, where Sammy, his father, and his uncle sat in one section but were told matter-of-factly that "niggers can't sit there" and were directed toward the "colored" area.

Sammy could feel his father's anger, and later that night he asked his uncle Will the question.

"What's a nigger?"

Will explained it was a nasty word some white people used to describe colored people. Sammy asked if he meant show people. Will said no, and that there was no definition of the word other than "it don't mean nothing except to say they don't like us." Sammy remained confused. He didn't think he was different from anybody else. But he saw the hurt in his father and uncle and he tried to make their pain and anger disappear by making them laugh. Everyone would see, Sammy thought, that by entertaining, he could make all the hurt feelings go away.

As Sammy and his talent grew and vaudeville died, variety acts turned to the clubs, the most prominent of which was the Copacabana in New York. Sammy listened to the radio and heard the stars of the day say how they loved playing "The Copa" and tell of their glamorous Hollywood lifestyles. He'd close his eyes, ignore his Harlem surroundings, and imagine himself immersed in the world of the rich and

famous. Sammy thought of big homes and swimming pools. He wanted to be a star.

After years on the road, and with no formal education, the child prodigy had grown into a young man. He tried to enlist in the army after the Japanese bombed Pearl Harbor in 1941, but he was only six-teen and told to go home with his father, who also tried to enlist but was told he was too old. Sammy was drafted in 1943 and he served in the U.S. Army's first integrated unit. He'd never been away from the protective eyes of his father and uncle, and his acclimatization to army life with young white men proved to be a life-changing experience. His color and small physique, at five feet, three inches tall, made him an easy target for insults and cruel jokes. A group of white soldiers once of-fered Sammy a bottle of beer but, when he took a sip, he realized it was filled with urine. Enraged, Sammy fought with the men that night and many other times through the long weeks when he'd endure racist slurs and constant reminders that he was "still a nigger." They even held him one night and wrote COON in white paint on his forehead. The fighting continued, and Sammy's nose was broken several times. He stopped fighting only when a black sergeant named Williams counseled him against violence.

"You can't hope to change a man's ideas except with a better idea. You've got to fight back with your brain."

The sergeant gave Sammy his first book to read—*The Picture of Dorian Gray* by Oscar Wilde—and Sammy sat up late at night on the floor of the latrine with a pocket dictionary by his side to look up words he didn't understand. When he finished, he was thirsty for more, and the sergeant obliged, giving him books by Charles Dickens, Mark Twain, Edgar Allan Poe, and William Shakespeare.

Sammy eventually escaped the verbal and physical onslaught after joining an entertainment unit, and he found that his talent shielded him from further abuse. He basked in the approval of hundreds of anonymous white faces clapping and hooting, and he realized that his dancing was his weapon that broke down barriers. He was a small, un-attractive black man with a crooked nose, yet his skills allowed him to

feel normal, like he did with his dad and his uncle. The stage erased his physical deficiencies, and his color, and he lived his days waiting patiently for those few minutes in front of the lights. His talent brought him respect, which was something his fists couldn't do. And when Sammy was discharged from the army, he knew he just had to be a star to maintain that respect. And he didn't want to be just any star. He wanted to be the best ever, to ensure that no one would ever insult or hurt him again. Sammy's obsession with stardom consumed him to the point where he knew he'd make a deal with the devil if that's what it took to get it.

Frank Sinatra didn't have horns, but he did have a golden voice that brought him great success and national celebrity in the 1940s. Sammy first met Frank in Los Angeles in 1945. The Will Mastin Trio opened for Frank when he fronted Tommy Dorsey's band in 1940, but they never spoke. Now Frank was a household name from coast to coast and Sammy hoped to get his autograph at the NBC radio studios. Sammy loved everything about Frank, particularly his voice, and, as a fan, Sammy waited behind hundreds of kids, hoping for a chance to say hello after Frank's performance on a radio show. Sammy watched in awe as Frank emerged from the stage door and looked and acted exactly like the star that he was, confident, in control, and making eye contact with each fan. He had a self-assurance and power that only emanated from someone completely at ease with his own talent. Sammy admired the respect and power Frank's celebrity afforded him and he could see himself walking out that door greeted by hundreds of admirers not interested at all in his color, only his talent. He'd be normal, like he always was with his father and uncle.

When Sammy finally reached Frank, he was shocked when Frank said he remembered Sammy opening for him five years earlier. They talked briefly, and Frank said he'd leave Sammy a ticket for his show next week. Sammy couldn't wait for the week to go by, and when the show began, Sammy was enthralled. The kids went crazy for Frank. Even more impressive were the people who stopped by Frank's dressing room after the show. Sammy was invited, and he waited patiently

for his turn while men in crisp suits walked in and out to pay homage. Frank and Sammy spoke again, and further cemented their connection. It wasn't long after that Sammy, his father, and uncle Will received a telegram inviting them to open for Frank at the Capitol Theater in New York. They couldn't figure why they were selected, other than Frank always opened his show with a black group. Sammy learned later that it was Frank who overstepped his booking manager and demanded that Sammy and the Will Mastin Trio open for him, at $1,250 per week. Frank was as much a fan of Sammy as Sammy was of Frank, and by the time the three-week engagement was over, the two men were friends. Friends for life, said Frank. And if Sammy ever needed Frank for anything, he was to call.

But it was Frank who'd make the next call a couple of years later, after learning that Sammy had been barred from seeing his show at the Copacabana. Outside of Harlem, blacks weren't allowed in the tony New York clubs. Frank told Sammy to return the following night, and when Sammy arrived, he was given his own table with two bodyguards by his side. Frank, again, demonstrated power. He made things happen because of his celebrity, and that influence was surely something Sammy knew he'd command once he became a star.

And he knew he'd be a star.

Sammy's celebrity was on the rise. By the 1950s he was given top billing, over his father and uncle. Sammy incorporated dead-on impersonations of major stars of the day into the act and he could sing just like Frank, Mel Tormé, and Nat King Cole. He could also do movie stars, and did perfect impersonations of Humphrey Bogart, James Cagney, and Edward G. Robinson. As the act grew in popularity, the bookings increased, as did the fees. When the trio arrived in Las Vegas, they were treated like anyone else on stage. But when the music ended and the crowd disappeared, they were black again and forced to sleep in hotels on the segregated west side of town. Sammy sat in his room late at night, looking out at the lights on the Strip, knowing he was barred from entering any of the hotels or casinos there.

It was only weeks later that the big break finally came. The Will Mastin Trio was booked to open for Janis Paige at Ciro's in Los Angeles. It was the night of the Academy Awards, and following the ceremony, many of the stars flocked to Ciro's, which hosted the only after-show event. Sammy understood the enormity of the evening, and the second he and his father and uncle hit the stage, they exploded and danced at a whirlish pace that mesmerized the audience. The applause grew louder with each number and it burst into one continuous ovation after Sammy finished his impressions. After two curtain calls, Sammy ended the performance with an impromptu impersonation of Jerry Lewis, who happened to be sitting in the audience with Dean Martin. After the show, Jerry and Dean and others flocked backstage to congratulate Sammy, who waited up until the sunrise to read the morning reviews. They were spectacular.

The *Los Angeles Times* called Sammy "dynamic," while the *Hollywood Reporter* said Sammy set Hollywood "on its ear." *Daily Variety* called the act a "walloping success."

The William Morris Agency immediately signed the Will Mastin Trio and Sammy was introduced all around town. He had lunch at the Hillcrest Country Club, where he met George Burns, Jack Benny, Groucho Marx, and others. Soon after came a recording contract with Decca, headline gigs at Ciro's and in Las Vegas. Upon his return to New York, even Milton Berle, the biggest star on television, invited Sammy to his nightly table at Lindy's in Manhattan.

Sammy electrified the entertainment world from coast to coast, and he readily enjoyed the money and adulation that came with it. During a lengthy run in Las Vegas, he hosted late-night, after-show parties, ordering nightly the best food and champagne and screenings of feature films directly from Los Angeles. Sammy remembered the party Frank threw during the three-week engagement at the Capitol Theater in 1945. On Thanksgiving Day—the next-to-last day—Frank invited everyone to the theater basement, from performers to the janitor. There was good food and drink and everyone adored Frank for his grand gesture, and

Sammy wanted to feel the same adulation. He also wanted the power and influence that came with being a celebrity. As Sammy's star rose, he declined appearances at venues that barred black people.

His ascent to stardom was temporarily halted when he lost his left eye in a car crash in 1954. The accident in San Bernardino, California, became national, front-page news. Even famed columnist Walter Winchell sent Sammy his best wishes during his popular Sunday night radio program. As Sammy convalesced, bigger offers soon came in for the Will Mastin Trio, including one from the New Frontier casino in Las Vegas that guaranteed $25,000 a week. Sammy returned to the stage wearing a black eye patch and converted to Judaism. He believed Jews and blacks suffered similarly, and he found comfort in the Torah and its teachings.

Sammy continued on his professional ascent starring on Broadway in *Mr. Wonderful* in 1956, after which he appeared in the feature film *Porgy and Bess* in 1959. His performance in the role of Sportin' Life earned terrific reviews. He was a bona fide star at the top of his game and he could do anything. Or so he thought. In late 1957, word of his relationship with actress Kim Novak leaked in the press. Novak was blond, sultry, and one of the most popular actresses of the 1950s; she had starred with Frank Sinatra in *Pal Joey* in 1957. But the relationship angered Harry Cohen, chairman of Columbia Pictures, who had personally groomed Novak to replace Rita Hayworth. Black America was also displeased with the affair, with the black press critical of Sammy for being "inexcusably unconscious of his responsibility as a Negro."

Sammy and Novak ended their relationship, and Sammy sought to make amends with black America by marrying Loray White, a black chorus girl he had previously dated. They married in January 1958 with a small ceremony at the Sands in Las Vegas, but divorced just a few months later.

By 1960 Sammy was a full-fledged member of Frank Sinatra's Rat Pack, and his celebrity reached mythic proportions as his career continued to expand. He starred in *Ocean's Eleven* and *Sergeants 3* and recorded albums for Frank's Reprise label. He starred again on Broadway

in *Golden Boy* in 1964, for which he was nominated for a Tony Award, and he made countless television appearances on a host of variety shows. He also married again, in 1960, and it was to a white woman, the Swedish actress May Britt.

Like his affair with Novak, Sammy's marriage to May drew outrage. He received vicious hate mail and death threats. And most hurtful, he was disinvited by incoming president John F. Kennedy from the 1961 inauguration. Sammy had worked hard campaigning for Kennedy, performing at various functions and fund-raisers in support of the senator from Massachusetts. And when he married May, he believed it was for the right reasons. Yet his love for May wasn't enough to overcome the quick and decisive judgment of the Kennedys and much of America, and Sammy was devastated and angered by their betrayal. He had maintained the belief that stardom would conquer all. But despite his international celebrity, he still wasn't big enough to quell old fears and hatreds.

Sammy remained married to May, and by 1965 he was a star ten times over. He owned a beautiful home in Beverly Hills, had three young children, and also placed his full support behind Dr. Martin Luther King Jr. and others at the forefront of the civil rights battle engulfing the nation, lending his name and openly campaigning for equality. Sammy was there in Washington, DC, in August 1963, along with 250,000 people, dressed in hip Nehru clothing, listening intently as Dr. King delivered his treasured "I Have a Dream" speech. Sammy shared that dream, and he wrote about it in his 1965 bestseller *Yes I Can,* which told of his desire for fame, his resultant success, and his pursuit of racial equality.

Researching Sammy's history, Sonny saw surprising similarities between Sammy and the Judge. Both men served in World War II, and both achieved great success in their chosen fields despite great difficulties. But, aside from his work on the bench, the Judge made his living catering to black people while Sammy was dependent on white people who paid his salary by filling the clubs and concert halls, buying tickets to his movies and buying his records. White America was Sammy's au-

dience, and balancing his dreams of equality with his need to maintain his stardom proved daunting at a time when America was deeply torn, and the pressures from both sides were often overwhelming.

After finishing *Yes I Can,* Sonny turned to *Hollywood in a Suitcase,* Sammy's 1980 account of his life in film, complete with his personal take on various film stars, from Marilyn Monroe to Humphrey Bogart. Sammy also wrote *Why Me?* in 1989, which was a sequel to *Yes I Can* and a mea culpa of sorts that provided a deeper reflection on Sammy's storied life, particularly his financial troubles. Sammy admitted to accumulating and spending several fortunes, and he described his failures as a husband and father, his passing interest in the occult, his surprising support of Richard Nixon and the Republican Party in the 1970s, and finally his efforts to rectify his debt to the IRS. Sammy also wrote about his addiction to cocaine and his "open" marriage with Altovise, which allowed him to seek physical comfort from other women.

Unlike the success Sammy had achieved in the 1950s and 1960s, when he appeared in films, on Broadway, on television, and made records, by 1970 his career appeared to downshift, relegated to touring with extended, highly paid stays in Las Vegas. The electricity and excitement that followed Sammy during the early part of his career had faded. He still remained a popular household name, especially after his brief, controversial performance on the top-rated television show *All in the Family.* Sammy's guest appearance ended with a kiss on the cheek of bigot Archie Bunker, portrayed by Sammy's good friend Carroll O'Connor, and the black/white moment created headlines across the country. Like he had for so many years, Sammy used his stardom to break down barriers, and the controversy over a simple kiss endured for years.

Sammy created yet another controversy, not with a kiss but with a hug. Unlike the Kennedys a decade earlier, Sammy believed President Richard Nixon genuinely sought his support to help make inroads into black America. Sammy visited Vietnam for Nixon in 1972 to perform for the troops, and he also served as an emissary for Nixon on a variety of issues, including civil rights. So, after Nixon publicly thanked Sammy

for his support at the 1972 Republican National Convention in Miami, Sammy responded in kind by walking up from behind the president and wrapping his arms around him for no more than a second. But it was enough time to be captured by photographers, and the picture was splashed over newspapers throughout the world. Black America vilified Sammy once more, and the outcry left him angry and confused.

Race, once again, became a deciding factor and flash point in his life and it interfered with a genuine moment of respect between two men. Sammy again was an Uncle Tom, a black man who couldn't stop himself from pandering to white society. Adding insult to injury was the 1972 recording of "The Candy Man." The syrupy pop hit was so anti-Sammy, so anti-black. And he didn't want to do it. But producer Mike Curb insisted, arguing that Frank Sinatra had his pop hit, "High Hopes," and Sammy could find similar success with "The Candy Man." So Sammy recorded the song, cheesy lyrics and all.

> *Who can take a sunrise, sprinkle it with dew*
> *Cover it with choc'late and a miracle or two*
> *The Candy Man*
> *Oh, the Candy Man can*
> *The Candy Man can 'cause he mixes it with love*
> *and makes the world taste good*

To Sammy's great surprise, the record was an instant smash that quickly raced to the top of the charts and became a national anthem of sorts for children around the globe. But the success of "The Candy Man" only fueled his critics, and there wasn't more Sammy believed he could accomplish. Nearing fifty, he still attracted huge audiences to his live performances, but after a lifetime of reaching for stardom, and finding it, it wasn't enough. So Sammy found solace in drugs, particularly cocaine and amyl nitrate, and experimented briefly with Satanism and pornography. He also wrote how his newfound interests infuriated Frank Sinatra, and the two friends didn't speak for years.

Sammy, indeed, was beholden to Frank for his support through

very difficult years. But he wrote that friendship with Frank was always on Frank's terms, and Sammy told of darker days with Frank, their friendship strained by Sammy's divorce from May Britt in 1968 and his continuing drug use during the 1970s. Frank was about control over everything in his life, including his friends. And Sammy wanted the same control, something he knew he'd never have with Frank. The two friends eventually reconciled, but only after Sammy promised to change his life, and Sammy ended *Why Me?* recounting his 1988 tour with Frank and Liza Minnelli, the earnings from which, Sammy wistfully explained, should resolve whatever moneys he owed the government. Life was good, Sammy wrote, and he was on the road to financial recovery, thanks to his friend Frank Sinatra.

After finishing the books, Sonny turned to films and every piece of Sammy's videos he could get his hands on. Talk shows, television specials, it didn't matter. Sonny immersed himself in everything Sammy, and with each tape he marveled at Sammy's talent. There were great singers and great dancers, but never someone who could combine both skills like Sammy could. Sammy was the consummate entertainer of his generation, perhaps even his century, and the world adored him and his talent. Sonny expanded his studies and even visited the local library, pulling old newspaper and magazine articles while picking up bits and pieces of information. And he supplemented his tutorial of all things Sammy by quizzing Altovise daily on her late husband. But her memory was scattered and focused on other celebrities, including Sinatra, Cosby, Dean Martin, Richard Nixon, and her former place with the SHARE girls, a celebrity-wives charity. Altovise defined herself as Sammy's wife and, despite the reality of her current situation, she still believed she was important.

Sonny thought long and hard about Sammy Davis Jr. The visual images that remained in the public consciousness, from being carried onstage like a little boy by Frank during their "Summit at the Sands" to the Nixon hug, belied a far deeper, more earnest side to his persona, a quest for truth and righteousness Sammy believed he could only find through stardom. The bigger Sammy became, the more change he be-

lieved he could help effect in a deeply divided nation. But he continually exercised bad judgment, which undermined his efforts. Sammy gave in to ridiculous parodies that set African-Americans apart. Particularly upsetting to Sonny and his family was Sammy's "Here Come da Judge." The skit, which Sammy made famous during his many appearances on the 1960s television show *Laugh-In*, infuriated Sonny. His father was, in fact, a criminal court judge in Brooklyn, and by diminishing the importance of his father's position in what was nothing more than a Stepin Fetchit character right out of a 1930s minstrel show, Sammy's performance was demeaning and insulting.

As Sonny discovered, Sammy indeed was a complicated man. Yet the sum of his endeavors was an estate in ruins and a widow on the verge of death. And sadly, his great talent and enormous career were, just four years after his death, a mere footnote to history.

CHAPTER
5

Joe Jackson pulled a handful of quarters out of his pants pocket and deposited them, one by one, into the slot machine. With each motion, the twenty-year-old inserted a fresh coin and then pulled the lever, causing the machine to spin inside, and he'd stand there, full of excitement, waiting for the machine to stop.

The Sands casino floor was jammed with people, many with their eyes on their slot machine or card game but their ears tuned to shouts or squeals of sightings of the Rat Pack. Thousands had rushed to Las Vegas with the hope of seeing Frank and Dean and Sammy perform, booking every available hotel room in the city and forcing others to find accommodations elsewhere. Many others, without tickets to the evening shows, simply sought just a glimpse of the famed group at the casino or on the street to satisfy their celebrity rush, while other stars, like Marilyn Monroe, Tony Curtis, and David Niven, were drawn to the sheer excitement of having Frank, Dean, and Sammy around, and they catwalked through town bathed in their glow.

Joe caught Sammy's eye in 1958 at the Chez Paree, Chicago's famous supper club. A local radio and television personality, Joe was a young entertainer who yearned for a life in Hollywood. He came to catch Sammy's show, and was awed by his talent and ability to move the audience, whose energy fueled Sammy's engine.

Sammy invited Joe backstage after the show, and the teenager waited in front of Sammy's dressing room as other guests, includ-

ing Elizabeth Taylor, stopped by to pay homage. Joe waited his turn, and when he was finally called inside, Sammy got right to the point.

"I'm going to do a couple of movies and I need a stand-in," said Sammy.

"That's great," said Joe, who didn't have a clue what a stand-in did.

Sammy explained that Joe's diminutive physique matched Sammy's own perfectly, and he offered him a job as his stand-in for the film Porgy and Bess. *Sammy had the role of Sportin' Life, which would later earn him an Academy Award nomination, and filming would begin later that year in Hollywood. Joe was ecstatic. His job as Sammy's stand-in was to be Sammy while the director and other crew members set up the positioning and lighting for each shot. When the filming actually began, the actors would appear and assume the same positions. Joe was paid $150 each day and thought he was on top of the world. After all, he was mingling with Sydney Poitier, Dorothy Dandridge, Diahann Carroll, and Pearl Bailey, all icons to the black community.*

Joe returned to Chicago after filming ended, but in January 1960 he was called out again, this time to Las Vegas to work as Sammy's stand-in for filming on Ocean's Eleven. *Las Vegas was abuzz as thousands arrived just to get a glimpse of Frank Sinatra, Dean Martin, Peter Lawford, Joey Bishop, and Sammy, who performed at the Sands at night and filmed the movie during the day. The live performances were sold out, but Sammy provided Joe with a ticket, and each night Joe marveled at the sight on stage, particularly Sammy, who was by far the most polished of all the entertainers. Sammy was electric.*

By day, after the filming stopped, the Rat Pack were treated like royalty and trailed by fierce-looking, grunting bodyguards, the kind of men Joe had seen back in Chicago. But since Joe was with Sammy, he was part of the entourage, and Sammy introduced his "stand-in" to his celebrity friends, among them Tony Curtis and

*Senator John F. Kennedy. Sammy also introduced Joe to his Rat
Pack pals. All were warm and welcoming, especially Frank Sina-
tra, who got Joe a raise. Joe decided to celebrate, and he headed
over to the casino floor at the Sands. Joe never gambled before, but
now that he had a few extra dollars in his pocket, and he was, after
all, in Las Vegas, he decided to take a position in front of a slot
machine, inserting coin after coin. He was interrupted by an angry
voice and sudden pull on his shirt collar.*

"What are you doing here?"

*Joe turned around, his chin pressed against the chest of a burly
security guard.*

"Did you hear me, what are you doing here?"

*Joe didn't understand the question. It was his first visit to a
casino. Was he too young to gamble? Was he dressed too casually?*

"I'm here with the company filming Ocean's Eleven *and I
thought I'd try my luck at gambling," said Joe.*

*"Well, you can't," said the guard, who pulled the little man by his
collar and dragged him across the casino floor and toward the front
door, only to be met by Sammy and his entourage, who were entering
the casino to shouts and squeals from Sammy's adoring fans.*

"Look, it's Sammy!"

*Sammy was resplendent in a black tuxedo, and he looked every
bit the star he was. But his infectious smile quickly disappeared
when he saw Joe being led out of the casino by the scruff of his
neck.*

"Joe, what's going on?" said Sammy.

*"What do you think," said Joe, shrugging his shoulders. "I
thought I could play slots here."*

*"You can," said Sammy, who quickly deduced what was trans-
piring.*

*Sammy had his own experiences in Las Vegas, memories seared
deep into his psyche. It wasn't that long ago that Sammy was head-
lining the Frontier Casino with the Will Mastin Trio but forced
to room in the segregated west side of town with his father and*

uncle. Sammy could work in the casinos, but he couldn't stay or play there.

Sammy was irate.

"Let him go!" he barked.

The guard quickly released his grip as Sammy's fans screamed his name and reached out past the bodyguards to touch him. The casino manager rushed over and Sammy, in no uncertain terms, made it clear that Joe Jackson was going to gamble at the Sands.

"Of course, Mr. Davis," said the nervous manager, who gave Joe a handful of coins.

"Go, have fun," said Sammy, turning to Joe. "And if anyone ever bothers you again, you come get me."

The flight from New York to Los Angeles was uneventful, with the exception of Altovise's constant trips to the bathroom. She carried a large handbag that always remained under her arm. Inside she hid a small mayonnaise jar and kept several containers of Altoids, a strong breath mint.

It was August 1994, and the trip to California had several purposes, including a much-anticipated meeting with Tracey Davis and initial discussions with the IRS, which finally recognized Sonny as Altovise's legal representative. Sonny still had no idea how much the estate owed the government. Different numbers had been thrown out. Some thought it was $2 million. The people who really knew, the executors Rhodes and Climaco and their attorney, Herb Sturman, weren't cooperating. Others thought it was less. After all, the government did sell the Davises' home and auctioned off most of their possessions, they said.

But when Sonny learned during his one-on-one meeting with IRS agent Marvin Samuels that the tax bill was currently over $6 million and rising each day thanks to interest and penalties, he nearly dropped to the floor.

"How much?" he said incredulously.

Samuels, who worked in the special collections department of the IRS, explained that Sammy and Altovise took deductions on their tax

returns in the late 1970s and early 1980s from investments in tax shel-
ters, deductions that the IRS later disallowed. Sammy appealed to the
U.S. Tax Court, but the court opined in 1989 that the debt was valid.
Altovise argued the "innocent spouse" defense, claiming that following
Sammy's death she knew nothing of her husband's financial affairs. But
Altovise signed the joint returns, and thus she was liable. Samuels said
the IRS tried to negotiate a deal with Altovise through her previous at-
torney, Richard Ferko. After all, Samuels said, the IRS didn't want to
be seen as the cold, indifferent bureaucracy many thought it was, and it
surely didn't want to throw Altovise out onto the street. But that's what
the IRS did, after a verbal deal to settle the estate fell apart. Sonny asked
for a copy of the tax court ruling. Samuels said he could get it.

"Look, we didn't want any bad publicity out of this," said Samuels.
"We are fully aware of who Sammy Davis Jr. was and we wanted to
negotiate a deal. We had a deal."

Instead, Samuels said, the IRS had no choice but to move forward
with the public sale and liquidation of Sammy and Altovise's assets. The
sale included their Beverly Hills home on Summit Drive and countless
personal possessions. But the sales did little to reduce the debt, and four
years after Sammy's death interest and penalties continued to accumu-
late, ballooning the debt to its current level.

It was the largest single open case of an individual taxpayer debt in
the nation, and Sonny knew he had his work cut out for him.

"I'll get back to you," said Sonny.

The meeting at the Beverly Hills law office of Robert Finkelstein
would serve as the first contact between Altovise and Tracey Davis
in several years. Sonny and Tracey talked again after their initial con-
versations in April, and they agreed to meet as soon as he arrived in
Los Angeles. But before the meeting, Altovise wanted Sonny to take a
detour to see her old home on Summit Drive.

Sonny was curious too. The twenty-two-room mansion on a corner
lot was once owned by Tony Curtis and Janet Leigh, before Sammy
and Altovise bought it after they married, and Altovise always talked

about how happy she was there. So they drove up and through the winding roads of Beverly Hills, passing one expensive and flamboyant home after another. This was money, old Hollywood, thought Sonny, a secluded oasis for the rich and famous.

After reaching Summit Drive, Altovise pointed toward a front gate, where they stopped. Sonny looked past the gate to the house, a portion of which was covered by vegetation. It didn't look like a twenty-two-room mansion from the outside, and Sonny peered across the street to the palatial estate once owned by actress Mary Pickford. Sonny's eyes darted around the grand surroundings while Altovise sat slumped in the car, her eyes focused on her old home, tears streaming down her cheeks.

"I lived here twenty years," she said. "Twenty years. This was my home. This was my life. See that front door? I welcomed the First Lady there. The president's wife. I hosted charity events. I was a SHARE girl. They all came to me, they all wanted me. And now . . ."

Altovise buried her head in her hands.

"I want my life back!" she screamed.

"We're going to get you well, and then we're going to settle your debts. But you have to trust me. Okay?"

"Let's go," she said.

They drove to Finkelstein's office without saying a word to each other and upon arriving they were led toward a large conference room. Sonny noticed the fine appointments throughout the office, the well-dressed employees, and the numerous signed photos of celebrity royalty that hung on the walls. Finkelstein was a Hollywood deal-maker whose legendary reputation was enhanced by his representation of Frank Sinatra, and Sonny could feel the power. When they walked into the conference room, they were greeted with a loud welcome.

"Altovise!"

Sonny recognized the voice. It was Tracey, and as she rushed to greet Altovise, he was struck by her beauty, which was a potent mix of Puerto Rican, African-American, and Swedish genes.

"You look wonderful," Tracey said, embracing Altovise. "It's the best I've seen you in years."

"Oh, Tracey, it's so good to see you," said Altovise. "It's been too long."

After exchanging pleasantries, and introductions to Sonny, they sat down around a large, rectangular table, with Sonny and Altovise on one side, Tracey on the other side, and Finkelstein at the head.

"Well, it's good to see everyone together again," said Finkelstein. "I want to tell you that Frank, Nancy, and Barbara Sinatra all send their regards. They wanted me to tell you they missed you."

Altovise smiled. "Please give them my love."

But the small talk, goodwill, and warmth masked years of deep mistrust, which reappeared as soon as Finkelstein said Altovise had no choice but to agree to Tracey's demands and sign over her rights to her late husband's estate.

"There are far too many problems with the estate and with the IRS," Finkelstein said. "We have the opportunity to make some money so long as Altovise signs over everything to Tracey and the other children, and as soon as she resolves her problems, those rights will revert back to her."

Sonny was firm.

"I can't do that," he said.

Sonny's response didn't sit well with Tracey. Her refined beauty aside, Tracey had the personality of a pit bull, and whatever warmth she displayed moments earlier toward Altovise morphed into a raging rant fueled by two decades of seething anger.

"This is embarrassing!" Tracey screamed. "This is about my father and his legacy, and right now it's as dead as he is. There is no legacy!"

Altovise remained quiet while Sonny responded, and after a few minutes she placed her handbag under her arm and simply excused herself for the bathroom. When she returned, she popped several Altoids into her mouth.

Tracey was still ranting.

"Why? Why can't we do this? We have a bona fide offer on the table from Quincy Jones for a musical about my father. We can do other business and generate income. Don't you understand?"

Finkelstein expanded on Tracey's point, arguing that it was the only way to capitalize on Sammy's name and body of work.

"Besides," said Finkelstein, "you'll never settle with the IRS. It's impossible to settle that debt."

Sonny said he understood their position but he wasn't going to advise Altovise to sign away her rights. Sonny also believed, privately, that Altovise was a victim, and the children along with Finkelstein were just another group in a long line of people looking to take advantage of his client.

"Al, you're wrong. I know you've been fighting with Herb Sturman to get the records. This is going to be impossible and I think you're making a big mistake," said Finkelstein.

Altovise got up from her seat again and excused herself. She was clearly wilting from the stress of the meeting, which took a decidedly negative and nasty turn.

"This is bullshit," said Tracey.

When Altovise returned, the smell of alcohol wafted through the room, and Tracey shook her head.

"Just like old times," she said.

Sonny and Altovise said good-bye and left the meeting with no resolution, leaving behind a frustrated Tracey whose forceful, passionate argument fell on deaf ears.

"Un-fucking-believable," said Tracey, pounding her fist on the table.

"Calm down," said Finkelstein. "You're just like your father."

CHAPTER 6

The diagnosis from Dr. William Van Meter was far worse than expected. Several months of one-on-one treatment with the Stroudsburg, Pennsylvania, psychologist, often three times a week, failed to improve her condition. She was an alcoholic, and her addiction was severe, the worst Van Meter had ever seen.

Altovise's problems began long before she suffered the pain and depression over losing her husband and her home. But she couldn't, or simply refused, to discuss what appeared to be traumatic events that transpired during her twenty-year marriage. Altovise had other health issues to deal with, including seizures, and Van Meter told Calvin and Sonny that she required intensive care and therapy twenty-four hours a day, seven days a week, for an extended period of time. Months, he said, perhaps even years.

Van Meter suggested three long-care facilities. Two—in Connecticut and another in Reading, Pennsylvania—charged $300 per day and were cost-prohibitive. The third was the Little Hill–Alina Lodge in Blairstown, New Jersey, which was across the Delaware River and roughly fifteen miles away from the Hillside Inn. Alina Lodge was for people who were "reluctant to recover" from their addictions. Admittance meant that you understood "your way wasn't working" and long-term care was required. Once admitted, you could leave only for a medical emergency. Alina Lodge could accommodate up to sixty patients and there were fifty there now, mostly female. The cost was a more reasonable $95 per day, with a required thirty-day advance payment of $2,850 along with a mandatory three-month minimum stay.

Altovise had been treated for her addictions before. In 1986 she entered the Betty Ford Clinic for a short stay, after which she attended Alcoholics Anonymous meetings, but again only for a short time. In May 1993 she suffered from severe anxiety and hyperventilation, which led to a seizure and admittance to Freeport Hospital in Long Island for a detox. Following each instance, she refused to acknowledge she had a problem and simply resumed her drinking. Dr. Van Meter didn't mince words about Altovise's condition: her lifestyle, particularly her drinking, may have produced minor brain damage. She was also in denial about her dependency on alcohol and she had to submit to intense treatment or die.

The Alina Lodge didn't accept health insurance, and since the facility dealt primarily with people with severe addictions, the structured and rigorous program demanded limited contact with the outside world. That meant very few visits from family and friends and no phone calls. Treatment, they said, would be uninterrupted. Everyone was on board, including Altovise and her parents, who agreed to borrow against their Queens home to pay the bill. Following a complete physical at Warren Hospital in Phillipsburg, New Jersey, Altovise was admitted to the Alina Lodge on September 19, 1994.

Few people knew that Altovise was living in the Poconos, and Sonny decided that aside from him, Calvin, her parents, the Judge, and Mama, no one would know she was being treated at Alina Lodge. If anyone asked, Altovise was out of town, in New York or Los Angeles, or somewhere. Anywhere but the truth, said Sonny, who believed Altovise deserved privacy and respect.

But Altovise's first few weeks at Alina Lodge were difficult. Just days after she was admitted, she suffered a seizure while standing on line in the cafeteria. Officials called Calvin and told him she was near death and paramedics had to use CPR to revive her before she was rushed to Warren Hospital. She was returned to the Alina Lodge a week later.

By mid-October Altovise showed signs of responding to the program and her welfare became less of a concern, which allowed Sonny to zero in on settling several other outstanding matters. First and foremost, he still needed to get copies of all Sammy's financial documents so he could

assess all his debts in order to make an Offer in Compromise to the IRS. But Sammy's handlers, particularly his attorney John Climaco and manager Shirley Rhodes, continued to ignore his many letters and requests for a meeting. Following his trip with Altovise to California in August, Sonny sent off yet another letter to Rhodes, but Rhodes never replied.

The frustration over Shirley Rhodes and John Climaco was put aside when the package with a return address of INTERNAL REVENUE SERVICE, LOS ANGELES arrived in the mail. Inside was a copy of the 1989 U.S. Tax Court decision reaffirming Sammy's IRS debt, courtesy of agent Marvin Samuels. Sonny slowly read through the eighteen-page opinion, and with each passing page his eyes grew wider.

The case was known as *Davis v. Commissioner* and the court was asked to rule on a previous decision that determined Sammy and Altovise were not entitled to deduct losses from tax shelters they invested in over a five-year span, from 1978 to 1982. Calvin told Sonny about the tax shelters, something about how Sammy's former partner, Sy Marsh, had put Sammy into the shelters beginning in 1972 to gain deductions to pay previous income tax bills. But the tax court decision, in its "Findings of Facts," said the investments disallowed by the IRS began in 1978, and included tax returns for the years 1979, 1980, 1981, and 1982, with amounts owed varying from $798,483 for 1978, to $1.53 million for 1982.

As an example of the unworthiness of the investments, the court focused on details of one particular shelter, a limited partnership known as Cannel City Associates. The shelter was formed in December 1980 by Ernest William Hall, who the court said later became Sammy's business manager in 1983. Cannel City planned to lease the rights to approximately three thousand acres of land in Kentucky to mine and sell coal in five- or ten-pound bags to consumers at fifty cents per pound. A market and economic report commissioned by Hall offered projections of 9 million tons of coal available in reserves in Kentucky, which would be sold at $200 per ton, which was ten times the actual market price. There was no explanation in the prospectus for the discrepancy between the consumer price and the expected per ton sale price. The prospectus included an en-

gineering report confirming the availability of the coal, but the court said Hall included that information without the knowledge of the engineer. Hall also failed to state that his coal reserve estimate included more than a million tons of "gob," a waste product of coal mining that was unusable. Gob piles also posed an environmental threat, because they leak acidic substances into the soil, which Hall didn't disclose since he only referred to the gob piles as a source of recoverable coal.

Because of the project's high risk, the prospectus limited investment only to people who could afford it and had high taxable incomes with a net worth of $250,000. Sixty units at $150,000 each were made available, but only twenty-one units were sold during the first offering, and eighteen went to Sammy on Climaco's advice. Two other investors, who had previous business dealings with Hall, bought three units. A second offering was made and, using Sammy's name as a lure, another 10.5 units worth $1.57 million were sold. But after selling the subscriptions and raising the money, Hall changed his strategy and decided against selling the coal in bags. The new plan was to mold the coal in the shape of a log, which could then be sold in supermarkets and hardware stores.

The court noted that coal logs had been manufactured before, but they were made of coal dust, sawdust, and a binding agent, and used only for aesthetic appeal and not to burn. The court, in clear language, said the idea of consumers buying such small amounts of coal for home-heating purposes was so ludicrous there was never any possibility of turning a profit. Cannel City, said the court, was never a genuine mining operation, with no realistic expectation that the coal could even be dug from the ground, and the lofty market studies commissioned by Hall predicting millions in revenues were fictitious.

The court determined that Cannel City had "no economic substance" and the entire endeavor was a carefully crafted scheme designed to defraud investors, whose money ended up in the account of another shell company, Salem Coal Corporation. By 1983 Cannel City defaulted on notes to its investors, and Sammy and Altovise claimed losses on their tax returns totaling over $2.5 million, which were later denied by the tax court.

As Sonny read through the decision, his eyes grew even wider when he saw that it wasn't Sy Marsh who advised Sammy and Altovise on the tax shelters. Instead, it was Sammy's attorney, John Climaco.

According to the court, the paperwork for the Cannel City tax shelter had been drawn by Climaco's law firm, Climaco, Seminatore, Lefkowitz & Kaplan, which was based in Cleveland. And it was Climaco who not only put Sammy into the Cannel City tax shelter, but who introduced Sammy to Hall, who, the court said later, became one of Sammy's "most trusted financial advisors." Climaco had a nearly twenty-year relationship with Sammy, first representing him in various business transactions in the early 1970s and rising to become his official attorney of record in the early 1980s, even being named coexecutor of Sammy's estate prior to his death. Despite the court opinion, there were never any allegations of wrong-doing levied against Climaco or his firm, but Sonny's head danced with questions: Who was John Climaco? Why was Sammy using an attorney from Cleveland? And since it was Climaco whose firm created the Cannel City tax shelter, why was he still a coexecutor of the estate?

Sonny was mystified. It didn't make any sense that Sammy Davis Jr. could have had the pick of any good entertainment law attorney in Los Angeles or New York yet would rely on an attorney from Cleveland who put him into a bad tax shelter. Sonny was also deeply concerned about Climaco's representation of the estate: he believed Climaco was involved in causing the debt, and he was now one of the people controlling the debt.

Sonny immediately raised the Climaco and Rhodes issue with the IRS, which, Sonny believed, had either ignored or missed the concerns he raised.

What to do about it was another matter.

Sonny demanded that Climaco and Rhodes be removed as executors. The IRS said they'd get back to him. In the interim, Sonny wanted copies of Sammy's financial information, including all the probate material, the will, and tax returns. Sonny now knew how much the estate owed the IRS, but he needed to know the actual amounts of Sammy's other debts. All of Sammy's financial information was in Los Angeles and in the custody of attorney Herb Sturman, who represented the ex-

ecutors, Rhodes and Climaco. And like the executors, Sturman ignored
Sonny's numerous letters seeking access to all of Sammy's financial re-
cords. So Sonny called the IRS to exert pressure on the estate to turn
over the information. He knew how the federal system worked and,
from the very beginning, his strategy was to let the IRS know he was
not only their friend but also the one man who could resolve the oldest
and biggest open individual tax case in their system. Unlike Sturman
and the executors, who thought Sonny was just some country-bumpkin
lawyer Altovise dug up from the hinterlands, the IRS was well aware
of Sonny's national reputation and background handling tax fraud and
other financial cases, particularly E. F. Hutton.

The IRS responded quickly and ordered Sturman to give Sonny
access to all the documents he sought. Sturman agreed, but he declined
to give Sonny physical custody. Instead, Sonny could view and copy the
documents, but only in Sturman's office in Los Angeles.

Sonny scheduled an appointment and, a week later, he was sitting
in a conference room inside Sturman's office, surrounded by more than
two dozen boxes. Sonny rolled up his sleeves and spent three long days
examining each and every document.

During a career that spanned more than six decades, Sammy Davis
Jr. grossed over $50 million in earnings. From the early days in the
1930s, when he filled his pockets with coins tossed on stage by apprecia-
tive audiences, to earning over $150,000 a week performing three shows
a night at the Las Vegas casinos in the mid-1970s, Sammy's income fol-
lowed the same trajectory as his stardom.

By 1975, when Sammy turned fifty, the bulk of his income was de-
rived from his live performances, particularly in Las Vegas, where along
with Frank Sinatra he was among the top-grossing acts. Sammy and
Frank drew more people than three conventions, and they were well
compensated. Revenues from other sources, including television, stage
plays, movies, and recording royalties and residuals, grossed less than 10
percent of his annual income.

Sammy no doubt made money, but he also knew how to spend it,

buying expensive gifts for friends and maintaining a growing gambling habit. He had a myriad of other expenses, including $1.4 million in annual salaries for his musicians, dancers, road crew, and other bills that went with maintaining a large road crew. Another $1 million went to expenses related to his company, SYNI.

Sammy's performance earnings remained fairly level through the late 1970s and early 1980s, but by the mid-1980s they began to fall, dipping below $3 million, which wasn't enough to pay the bills for his extravagant lifestyle as well as the salaries of his extended staff, many of whom were family to Sammy. Among them were longtime employees like George Rhodes, Sammy's pianist and conductor who had been with him since *Mr. Wonderful* in 1956. George's wife, Shirley, who began as a secretary, was later elevated to serve as Sammy's manager and an officer in his new company, Transamerican Entertainment, following his breakup with Sy Marsh in 1981. Murphy Bennett, a father of five, joined Sammy in the late 1950s and became his road manager and good friend. Brian Dellow headed a six-man security crew that included the shotgun-toting Akram Mankarios, whom Brian personally recruited out of Las Vegas. Shirley's niece Eygie worked in the office along with Treva Wilson, a young beauty with a penchant for crunching numbers. Jolly Brown was the heavyset road crew manager overseeing a small staff that included Dino Meminger, a twentysomething who ran Sammy's errands and was known as his "road son," and Fortunatas "Fip" Ricard, a trumpet player.

Altovise, on paper, ran the house. In reality, those duties rested with Lessie Lee Jackson, Sammy's longtime housekeeper who had been with him since his marriage to May Britt in the 1960s. Lessie Lee knew her place in Sammy's life, and it occupied a big space—so big, in fact, that soon after Sammy married Altovise, Lessie Lee made it clear in no uncertain terms who had the real power in the house.

"I was here long before you, and I'll be here long after you're gone," she said to Altovise during one blowup.

Bernard Wilson, the valet, and Eddie Peterson, the house secretary, rounded out the home detail. Others, such as attorney John Climaco and

accountant George Louis, were paid either on retainer or fee, though the charges often headed into the six-figure range. Climaco, for instance, was paid a $5,000 monthly retainer in addition to other income, for directing Sammy in and out of various investments and business ventures. Louis worked for an accounting firm that did business out of Chicago.

By the late 1980s Sammy's annual income had steadily declined, a precipitous drop that appeared to mirror the trajectory of the aging star's career: aside from filming two *Cannonball Run* movies in the early 1980s, Sammy was losing his earning power. Vegas still loved him, but his performance fees had dropped considerably after 1983. Things changed in 1988, and for the better, thanks to his reuniting with Frank Sinatra and Dean Martin. The old Rat Pack friends scheduled a worldwide, two-year tour dubbed Together Again. But Dean lasted only a couple of weeks, leaving the tour in Chicago to check himself into Cedars-Sinai Hospital in Los Angeles complaining of unidentified health issues. A replacement was found in Liza Minnelli, and when the tour restarted, it proved lucrative for Sammy. After several lean years, he reported gross earnings of $1.7 million on his 1988 tax return and $1.71 for 1989. He would have earned more but the tour was cut short in August 1989 following his cancer diagnosis. In 1990, the year he died, his adjusted gross income was minus $804,994.

Sammy was broke.

Sonny read through all the tax returns, from 1975 through 1990, and the numerous probate filings. Upon Sammy's death, his assets, including his home and possessions, exceeded $5 million. But his debts totaled an astounding $15 million.

In addition to the millions Sammy and Altovise owed the IRS for their involvement in the fraudulent tax shelters, they also owed $1.7 million to the California Franchise Tax Board, with interest and penalties accruing on both tax bills. Sammy also had a claim against him for $4 million by the estate of his late uncle, Will Mastin, and had numerous other debts, from $523 to the Roxbury Pharmacy to $1,754 to the Beverly Hills Camera Shop.

Sturman, the former assistant U.S. attorney hired by Shirley to pro-

bate her husband George's will after his sudden death in 1985, immediately discussed selling assets to reduce the IRS bill following Sammy's death, including all remaining possessions and the Summit Drive home.

Altovise's attorneys, first Bill Choulos and then Richard Ferko, assured the estate of her cooperation. Altovise was allowed to remain in the home rent-free until its sale, but she was noncooperative and refused to allow Realtors to show the home to prospective buyers. Appointments were made, but when a broker arrived with a potential buyer, Altovise claimed she either forgot about the appointment or for whatever reason couldn't make arrangements to leave a key behind. She also failed to cooperate with efforts to catalog all the possessions in the home and raged about how Climaco and Rhodes had placed her in this position in the first place.

Sturman eventually was forced to seek help from the courts in order to gain Altovise's cooperation, claiming in court filings that Altovise had created an "extremely difficult and at times impossible situation." Sammy, for instance, had an insurance policy with Lloyd's of London, which covered hundreds of items, including 248 pieces of jewelry, 185 pieces of fine art, 4 furs, 85 guns, and other assorted china, crystal, furniture, music records and instruments, silver, cars, and appliances. After Sammy's will was submitted for probate in September 1990, two paralegals from Sturman's office visited with Altovise to begin preparing the inventory of her property. With a copy of the insurance policy in hand, the paralegals figured it would be easy enough to check off items against the policy, particularly all of Sammy's jewelry. Instead, they found hundreds of items missing, including 185 pieces of jewelry, which were valued at over $500,000. Also missing were two important paintings—including an Andy Warhol work titled "Campbell's Tomato Soup" that was valued at $80,000—and five fur coats.

In December 1990, Sturman wrote to Altovise demanding immediate return of all the missing items, which included many spectacular jewelry pieces often seen hanging on Sammy's chest or on his fingers. Among the missing was a fourteen-karat yellow gold necklace, with a thirty-nine-inch-long cable link chain with ten pavéd stars set with eleven single-cut diamonds in each star, totaling one hundred ten

diamonds, all with near-perfect clarity and color. Another item was a thirty-six-inch chain featuring four diamond clusters with twenty-eight diamonds weighing 5.6 karats. A fourteen-karat yellow gold, satin-finish bracelet with white gold initials MR. D soldered on the rectangle identification bar, and eighteen-karat yellow gold, rectangular cuff links, made by Piaget, to match a ring, set with thirty round brilliant-cut diamonds in each link for a total of sixty diamonds of near perfect color and quality. The missing jewelry included other necklaces, rings, bracelets, and dozens of watches. It was an incredible collection, but it was gone.

Sturman included a complete inventory of the missing items in his thirty-page letter, in which he wrote: "it would appear that there is either a plausible explanation with respect to the fact that the above-mentioned items are missing, or, alternatively, that there has been a mysterious disappearance or theft of these items."

Altovise ignored the letter, so Sturman filed a complaint with the Beverly Hills Police Department on January 21, 1991, alleging that subsequent to the death of Sammy Davis Jr., many of his personal items were missing, and possibly stolen. The report was for documentation purposes only, and a copy was delivered to the IRS. Sturman filed a motion a month later, in February 1991, on behalf of the executors seeking the court to compel Altovise to return the missing items. Even under optimum conditions, with Altovise's full cooperation, Sturman said it would be difficult to remedy Sammy's debts. But with Altovise's noncooperation, it was proving to be an impossible situation.

Altovise was later compelled to appear for two depositions, during which she denied any knowledge of the whereabouts of the missing items, even after Sturman produced FedEx receipts for packages she sent immediately after Sammy's death, addressed to her father in New York and in Jamaica, and to attorney Bill Choulos in San Francisco. Aside from missing jewelry, furniture, and paintings, Altovise also said she didn't know the whereabouts of twenty-one photographs and nude studio stills of Marilyn Monroe. Her response to the location of the photos, along with dozens of other missing items, was "I don't know."

By July 1991 Sturman finally received an offer to buy the Summit

Drive home, but at $2.2 million it was well below the $4.2 million asking price and was rejected. Another offer came in a month later at $2 million, which was also rejected. Two more offers came in later that month, but neither was above $3 million. The home had been on the market for eight months with no significant offers, but with a monthly operating bill of $40,000—which included payments of first and second mortgages, taxes, insurance, and other costs—the estate was falling deeper into debt.

With the hope of selling the home quickly, the listing price was lowered to $3.1 million, and on September 12, 1991, Sturman received a fifth offer for the full asking price, subject to an inspection of the home by the buyer, who was from out of state. Altovise refused to show the home, and the offer was withdrawn.

Ten days later, the auction of Sammy and Altovise's possessions began on Sunday, September 22, 1991, at Butterfield & Butterfield. The auction was a testament to Sammy's celebrity, and his excess. More than 1,300 people, including celebrities, collectors, and curious onlookers, crammed into the Hollywood auction house. Among the thousands of items available for sale were household furniture from every room, celebrity-inscribed photographs, numerous paintings, 160 home video tapes and dozens of taped movies in a fiber case, a *Mod Squad* script, 3 scripts from 1960s *Laugh-In* program, gold and diamond watches, including a Snoopy watch, and assorted other jewelry, 70 bowties and 50 neckties, a white satin jumpsuit with cascading rhinestones and lace-trimmed sleeves dotted with gold sequins, dozens of shoes and boots, hundreds of shirts, dozens of felt hats, and scrapbooks noting important periods and events in Sammy's life, including a signed thank-you letter from President Richard Nixon for entertaining the troops in Vietnam, and a collection of President John F. Kennedy clippings.

Other items included inscribed photos from Elvis Presley and Marilyn Monroe (offered at $3,750 and $5,500, respectively), an eight-foot-tall statue of a character from the film *Planet of the Apes,* which was offered for $2,500, and several hundred of Sammy's musical arrangements, offered for $10,000.

The auction drew worldwide interest and buyers paid $11,000 for a pair of Sammy's tap shoes, while a collection of canes realized another $7,150. A director's chair with Sammy's name across the back fetched $3,850. A condolence book with letters from Mickey Rooney, Sugar Ray Robinson, and others sent to Sammy following his father's death garnered $600. While many items sold, some didn't, including Sammy's collection of fur coats, several hats, shirts, and pants. When all was said and done, the event realized only $429,488. Missing from the sale was the bulk of Sammy's jewelry collection, which was now valued at over $1.5 million.

Days after the auction, a sixth offer for the Summit Drive home was received, at $2.7 million, but again Altovise proved impossible to deal with, denying access and refusing to give brokers keys to the front door and a "clicker" to open the iron gates that allowed entry onto the property. Sturman had enough and he petitioned the court to order Altovise to comply with requests for brokers to show the home. The court granted the order, and told Altovise to give a key to Shirley Rhodes.

In October 1991, a seventh offer, for $2.71 million, from a doctor and his wife, was accepted by the executors. The IRS approved the sale, as did the California Franchise Tax Board, each of which had liens on the home, and a court order forced Altovise to finally move out by December 10, 1991. She left, but not before household fixtures were removed, with many stripped off of sinks, bathtubs, and showers. The subsequent damage to the home cost another $50,000 to repair, and the Realtors deducted the amount from the purchase price.

When the sale of the home closed on December 20, 1991, and after subtracting amounts owed on the first and second mortgages, real estate commissions, and other costs, the estate sale realized only $279,584. And along with the income from the auction, the house and estate produced a combined gross of slightly more than $700,000, which barely made a dent in the overall debt.

Sonny shook his head in disgust while contemplating the same question asked by Tracey Davis and others: *Why was Sammy broke?* All that money, earning capacity, and power, and after all these years Sammy had nothing to show for it but millions in debts.

Sonny's immediate thought was that Sammy was just another black superstar who followed a long list of black celebrities, including Joe Louis, Sugar Ray Robinson, and Billie Holiday, all of whom died without having anything to their name but bad debts. In Sonny's mind, Sammy indeed *was* a minstrel, brilliant on the stage but someone without the smarts or wherewithal to keep any of his earnings. Instead he spent it—on parties, jewelry, cars, clothes, gifts. He lived in the here and now and never considered the future. Didn't Sammy ever think about his children? His legacy? If only the Judge knew. Sonny could imagine his father sitting Sammy down for a lecture on fiscal responsibility and respect not only for himself but for his race.

Sammy's flagrant spending and dissolution of his fortune was sickening to Sonny, but as he perused the paperwork, other questions emerged, chief among them: Who was *really* minding Sammy's finances? Sammy had a large entourage that, in the late 1980s, included his manager, accountant, and office, security, road, and household personnel. In 1989 he paid nearly $60,000 a month in salaries, including over $13,000 a month to Shirley Rhodes and a monthly retainer to John Climaco. But Rhodes was, after all, a secretary and Climaco was from Cleveland, of all places, and he clearly was not known as an entertainment lawyer. Something wasn't right, Sonny reasoned. Sammy wasn't protected. No one managed Sammy's assets, determined proper salaries, cut down on household bills, or sought sound financial management. Instead, despite his exorbitant earnings, Sammy had inexplicably borrowed against insurance policies to pay bills, and had a revolving line of credit with various casinos in Las Vegas. If he needed money, he'd make a call to Las Vegas, and then work it off performing. It was a terrible and irresponsible way to manage the finances of an international celebrity.

Even after Sammy's death, his handlers didn't try to save the estate or help Altovise in her dealings with the IRS. Instead, they nibbled at the remaining scraps. Sturman charged over $260,000 for what he described as "extraordinary fees" for additional services, which, he claimed, included representing the estate in the sale of the Beverly Hills

home, the celebrity auction, defense of a lawsuit filed against Sammy by the estate of Will Mastin Sr., and other matters.

On June 26, 1992, Sturman appeared before California Superior Court Judge Ann E. Stodden to make the case for his additional fees. But Stodden was in no mood to hear any argument, cutting Sturman off with questions about other bills that were charged to the estate, including $19,000 in expenses for John Climaco to travel back and forth from Cleveland to Los Angeles.

"I'm denying that," said Stodden.

"But he's made seven trips out here," said Sturman.

"That's why he is paid a fee, and he sure is getting plenty of fees on this one," said Stodden, who then zeroed in on Sturman's fees.

"I think a quarter of a million dollars in fees is pretty heavy stuff," she said.

Sturman said his firm had to negotiate numerous debts, analyze and appeal the fatal IRS debt, handle a myriad of other legal duties, and deal with Altovise's noncooperation, which caused multiple delays and legal burdens.

"Okay, I'm going to give you $160,000," said Stodden.

"Your Honor, I really don't think that's fair," said Sturman.

"You don't?" said Stodden.

Sturman said a good deal of his firm's time was spent tracking down numerous possessions and assets that had disappeared, but were included on an inventory listing taken before and after Sammy died. Sturman estimated at least $500,000 in assets were missing, some of which were found in a storage facility in Burbank rented with a stolen driver's license. "I can tell you that at least $125,000 would not have had to be spent had Mrs. Davis been cooperative," Sturman said.

"I think to charge an estate at $325 an hour is just obscene," said Stodden, who ended the hearing with a wave of her hand.

"Thank you very much," she said. "That's a clerk order. That will save you fifty bucks."

Sonny chuckled while reading the transcript. He'd been in front of

judges like that before, and it was no picnic. But it appeared she had a point. The executors and their attorney were charging excessive fees for their work on the estate, including Climaco's travel. Instead of protecting the estate, Climaco and Rhodes were profiting from its insolvency after they were named executors in Sammy's will, which was dated March 12, 1990, and signed just two months before his death.

The ten-page document gifted $50,000 to his mother, Elvera, $75,000 to his sister, Ramona, $50,000 to his recently adopted son Manny, $25,000 to Shirley Rhodes to be used as "fun money," and $100,000 to Murphy Bennett. He gave another $100,000 to his housekeeper Lessie Lee, a Gary Cooper gun to Clint Eastwood, a car and non-Western gun collection to his security chief Brian Dellow, and $100,000 to Morehouse Teachers College for a scholarship fund. Aside from the money for Manny, Sammy didn't leave anything in his will for his other children.

The Beverly Hills home, jewelry, furniture, and all other possessions, including Sammy's name and likeness, were left to Altovise, but Sammy gave absolute authority over the distribution of his estate to Rhodes and Climaco. Witnesses who signed the will included his former publicist David Steinberg, Treva Wilson, and Ben Garfunkel, a white businessman who became Shirley Rhodes's love interest after George died.

Sammy's signature was prominently visible on each page.

But the will was worthless, since the estate was insolvent and all the money and gifts had been claimed by the IRS. And despite payments from the auction and the sale of the home, the penalties and interest continued to accrue on the tax bill even after Sammy's estate was finally closed out on August 12, 1992.

By the end of the third day at Sturman's office, Sonny requested and received copies of the will, tax returns, and probate material. He thanked Sturman for his cooperation, flew back to New York, and drove home to Pennsylvania.

The Judge and Mama were busy, as usual, preparing for yet another sold-out weekend at the Hillside. Since its reopening in 1989 with its new rooms, Olympic-size swimming pool, and other facilities, visitors flocked there content in the knowledge that they were staying at a black-owned resort and would be treated as family.

When guests arrived, Mama stood in the lobby to welcome them, greeting every man, woman, and child with a handshake, a hug, and a story. And everything, from the distinct Southern menu to the Sunday gospel hour, was designed to make guests feel like they were home. Dinner, which was served family-style to encourage conversation, featured collard greens, homemade bread pudding, peach and apple cobbler made by Mama, cornbread made by the Judge, candied yams, and grits. Fried fish was served on Sunday. Other amenities included live music at night, a one-acre lake, tennis and basketball courts, softball field, game room, an exercise room, and a three-hole executive golf course. Friday and Saturday nights featured live jazz and R&B bands—with no cover charge. Mama and the Judge would join the party around eleven P.M. Mama would dance with the Judge to "I Can't Stop Loving You." The Judge was gangly and awkward, but Mama was elegant and polished. She loved to dance, especially the line dances, and would teach the guests. Before they excused themselves for the night, the Judge made one last pass around the large room. They always wanted people to socialize, but they didn't encourage excessive drinking and wanted to make sure before turning in that everyone was simply enjoying themselves.

Unlike at other hotels and resorts, guests weren't required to check out before noon. Instead, after the gospel hour, Mama wanted everyone fed before they went home, and Sunday dinner was served at three P.M. Mama loved her guests, so much so she'd give away items for sale in the gift shop, whispering: "Please take it, only don't tell the Judge." When the Judge asked for the receipts, Mama made up the difference from her own money. Visitors were generally repeat customers the Murrays knew by name, or had found the Hillside through word of mouth, and new visitors marveled at the fact that they were staying at a successful black-owned resort.

And as the Hillside prospered, the Judge sold homes and town-houses at the Murray Pocono Estates across an open green field from the Hillside. With over one hundred acres, the Judge sought to capital-ize on the westward migration of New York–area residents moving into the Poconos seeking cheaper housing, and he parceled his property and built thirty-five affordably priced homes and one- and two-bedroom town houses. The Hillside was successful and profitable and kept the Judge and Mama busy, which was a good thing for Sonny, given he was spending an inordinate amount of time on the Sammy Davis Jr. estate.

Altovise remained at the Alina Lodge, and visiting hours were re-stricted to Saturdays only. Preapproval was required for the few guests allowed to visit. Altovise's parents, Sonny, and a close friend, singer Dionne Warwick, were among the few on Altovise's list, as was Calvin, who always felt nervous coming here, as if it were an asylum. But Al-tovise wanted to see him. The perpetual alcoholic fog that hung over her like a heavy shroud had finally been lifted thanks to the intense regimen. Clarity also offered Altovise the ability to gather her thoughts, which were now centered not on her deceased husband but on the men she turned to following his death—Al Carter, Manny "Cheech" Illu-manardi, and Timothy "Tiny" Alexander.

Calvin thought Carter was a smooth-talking huckster the moment he met him in 1993. Now, more than a year later, Altovise had a mes-sage for Calvin and she wanted him to pass it to Sonny: Get my stuff back from Carter. Altovise claimed Carter was holding numerous pos-

sessions, including jewelry, artwork, guns, records, music scores, more than a dozen boxes of clothes, furs, furniture, a Rolls-Royce, and money—more than $500,000 in cash.

There was also another $100,000 being held, some of which was in the form of checks from the Screen Actors Guild, Sammy's pension and welfare funds, and Israeli bonds. Altovise also said something about money from "London and Las Vegas."

"You have all of this?" said Calvin.

"No, they have this, and I want it back," said Altovise. "In my room in your house, inside the nightstand next to the bed, you'll find letters. There's one with a return address for Peggi Bongiovanni. Get it and show it to Sonny and tell him to do whatever he must to get my stuff back."

Calvin returned home and found the envelope exactly where Altovise said it was. And inside the envelope were two letters, a police report, and criminal history record for Manny Illumanardi.

Altovise received the letter from Bongiovanni weeks before she was admitted to Alina Lodge. She didn't say how she met or heard of Bongiovanni, who told Altovise in her letter that she and her husband, Joseph, had formed a telephone counseling service in 1992 with a woman named Elizabeth Savage. Bongiovanni said she and Savage were close friends for eighteen years but Savage had a new boyfriend, Manny Illumanardi, who also became Savage's business partner. Bongiovanni said that Manny was a young, unscrupulous con man who quickly took over the counseling service. Concerned, Bongiovanni said she sought an audit, especially of all-important insurance documents required by the state, since the business, called the Talk It Out Line, counseled people in distress. But Manny refused Bongiovanni's requests to audit the books and she hired an attorney, who dug into Manny's past.

It didn't take long to discover that Manny was a convicted felon sentenced to the California Institution for Men at Chino after pleading guilty to grand theft on May 21, 1990. A police and criminal history report stated that Manny served a year in jail for defrauding a widow out of more than $1 million by using her credit cards, pawning her jewelry,

and fleecing her out of her home left by her late husband. Other women had been swindled by Manny in the same manner, said Bongiovanni, and Manny had a criminal history that went back to 1982 and included charges of prostitution, pandering, and forgery.

Among Manny's associates were Al Carter and Tiny Alexander.

Calvin delivered the letter and Altovise's message to Sonny, who was shocked and angered. He was also concerned. The IRS wouldn't look too kindly at the list of missing items, which Altovise apparently hid before and after Sammy died. If the IRS learned of the list, especially the cash, Sonny knew he'd have a hard time negotiating a settlement. He was also perturbed by Altovise's participation in what amounted to the looting of her own possessions. He wrote the letter to Carter anyway, demanding the return of all personal items and cash belonging to Altovise. Carter didn't respond, so Sonny wrote another letter, and then another. Six letters within two months were sent via certified mail to Carter, who had a Beverly Hills address. Carter finally responded with a letter of his own in January 1995. Sonny read it and was speechless. He gave it to Calvin to read, and Calvin was equally shocked. Carter denied taking any of Altovise's money or possessions, saying that whatever he had was payment for the years he spent trying to help as her advisor. But Carter didn't stop there. He intimated that if Sonny pursued any action against him, legal or otherwise, he would publicly humiliate Sammy and Altovise. Carter claimed that Sammy was deeply involved in the occult, particularly voodoo and devil worship. The satanic rituals, said Carter, included the use of sharp objects, sometimes broken bottles, to draw blood from sensitive and private areas of the body. Sonny recalled that Sammy admitted to a passing interest in devil worship in the 1970s in his book *Why Me?*, but Carter claimed it was far more involved than that, and it continued well into the 1980s.

Sonny and Calvin drove to the Alina Lodge and gave the letter to Altovise to read, and they watched as she silently reviewed each line, and her newfound sobriety brought her back to a not-too-distant past.

Al Carter and his wife, Patrice, were lounge singers who initially drew the attention of conductor George Rhodes in the early 1980s. Rather, it was Patrice who attracted George's interest. The Carters were a husband-and-wife act trying to break into the business, but the act was awful and got little notice. That didn't stop Carter, who routinely sent his wife out before and after gigs to soften up managers and booking agents. It worked with George, a notorious womanizer who immediately booked the pair to open for Sammy at Bally's and the Desert Inn. The Carters soon became part of Sammy's after-show entourage, which partied past dawn. Patrice was a beauty and quickly drew Sammy's eye while Carter became intimate with Altovise.

And it was Carter whom Altovise, ostracized for years by Sammy's employees and his children, turned to during Sammy's illness. Carter also claimed to be an attorney, and he advised Altovise to take everything she could from the home and hide it from the IRS. Following his instructions, she took jewelry, furniture, paintings, furs, golf clubs, and pictures. She gave Carter her Rolls-Royce, which he hid at his father's home in Las Vegas. Carter also suggested to Altovise to reach out to her celebrity friends for loans. Claiming she was broke, Altovise borrowed money from a host of people and the list was long and eye-opening. She took $50,000 from billionaire Kirk Kerkorian and $20,000 from Motown's Berry Gordy. Composer Henry Mancini, hairdresser Vidal Sassoon, and Sammy's best friend, Jack Haley Jr., the son of the actor who played the Tin Man in *The Wizard of Oz,* each gave $10,000 while Bob Hope and actor Carroll O'Connor each loaned $15,000. Ed McMahon, Johnny Carson's *Tonight Show* sidekick, and singer Gladys Knight lent $7,500 each, and Dionne Warwick pitched in $1,500. In total, Altovise borrowed over $250,000 from her celebrity friends and gave it to Carter, who said he'd deposit the money in his bank account to keep it away from the IRS.

But questions arose about Altovise in December 1991, when police in Burbank found a storage locker filled with Sammy's possessions, including clothes, musical equipment, a jukebox, antique record player, and dozens of other items. The locker had been rented under the name

of a man whose driver's license had been stolen. When he received the $365 bill, the man called the police, who tracked down the individual who used the stolen identity to rent the space. It was Timothy "Tiny" Alexander, one of Carter's crew and one of the three men Sonny saw in Calvin's driveway. The locker had been rented in October 1991, just two weeks after the Butterfield & Butterfield auction. Tiny told police he was helping Altovise hide the property from the government. The instructions, he said, had come from Al Carter. The case was turned over to the IRS, which declined to press criminal charges.

Carter was also involved in a disastrous benefit concert at the Sands in Las Vegas in August 1991. What began as a star-studded tribute to Sammy turned into a fund-raiser for the "Sammy Davis Jr. Foundation," a nonprofit organization for cancer research. With appearances by Joey Bishop, Quincy Jones, Ed Asner, Jayne Meadows, and her husband, Steve Allen, the event was initially deemed a success. But the proceeds were given to Carter and disappeared, and the Sands reported that $10,000 in outstanding bills went unpaid. Even worse, *People* magazine reported there was no official record of a "Sammy Davis Jr. Foundation" and that Carter wasn't an attorney at all. He professed to the magazine to have a law degree from Santa Clara University, but officials there never heard of him nor had any record of him attending the university.

Ten months later, Carter was in the middle of another celebrity-filled benefit in London. It was Liza Minnelli's "Tribute to Sammy" and it drew Princess Diana, Tom Jones, Jerry Lewis, and a host of other celebrities. The event was scheduled for June 1992 at Royal Albert Hall, to benefit the Royal Marsden Cancer Appeal, which was a pet project of Princess Diana and the Sloan-Kettering Memorial Cancer Hospital in New York. Large television monitors played a video salute to Sammy, which included a message from Frank Sinatra, and Liza performed the entire second half of the show.

Altovise was there, having agreed months earlier to attend the benefit. But she had a price: first-class plane tickets for herself and her entourage, which included Carter and Tiny, several hotel suites, and

$45,000, which would be paid out as part of "royalties" from a special CD set produced for the show and a "special" reissue of Sammy's 1989 book, *Why Me?* Burt and Jane Boyar, who coauthored the book with Sammy and owned 50 percent of the royalties, never heard of or received any payment. The check, at Altovise's insistence, was written to "Altovise Gore." She explained in a letter to producer Geoff Morrow that using her maiden name was a "better way of handling finances at this time." Altovise gave the check to Carter, who sent it to his bank in Los Angeles. The payment was never reported to the IRS. And Altovise had no idea what happened to the money destined for Sloan-Kettering. She suspected that money was also wired to Carter's bank.

Upon Altovise's return to the United States, Carter said the IRS was bearing down on her and he suggested they lay low for a while and she move in with her parents in New York. Her money, said Carter, was safe with him. Several months later, under crushing pressure from the IRS and increasingly strained relations with her father, she moved to Pennsylvania.

Altovise finished the letter, folded and slipped it back into the envelope, and then placed it in her back pants pocket.

"Anything we need to know?" said Calvin.

"Not really," she replied.

"He's going to keep all this stuff?"

Altovise didn't answer.

"Wait a second," said Sonny. "You said he stole your things, right? Do we need to discuss some of the other things he mentions?"

Altovise didn't want to talk about the letter or its contents.

"How are we doing with the IRS?" she said.

Altovise had a problem, which was Al Carter, and it became increasingly clearer to Sonny and Calvin that she didn't want to shine any light on Carter because that same light would reflect back on her.

Sonny was readying an Offer in Compromise, or OIC, to the IRS and he needed to know what was stolen, and if possible, where the missing items were hidden. Given what he knew about Carter, Sonny decided he had to list every known missing item on the OIC. That way, if

they ever surfaced, the IRS wouldn't be surprised. Sonny knew he had a client who was vulnerable and unstable, and, as a former assistant U.S. attorney, he knew that honesty was the best policy and he'd deal with whatever consequences arose.

While the revelations about Carter were disturbing, Sonny now had a more precise understanding of the estate's debts. But there was more to learn, and he flew to Los Angeles in February 1995 to meet with Sammy's insurance agent, Leonard "Bud" Isenberg.

Isenberg was another polished Hollywood veteran, and a firm handshake was followed by an honest conversation regarding Sammy's multiple life insurance policies and their beneficiaries. Sonny explained that he needed to review each and every policy to ensure a proper accounting with the IRS, and Isenberg readily obliged. Some of the policies were older, while others were taken out just a few years before Sammy's death. Many of the policies had loans against them, which for Sonny was another indication of Sammy's poor financial health. The records showed that beneficiaries were changed frequently. One policy for $1 million was changed just a month before Sammy died, and the beneficiaries were changed from Transamerican Entertainment to his children Tracey, Mark, and Jeff. Another $500,000 policy was also changed in their favor. And May received a generous gift of $241,248. Her relationship with Sammy officially ended in divorce in 1968, but over time the two reconciled, remained friends, and continued to care for each other deeply.

Isenberg produced paperwork for the remaining policies, and Sonny was taken aback when he saw that Altovise got far more than the $1 million she claimed to have received. Isenberg said Altovise was sole beneficiary of several policies totaling a whopping $2.2 million. The money had been paid out within six weeks after Sammy died, but there was no indication that any of it remained.

"What could Altovise have done with so much money?" said Sonny.

Isenberg had no answers, and he braced Sonny for the next revelation. Sammy's company, Transamerican Entertainment, received $3.8

million in insurance proceeds. Of the more than $7 million in insurance money paid following Sammy's death, Transamerican received more than half. According to the estate filings, Transamerican reported receiving only $1 million. The whereabouts of the remaining $2.8 million remained at issue. Sonny speculated this was the reason why the executors weren't cooperating with him.

"And his kids got only $500,000 each?" said Sonny. "Why did Transamerican get more money than anybody else, and why wasn't that money, and the $2 million Altovise received, used to help pay off the IRS debt?"

"Hey," said Isenberg. "I'm just the insurance guy."

CHAPTER 8

The Qantas jetliner sat on the tarmac at the Sydney airport, its full load of passengers growing impatient waiting for mechanics to fix whatever problem ailed the plane, which delayed their flight to Los Angeles.

Sammy sat in first class and played gin with his young publicist, David Steinberg, while road manager Murphy Bennett snored loudly behind them. The three men made the grueling eighteen-hour trip to Australia just three days earlier so Sammy could serve as a presenter for the 1974 Logies, the Australian version of the Emmy Awards. The show went off without a hitch, there was plenty of booze and laughs, and now it was time to go home. But the flight was delayed, and since the boarding stairs had already been moved, the passengers were forced to remain in their seats. One hour turned into two, and then three, and Sammy decided it was time to take action. So he stood up, his heavy jewelry dangling around his neck, and he walked over to a stewardess.

"Excuse me, miss," said Sammy. "I'm wondering, would it be a problem to send out?"

"Send out?" said the surprised stewardess. "I'm sorry, Mr. Davis, but no one can leave the plane."

"No, that's not what I'm saying, baby," said Sammy. "I want to send out . . . for some Chinese food. You dig where I'm coming from, baby? I'm famished."

The stewardess was taken aback for a moment, and then leaned over Sammy's shoulder and pointed to the main cabin.

"Well, Mr. Davis, as you can see there's a plane full of people," she whispered into his ear. *"We can't just send out for you."*

"Oh no, no, baby. That's quite all right," said Sammy, smiling. *"I'll buy for the whole plane."*

The stunned stewardess walked into the cockpit to inform the pilots of the unusual request and an hour later a truck pulled up filled with boxes of freshly cooked Chinese food. Quarts of wonton soup, dumplings, egg rolls, and other assorted delicacies were distributed to the plane's passengers and flight crew while Sammy pulled out a wad of $100 bills and peeled them off one by one to pay the tab. It was U.S. currency, but this was Sammy Davis Jr., and they took it anyway. Sammy then sat down with Steinberg and the awakened Bennett to enjoy his tasty and expensive feast.

"You know," said Steinberg, *"when you die, people are going to wonder why you didn't die with a shitload of money, and I'm going to tell them stories like this."*

IRS transcripts and other financial documents littered a large conference table inside Weseloh & Company. Sonny had hired the small East Stroudsburg accounting firm to help with the process of reconstructing the IRS debt owed by Mr. and Mrs. Sammy Davis Jr. After nearly a year, what once appeared to be a gargantuan task had finally been streamlined, and numbers were coming into focus.

Sammy's tax problems indeed began long before he invested in the bogus shelters. Despite annual earnings in the millions, Sammy spent more than he earned, presumably to maintain his lavish lifestyle. What was woefully clear to all was that Sammy lived according to his gross, not his net, and he failed to consider saving 40 percent from each payment to cover local, state, and federal taxes. Sammy thought a million dollars meant he had a million to spend, and he appeared to be unaware of or uninterested in the consequences. If he wanted to buy an expensive gift for a friend, he did. If he wanted to stay in a duplex suite with bowls full of caviar and cocaine, he did, as one legendary story goes. And if he wanted to entertain dozens of friends with thousands of dollars' worth

of food at his home during movie nights, where he would show pre-released, first-run films, he did.

While Sammy Davis Jr. may have been one of the greatest entertainers of the twentieth century, as a business entity, he was a dismal failure. Aside from the fraudulent tax shelters there were failed investments in food companies, real estate ventures, restaurants, video production facilities, and, in 1975, a proposed investment to become a partner in the Tropicana Hotel and Casino in Las Vegas, which ultimately fizzled. After assembling and reviewing Sammy's entire portfolio, Sonny couldn't understand why Sammy didn't have the smarts to hire experienced and competent people to manage his affairs. It was a question that had gnawed at him for months, and he needed to reach out to someone who knew Sammy well. So Sonny reached out to Brian Dellow.

Sonny obtained Brian's phone number months earlier from an associate of Sammy's who explained that Brian was the head of Sammy's security team and a close confidant. A former British intelligence officer based at Scotland Yard, Brian was head of security at the Grosvenor House in London in 1977 when Sammy had arrived for a weeklong schedule of shows. The two men were introduced and Sammy admired Brian's security expertise during his short stay there and invited Brian to work with him on a two-month tour of Australia. Brian agreed and became one of the few white men to travel with Sammy's entourage.

Brian was tall, soft-spoken, and reserved in typical British fashion. His knowledge, commitment, and professionalism were a breath of fresh air for Sammy but drew groans from others, particularly Shirley Rhodes, who felt threatened by Brian. He traveled in slacks and a jacket, sometimes a suit, with top collar and tie, while everyone else, including Shirley, traveled in sweatshirts and sweatpants. Whenever the group deplaned, it was Brian, not Shirley, who looked the part of manager and would be the first to be greeted by local dignitaries.

"No, not me," he'd say, pointing them toward Shirley.

Brian's duties included protecting Sammy not only from his adoring fans but from himself. During another visit to Australia, Brian was awakened in the middle of the night with an urgent telephone call. The

hotel security staff learned that Adnan Khashoggi, the wealthy and no-torious Saudi arms dealer, was en route to the same hotel. Khashoggi's wife, Soraya, had been secretly traveling with Sammy, and Khashoggi was due to arrive at six fifteen A.M.

"Boss, we've got a problem," Brian said, explaining that Khashoggi was no doubt traveling with several of his own highly skilled security personnel.

"Ninja bastards," said Brian. "We can't deal with them."

"Well fuck 'em," said Sammy. "I'm not telling her to leave."

Brian explained this wasn't a debate and Sammy had no choice but to help rush Soraya out of the hotel, which he did, at six ten A.M. and just minutes before Khashoggi arrived.

Sammy later realized, thanks to Brian, that he avoided what could have been a very unpleasant situation. None of Sammy's other employ-ees would have been so adamant. Once Sammy said no, they would have moved on with an "Okay, boss." But Brian was different. He saw a situation and acted, providing the kind of counsel and decision-making Sammy needed and respected. Their relationship quickly grew beyond employer/employee, and Brian remained Sammy's protector. Brian didn't use drugs, but working for Sammy he had to deal with them, especially cocaine. Following performances on the road, Brian cleared Sammy's suite of strangers and well-wishers so Sammy could enjoy copious amounts of cocaine, amyl nitrate, and curvy women. Sammy respected Brian's posi-tion on drugs, and he never forced Brian to cross that barrier. Brian wished Sammy would simply give up the drugs, but he was the employee and the best he could do was simply make sure Sammy's suite was secure, say good-night, close the door, and return to his own room.

It was Brian, more than anyone else, whom Sammy trusted and confided in. When Sammy sought quiet time, usually in Arizona, it was Brian who accompanied him. Together they'd receive "special friends," such as adult film star Marilyn Chambers and her husband, Chuck Traynor. Sammy had known Traynor since 1972, when he discovered the porn classic *Deep Throat*. Sammy was in London at the time and was so fascinated with the film he ordered a personal copy to show at

special viewings for all his friends. The film's star, Linda Lovelace, later became a regular guest at Sammy's home along with Traynor, to whom she was married at the time. Traynor and Sammy collected guns, and Traynor gave Sammy a specially engraved Colt .45 as a gift.

Brian saw people like Traynor drift in and out of Sammy's life all the time. Some, like Harvey King, simply dropped in and wouldn't leave for months. Harvey lived on a boat in Miami and was friendly with the Cowan family, the owners of the Diplomat hotel. Whenever Sammy performed at the Diplomat, Harvey would be there, accompanying mob figures from Chicago, Cleveland, and Miami. Brian could never figure out the mysterious Harvey, and he didn't want to. Only five foot seven inches tall, and balding, Harvey seemed to have no other duties but to hang out with Sammy, read the newspaper, and direct Sammy's other visitors out of the home. While Burt Boyar was researching *Why Me?,* when Harvey thought Boyar's interviews with Sammy went too long, he looked at his watch and yelled, "Time to go!" and Burt scurried upstairs to his room. But Brian knew that Harvey was more than a traffic cop, especially after he found a black bag filled with cocaine, which Harvey had hidden under the seat of one of Sammy's cars. It was but one of the many odd things involving Harvey King, along with other people in Sammy's life whom Brian didn't know much about and knew not to ask.

And that applied to John Climaco.

While Climaco was Sammy's attorney, Sammy invested in business ventures that appeared to go belly-up as quickly as they were conceived. Restaurants, stocks, even a chili recipe with Sammy's signature on the box, were all immediate failures. Brian brought up Climaco only once, but as close as Brian was to Sammy, the only reply was a cautious "He's a heavy hitter," and Sammy quickly changed the subject. Brian remained unsure if Climaco was really someone Sammy wanted in his life and he wondered why Sammy kept him as his attorney. And it wasn't as if Sammy was happy with his business dealings. He wasn't, and the failures overwhelmed Sammy to the point where he fell into a funk. Whenever Brian probed and asked if there was anything he could do, Sammy sighed and said, "I just got some shit going on." He'd throw himself into his Pac-

Man arcade game and play for hours. Brian thought the game served as a cathartic release from the unknown pains of Sammy's daily life.

The days got even darker following the terrible news about Sammy's cancer.

The radiation and chemotherapy treatments forced the cancer into remission before Christmas, and in January 1990 Sammy joined Eddie Murphy in Chicago to shoot a CBS television special. But Sammy's neck was red and raw and he spent more time in the bathroom vomiting than he did anywhere else, and when he went to Cedars-Sinai upon his return to Los Angeles, he was told the cancer had spread and the diagnosis was terminal. Friends came to visit at his home, but after a brief hello, Sammy would leave and retreat to his bedroom. There wasn't much anyone could do and he really didn't want to see anyone, especially Altovise. More often than not she was drunk somewhere in the house. At times she was barred from entering her own bedroom for fear that in her inebriated state she'd trip and fall on Sammy or the medical equipment next to his bed.

His fate certain, Sammy's thoughts during his final weeks centered on the distribution of his estate, or whatever was left of it. Sammy's financial condition mirrored his health, and he called Brian over to his bedside one night to review a handwritten list with names and gifts he wanted to give people. Included on the list was a $7,000 Piaget watch he gifted to Brian, who made a copy of the list before placing the original at Sammy's bedside. The next day Altovise had the list and showed it to Brian, whose name she had removed. Brian didn't say anything. It was a bad time and his thoughts were with his friend and employer. Besides, Brian always pitied Altovise. She desperately sought love and attention from Sammy but, aside from appearing together at public functions, Sammy had all but cut Altovise out of his life. During the years before his diagnosis Sammy had a live-in lover, a beautiful, young white woman named Sue Turner, and Altovise had no choice but to share her home with her husband's girlfriend. Turner was an acquaintance of Harvey King, and the tension between her and Altovise became palpable and often exploded into angry arguments between the women. During one exchange, Altovise dragged Turner by her hair down a flight of stairs.

Sammy was irate, and Altovise buried herself in a bottle and in the comfort of other men, including Al Carter.

Brian knew Carter was a bad piece of work, and he could only shake his head when he peered outside Sammy's bedroom a few weeks before Sammy died, to see Carter and Altovise dancing in the backyard under the moonlight. Brian took the night shift during those chaotic final weeks as Sammy lay dying and his home was being looted by his employees and Altovise. Overnights were calmer, with fewer people to deal with, especially Shirley, who issued a statement for the press telling the world that Sammy died peacefully with his family around him. Brian knew otherwise, but he kept quiet.

Brian remained on the payroll for a scant month after Sammy's death, helping with security arrangements for the funeral and accompanying Altovise on a dinner date with Donald Rumsfeld at the Century Plaza Towers hotel. The conservative former congressman from Illinois, whose help in securing Nixon's victory in 1968 earned him a place on his staff as director of the Office of Economic Opportunity, hit it off with Sammy and Altovise. Rumsfeld later served as defense secretary under President Gerald Ford before leaving politics for private business. He was a regular visitor to Sammy's home in the 1980s. Rumsfeld's dinner with Altovise was a quiet affair. When she arrived home afterward, she immediately phoned Rumsfeld, putting her hand over the receiver and her mouth and whispering so Brian couldn't hear. She sounded like a little girl on her first date. Brian had no idea as to the nature of the relationship, but he thought it was an odd pairing. Altovise claimed several relationships with powerful and successful men, yet, given her drinking and character flaws, none of them made sense to Brian.

Shirley fired Brian soon after Altovise's dinner with Rumsfeld, and five years later he was working as chief of security for Quincy Jones. Yet his anger over the events surrounding Sammy's death remained. Sammy, Brian said, was surrounded by incompetents, people he remained loyal to for so many years but whom he should have dismissed long ago. Shirley, for instance, manipulated Sammy's life and his home, particularly during his ill-

ness, he said. She selected the medical team to treat Sammy, who was under a steady stream of morphine while his employees looted the house.

Shirley entered Sammy's life after marrying George Rhodes, and by the mid-1970s she served as Sammy's quasi-manager, overseeing Sammy's bookings and itinerary. Shirley had no formal business experience, yet she earned the official title of manager in 1981, following Sammy's breakup with Sy Marsh.

Before he was let go, Brian saw how Joe Jackson, who remained in Sammy's employ after serving as his stand-in for a number of movies, would be sent on errands just because Shirley wanted to get him out of the house. Sammy had hired Joe long ago to catalog his extensive record collection of nearly three thousand albums, which reflected a taste in music that was as wide and diverse as Sammy's interests in life. The Beatles, Frank Zappa, Neil Young, The Shirelles, Elvis Presley, The Beach Boys, Hank Williams, Bob Dylan, John Coltrane, and Stevie Wonder were part of a collection that also included The Four Tops, Wilson Pickett, Kingston Trio, Charlie Parker, Buddy Rich, Slim Whitman, and The Rolling Stones. Sammy loved music—all music—and he entrusted Joe to keep his vast collection in order, particularly on days following evening parties.

Joe maintained his daily schedule during Sammy's sickness and made himself available for household duties, anything, just to help out. One afternoon Joe was sent on an hour's drive to buy chicken even though the nearest restaurant was only ten minutes away.

"It's a special kind of chicken," said Shirley.

When Joe returned sooner than expected, he saw Shirley and her niece Eygie filling a station wagon with Sammy's possessions.

As Sammy's condition worsened, the situation inside the home became more chaotic and unmanageable. Brian couldn't watch and remained with Sammy overnight. Other security employees sided with either Shirley or Altovise. Akrum Mankarios chose Altovise and helped deliver her goods to Al Carter.

Brian shared with Sonny his firsthand account of the looting of Sammy's home. He also had something else to share.

"They changed Sammy's will," he said.

The night before Sammy was finally discharged from Cedars-Sinai Hospital on March 13, 1990, to go home to die, Shirley visited Sammy with her boyfriend Ben Garfunkel, Murphy Bennett, and Dino Meminger, one of Sammy's road crew. They ordered Brian to leave the room so Shirley could speak privately. Brian walked out into the hallway and ten minutes later the door opened and the foursome exited the room. When Brian walked back in, Sammy was lying on his bed, staring aimlessly out the window.

"What was that about, boss?"

"Nothing, man," said Sammy. "Just some stuff."

Sonny didn't understand.

Brian said that among Murphy Bennett's many duties during his three decades working for Sammy, he also signed Sammy's signature in such a way that, at first glance, it looked exactly like Sammy's. Unbeknownst to but a few people, Murphy had signed all of Sammy's fan mail, pictures, and posters—and, if Sammy wasn't around, his official documents. Sonny recalled reading the will in Herb Sturman's office; on the surface, it appeared ordinary and unspectacular. There were instructions for several financial gifts, and the rest of the property and possessions were bequeathed to Altovise.

The will was never challenged, and probated in August 1990.

But Brian said that Murphy, for one, had been promised $1 million from a life insurance policy and was also beneficiary of a trust fund opened by Sammy through Transamerican Entertainment. Sy Marsh, Sammy's former manager and partner, was also promised a $1 million payout, which never materialized, Brian said.

"Are you sure about this?" said Sonny.

Brian said he knew that Murphy was promised he'd be taken care of.

"And I know he was supposed to get $1 million from Sammy's insurance," said Brian.

But Murphy Bennett didn't get a dime after thirty years with Sammy, Brian said, and Murphy died a couple of years after Sammy, leaving behind a wife and five children.

CHAPTER 9

On March 27, 1995, nearly a year after accepting Altovise Davis as a client, Sonny Murray made an Offer in Compromise to the IRS.

The federal tax debt, with penalties and interest continuing to accrue, exceeded $7 million, but Sonny's offer was for $105,000, which would be split into separate payments of $25,000 upon acceptance of the OIC, another $25,000 to be paid within six months, and the final $55,000 paid upon the acquisition of numerous personal items, many of which were held by Al Carter. Among the listed items were a Rolls-Royce, a 1989 Chrysler LeBaron, eight ladies watches, four bangle bracelets, several sets of earrings, and two wedding wrist bracelets. In addition there was artwork, clothing, furnishings, and other miscellaneous items. Three lots on Grand Bahama Island valued at $20,000 were also included. Sonny wanted to disclose all possible assets, knowing that if for some reason something wasn't divulged, it could nullify the agreement.

In return for the payment, Sonny sought ownership for Altovise of Sammy's estate, which included his name and likeness and all residuals and royalties due. The initial cash offer was very low, almost insignificant, but it was based on what Sonny knew Altovise could possibly pay, and what the estate had earned since Sammy's death. Shirley Rhodes, as coexecutor, had been charged by the IRS with handling business affairs for the estate and residual income from endorsements, record contracts, film and television shows brought in roughly $50,000 annu-

ally. It wasn't much, and Sonny believed there was more, much more. But the low number proved fortunate in that it allowed Sonny to argue that, with little expected income from the estate, he could only offer a low settlement number. The offer also included additional payments that, after Altovise regained the right to develop Sammy's image and likeness, would amount to 50 percent of annual income above $110,000 for fifteen years.

The OIC was based on a thorough, months-long review of what the IRS claimed it was owed. Sonny expressed concern that their accounting was accurate, and his accountants pored over the IRS bill, looking for possible mistakes and ensuring Altovise received proper credit for the few payments that were made.

The OIC also included a Schedule "B" Supporting Statement from Altovise, in which she explained, over four typewritten pages, what transpired prior to Sammy's death. The statement, which, along with the OIC, was copied to Calvin and Altovise, served as a sort of roadmap to her marriage to Sammy, the people involved, and how, she claimed, she had been sliced out of any decision-making.

"I am not personally responsible or liable for the taxes due the IRS for the years in question. (I don't believe I owe this tax.) I am also aware of the tax case decided by the Federal Tax Court. (I was not given the opportunity to appeal the decision.)

"Today, I have a sense of being. From the day I married my husband, Sammy Davis Jr., in 1970, we lived at 1050 Summit Drive, Los Angeles, California. Soon after, we stayed at the Ambassador Hotel while looking for a new house—preferably close to the children. I found the perfect house and we moved to 1151 Summit Drive, in Los Angeles. I lived there for twenty years, until my husband's death on May 16, 1990. My house was sold in 1992 by the IRS for taxes owed to the government.

"From 1970, I became involved in the community and did various charitable services. One being SHARE, which is a big event held every year. I was Ambassador for the City of Los Angeles and for the Los Angeles Visitors and Convention Bureau. I was a professional dancer, and

worked occasionally on television. I did not participate in the business affairs or day-to-day operations of my husband's entertainment company. I had no control of, or access to, the books and records, accounts, or other financial documents of my husband's company. All personal and corporate business and financial matters, from the beginning of our marriage until my husband's death, were handled by his various accountants, attorneys, and financial advisors. Financial decisions, with respect to investments, tax planning, purchase of real estate, and other items, were made by my husband's advisors. They were all on large financial salaries, and we relied exclusively upon their professional judgment.

"Specifically, I was to be a 'celebrity's wife' without the responsibilities of managing our finances. I loved my husband, my children, and my home.

"In the late 1970s, Sy Marsh was the financial advisor and partner with my husband. The company's name was Sy and I. Mr. Marsh and my husband made all financial decisions, paid all bills, and signed all checks. My husband bought Sy Marsh out approximately six years later. George Louis was our accountant and handled all personal and corporate taxes. I never had a financial advisor, accountant, or attorney of my own. Because of my past health challenges, I was discouraged and prevented from participating in business matters. I acted solely as a housewife, being responsible for the care of our children and family, maintenance of our residence, and loving support of my spouse. Also, I have never had education or training in finances, business, or law.

"When our personal taxes were due each year, I would gather the household receipts and give them to George Louis who had done them for my husband previously to my being married. I was to read them over and sign the tax papers. Our taxes were jointly done and that was that. I knew that my husband was the sole breadwinner. When I asked our financial advisors about filing separately, I was told that doing it jointly was the best way: 'You'll always stick with your husband.'

"When Marsh was bought out, Shirley Rhodes and John Climaco, Esq., took over. A company was formed called Transamerican Entertainment Corporation to replace Sy and I. Things changed and the

office moved to South Beverly Drive. All business transactions were done without me. I was not on the Board and made no major decisions nor had any control over the books. In fact, when I wanted to see them, I was refused many times over. My husband began to sign his own checks for the road, office, and salaries for household personnel. He also wrote checks for various family members. I was not allowed to participate, and was ignored when I questioned Mrs. Rhodes about expenditures. All the household bills were sent directly to the office. I paid for none of that. Later, I began to ask to see monthly bills, but was told by the office that it was not necessary.

"While at times we made extravagant expenditures, it was in accordance with a budget given to us by the financial advisors. Many times when moneys were low, the financial advisors continued to get excessive salaries, while my husband struggled to earn income from his performances.

"I received a salary that was for gifts, my dogs, pocket money, clothing, and small items that I might purchase.

"The managers and business people would plan an entire yearly schedule and present it to me. I never attended business meetings on this schedule. Moreover, I never knew what businesses or investments we were involved in, other than the Bahamas property.

"Concerning the tax shelters, sometime in the early 1980s attorney Climaco introduced us to his business partner, a gentleman named Bill Hall. Climaco recommended Hall to get my husband into various investments, such as barbecue sauce and other food items.

"During the year, my husband, Climaco, and Rhodes would meet at the office, but usually at the house or on the road (I was not present). They would bring along various financial papers and documents for tax shelters. I do not know what a tax shelter is, or what it is to accomplish with respect to the tax laws. I was told about some of them and shown a few, i.e., Black Stallion, Halco, and a few others. Mostly, I brought refreshments into their meetings and left.

"I casually looked at materials and information on these various enterprises. No one took the time to explain them to me. Mr. Climaco

did not advise me of the consequences of signing any financial documents. I did not understand and appreciate their purpose, nor sign or knowingly agree to participate in any of the shelters. I had no idea what I was looking at.

"However, my husband did explain that he would not invest in something that was not going to make money, and I went along with his wishes.

"Climaco did not advise me to have another attorney, who would represent me, review the documents.

"I have never seen the financial decision of the Tax Court nor how much was owed. I was not advised as to whether attorney Climaco or estate representatives appealed the decision. All I know is that after my husband died, the financial obligation to pay the IRS was on me.

"I was not properly advised as to what to do, as the coexecutors have kept me alienated from all business affairs. I have not seen the books and records of my husband's business. Both Climaco and Rhodes took over as executors of my husband's estate and have continued to control his and, indirectly, my financial affairs.

"During the administering of the estate, I relied upon the representations and advice of an attorney and a person who held themselves out as an attorney. They advised me that they were settling matters with the IRS and that they would need money to file an Offer in Compromise; this was only partially true, because no moneys have been paid to the IRS on my behalf, nor has there been a settlement.

"I was misled and kept in the dark about my responsibilities and rights regarding my personal property. At the time of my husband's death (and for several years thereafter), I was seriously incapacitated and my health deteriorated. I could not mentally or emotionally fully appreciate or understand many of the events that were occurring.

"During his lifetime, I was assured by my husband that all financial matters and, specifically, the tax situation were being handled in a proper manner. I did not question his judgment. However, I do believe that my husband realized, at the end, that there was a lack of moral ethics and nothing to protect me at all.

"I felt discouraged and totally fragmented by the fact that even though I had legal and financial representatives, no one advised me to file separately nor was I given any explanations as to what would be in my best interest with respect to my financial obligations, or lack thereof. To say the least, I was totally sheltered from financial matters, and did not knowingly, intentionally, or willfully create the tax problems that I find myself in."

The IRS assigned the Davis case to Daryl Frerking, a career investigator based in Los Angeles. Frerking's job was to examine the offer, determine actual income and assets, and then come up with a counteroffer. His investigation was expected to take months.

Of immediate concern to Frerking was Altovise. While the IRS felt very comfortable dealing with Sonny, their previous experiences with Altovise left them with doubts. Sonny explained that she was very ill and secretly undergoing treatment at a rehabilitation facility, where she still remained after six months. Sonny also said he planned to seek the removal of John Climaco and Shirley Rhodes as executors. But after so many years, Frerking said the IRS was simply sick and tired of Sammy Davis Jr. and Altovise and the whole affair and just wanted to finally close the books on the case. So the IRS declined to address the issues of Climaco and Rhodes and the accounting for the insurance money paid to Transamerican Entertainment.

But the IRS did go after Altovise, Frerking said, after learning of her amateurish and ill-fated attempt to hide nearly a million dollars by purchasing a home.

"What?" said Sonny, who was stunned yet again to learn that Altovise attempted to buy another house with her hidden insurance proceeds after losing the home on Summit Drive. She bought the home using her mother's name, with money she should have reported and turned over to the IRS. When the IRS learned of the purchase, they quickly saw it for the fraud it was and seized the home.

Sonny was embarrassed and angry. His dealings with the IRS to date had been honest and cordial. The last thing he needed as he worked

to resolve the debt was to hear of some last-minute surprise that could kill the deal. Sonny was deeply concerned that she had hidden other important information from him, so he decided to call Richard Ferko.

Richard Ferko's pinkie finger was shaped like a Z, and he showed it off proudly as a testament to his college football career. Ferko played for the Ohio State Buckeyes, and the 1971 Rose Bowl game pitted the Big Ten powerhouse against the Pac Ten champ Stanford Cardinal. For Ohio State, the game was a mere formality on the road to being crowned national champion following an undefeated season. But two late touchdown passes by Cardinal quarterback Jim Plunkett led Stanford to a 27-17 upset win, and Ohio State shared the national championship with Nebraska.

The visit to Southern California wasn't a total loss for Ferko. The young man from Pittsburgh, who did the unthinkable and crossed the state line to play linebacker and special teams for Ohio State, fell in love with the beaches, palm trees, and golden sunshine and vowed to return, which he did in 1973 after graduating law school with a head full of dreams and a couple of dollars in his pocket.

By 1990, Ferko had built a successful and affluent law practice focusing on entertainment law and celebrity clients, and his reputation extended beyond Hollywood, which is why he received a call from a Las Vegas friend Jack Medlevine, asking if he'd be interested in representing someone described only as "a very big client." When the sandy-haired and still-muscular Ferko, now in his early forties, walked into the conference room the day of the meeting in July 1990, he was introduced to Altovise Davis, Al Carter, and Manny Illumanardi. Ferko had no idea who they were, and when Medlevine began the meeting, Ferko played dumb and just listened. After a few minutes, several details emerged, and he finally pieced together that Altovise was actually the widow of Sammy Davis Jr. She said she owed millions to the IRS and her husband's advisors were taking everything she and her husband had owned.

"I'm not getting anything," she complained.

Altovise claimed she shouldn't be responsible for her husband's onerous tax bill. She wanted to keep her Beverly Hills home and was using another attorney, Bill Choulos, whom she and her husband had known for years. But Choulos was based in San Francisco and Altovise needed someone on the ground here, in Los Angeles.

Ferko agreed to represent her, but Carter said they had little money.

"Well I can't work for free," said Ferko.

Carter said that Sammy had given him money to take care of his widow, from which he would pay a retainer with the promise of more to come. But it didn't take Ferko long to realize he had a problem client. He could smell the alcohol on Altovise's breath during initial visits to her Beverly Hills home to watch as its contents were inventoried. But by his later visits, many of the items that had been counted simply "disappeared." Two large individual portrait paintings of Sammy and Altovise, which hung opposite each other in the foyer, were gone, as were the diamond-encrusted tennis bracelet Altovise wore on her wrist, and the absurdly large leather Gucci sofa that sat in the sunken living room off the foyer. It was custom-made to fit what served as Sammy's movie room.

When he asked about the bracelet, which Sammy wore during his illness, Altovise said it was a woman's bracelet and belonged to her.

"What happened to the sofa?" said Ferko.

"Sammy gave it away before he died," said Altovise.

"And what about the paintings?"

"There were a bunch of Realtors in here. They must have taken them," she said.

Ferko watched as other household items and possessions disappeared, and each time he questioned Altovise she pleaded ignorance. She also said she had no idea what Ferko was talking about when he asked about an angry call he received from an executive at the Sands casino in Las Vegas, who was looking for Altovise and Carter in regard to missing money from a benefit held there for Sammy.

Ferko tried to explain that taking possessions from the home and

the bad press that followed weren't helping matters, especially after the IRS indicated it was willing to settle the debt. During Ferko's initial conversations with the government, the IRS considered a settlement offer that included the sale of the home, an auction of its contents, and a percentage of future revenues from Sammy's image and likeness for five years, and only up to $500,000. Ferko explained there'd be some pain losing the home, but it allowed Altovise to get out from under the debt and begin a new life, as well as oversee her husband's estate. The deal, if accepted, made all the sense in the world, but Altovise wanted to keep the home and, ostensibly, her past life, so she kept delaying and lying, which infuriated the IRS, executors, and their attorney.

Herb Sturman bore down hard on Ferko, telling him in several letters that his client wasn't cooperating with the sale of the home or with the retrieval of numerous possessions. Frustration aside, Ferko felt a sadness for Altovise, who was desperately trying to hang on to her husband's celebrity, which defined her life. Her celebrity existed only because of her husband, and now that she lost Sammy, all she had left was the home they shared for two decades, and to hold on to it, she relied on her own street smarts, which, at the end of the day, weren't very smart.

But Ferko also knew that Altovise was, in part, a victim. It was John Climaco, not Sy Marsh, whose firm created the Cannel City tax shelter, which helped send the estate spiraling into insolvency. Now Transamerican Entertainment received proceeds from a life insurance policy, and Rhodes was taking property from the estate that should have been turned over to the IRS, but wasn't. Climaco also wanted to retain Sammy's name and likeness for future exploitation.

Ferko strongly suggested to Altovise that she file a lawsuit against the people who put her and Sammy into the tax shelters—chiefly, Climaco—and insist that the IRS begin an investigation. During tense court hearings and depositions, Ferko even told Climaco of his intent to sue.

Climaco was a round, gruff, and loud man, and he didn't take too kindly to Ferko's threats of a lawsuit.

"Do you know who I am?" he growled.

"I don't give a shit," said Ferko. "I believe you have a conflict and I'm going after you."

It was Altovise who later told Ferko all he needed to know about John Climaco.

"He's a powerful guy," she said. "Sammy was with him a long time."

Altovise said that among Climaco's most notable clients, aside from Sammy Davis Jr., were the city of Cleveland, several alleged mobsters, the Teamsters union, and its former president Jackie Presser. Presser was also from Cleveland and led several local unions, including Local 507, prior to his election as Teamsters boss in 1984. Climaco, who had represented Presser through the 1970s, was elevated to chief counsel for the Teamsters, a position in which he continued to serve until Presser's death in 1988.

Ferko wanted Climaco and Rhodes removed as executors. He also believed that if Altovise moved quickly with a lawsuit, she would place herself publicly in a sympathetic position and receive more assistance from the IRS. But the IRS wasn't interested in removing the executors or exploring any complaints of wrongdoing. Already painted as ogres for trying to kick a widow out onto the street, the IRS wanted the case to go away, while Sturman threatened to sue Altovise for her "baseless accusations" and "slanderous comments" about Climaco and Rhodes. If Altovise had any factual evidence, wrote Sturman in July 1991, then she should present it, otherwise back off. But Altovise didn't have the wherewithal to press her claims, or the desire, and Ferko never filed suit against Climaco or Rhodes. Instead, he watched as Altovise's deceitful actions and her trust in Carter and his cronies caught up with her and her tactics backfired.

First came the missing items found in the storage locker in Burbank. Ferko learned about it not from Altovise, but from the radio. It would have been laughable if it wasn't so stupid. All they had to do was pay the storage fee and the guy with the stolen license wouldn't have known a thing. Instead, the bill was due, a call was made, and the caper was all over the evening news. Carter, Tiny, and Cheech, who were

sporadically paying Ferko his growing legal fees with cash delivered in paper bags, were the Keystone Kops in disguise, a trio of incompetents who couldn't help but stumble over their own feet. Altovise, of course, tearfully denied having any part in the Burbank fiasco, but Ferko believed otherwise.

"It's none of my business," he said. "You're not getting good advice. These people you think are your friends aren't, and you need to realize that."

"I know, I know," she cried. "I need to do something."

With a settlement under discussion, the IRS wanted Altovise to return several "missing" items as a show of good faith, including a diamond pin and an Andy Warhol "Campbell's Tomato Soup" painting, which Sammy bought at an auction at Sotheby's in the 1970s. Altovise initially claimed she didn't have the painting, but then admitted that she took it because Shirley had her eye on it. Ferko insisted she produce the painting and pin if she wanted to get the IRS off her back.

"You don't understand. This is a breaking point with the IRS," said Ferko. "I'm close to making a deal and you're close to screwing up everything. I'll be back at your home tomorrow and they better be there. I don't care how you do it. Give them to me and I'll surrender them."

When he arrived the next day, the pin and the painting were in the foyer, wrapped in brown paper. Holding the painting under his arm, Ferko walked up the stairs of the central court in downtown Los Angeles. The IRS asked about other items, mostly jewelry. Ferko said he knew the exact location of one of Sammy's rings, a yellow sapphire. It was on John Climaco's hand, he said. He had also seen a gaudy diamond tennis bracelet last seen on Sammy's wrist—on Altovise's arm.

Ferko believed the goodwill he had shown in delivering the pin and the painting brought him closer to a deal with the IRS. The Butterfield & Butterfield auction subsequently produced some cash and the Davis home was in the process of being sold. But any potential settlement was shattered when the IRS learned that Altovise somehow came up with $850,000 to buy another home, and placed the deed in the name of her mother. The money, the IRS learned, came from $1 million in

unreported insurance money she had hidden. When the IRS got wind of it, Altovise tried to convince them the money had been given to her by Frank Sinatra.

"It was a gift," she said. "He doesn't want to see me homeless."

But Ferko knew that Altovise complained bitterly to friends about Sinatra, who she said had abandoned her and refused to give her any money.

"He won't give me a dime!" she cried.

The IRS immediately slapped a lien on the new home and took possession, and Ferko's relationship with Altovise ended soon after with a phone call from Al Carter, who claimed that, as a fellow attorney, he could handle Altovise's affairs.

"What about my bill?" said Ferko, who was owed over $200,000 in legal fees.

"Can't do anything about that now," said Carter. "But when we get her on her feet again we're gonna take care of everything. You have my word."

Sonny's phone conversation with Ferko was enlightening if only because, along with what he learned from security chief Brian Dellow, the two men shed light on the madness that consumed Sammy's home before and after his death. Ferko and Sonny agreed to remain in touch, with Ferko half-jokingly reminding Sonny about the six-figure bill he was owed.

"I believe we're finally gonna settle this thing, and when we do I'll get it back to you," Sonny said.

Given Sonny's determination, Ferko almost believed him.

"Well, you keep me up to date. And keep fighting," said Ferko. "Altovise may be stubborn and has no grasp of reality, but she's damaged and, in her own way, she wants what she believes is right."

CHAPTER 10

More than six hundred of the world's most famous and beautiful people assembled in Monte Carlo in June 1974 to attend the opening of the new Sporting Club. The gala was a benefit for the Red Cross, hosted by Monaco's Princess Grace and Prince Rainier, and Sammy would headline the festivities.

In lieu of payment, Sammy agreed to perform for $30,000 in expenses to cover the cost of his party of sixteen, which included his usual entourage of Altovise, Shirley and George Rhodes, David Steinberg, Sy and Molly Marsh, Murphy Bennett, and his road crew. Sammy was also given use of a fully stocked, eight-berth yacht, the Silver Gate, *to cruise the Mediterranean for ten days, and he invited his good friend, French watchmaker Yves Piaget, and his wife to join the cruise.*

Sammy had known the former Grace Kelly since the 1950s, thanks to an introduction by Frank Sinatra, and he felt, as he did with other show business veterans, there was a kismet, a certain something that connected them. So Sammy didn't think it was a problem when he arrived in Nice, France, a day late. But he did have a problem with the reception he received, which "only" included the director of Air France, flower girls, and several limos. Missing were any officials from Monaco to greet him. Things went downhill from there after Sammy arrived in the tiny principality. As part of the festivities, the Rainiers were receiving "special" guests

at the palace, including athletes, business titans, various entertainers, and the like, but there was no invite for Sammy, who instructed Steinberg to find out what was going on and get him up there.

Steinberg made the call, but he was politely informed by a representative of the Rainiers that Sammy would not have a private audience with the hosts. Steinberg also learned that Sammy would be seated at the main table with the Rainiers during the lavish affair, but Altovise would be elsewhere, sitting in the back.

Having been drinking champagne since early morning, Sammy was angered when he received the news. He firmly instructed Steinberg to call back and demand that he not only be given an audience with the Rainiers, but that Altovise be seated with him at the head table. The message was delivered, and Princess Grace, replying through her intermediary, said that there would be no preshow audience and there was no room at her table for Altovise. The princess suggested that after Sammy's performance he should retrieve Altovise and bring her to the Rainiers' table for the introduction.

Sammy was irate.

"Who do they fucking think I am!" he screamed between swigs from a champagne bottle. "The monkey on the end of the string with the organ grinder? That after I perform, THEN I bring Alto over? No fucking chance!"

Sammy told Steinberg to relay his deep disappointment to Princess Grace and demand she reconsider. If not, then he would pack up and leave. Steinberg relayed the message to the princess's intermediary, and when the phone rang again that afternoon, Steinberg took the call, only it wasn't the intermediary on the line, but Princess Grace.

"I understand Mr. Davis is out of sorts," she said calmly. "Maybe he's just a little too old to be doing this, and I suggest he should just get onto his little yacht and toddle off into the sea."

The young publicist was stunned and didn't know what to say, but his awkward silence didn't stop the princess, who delivered a verbal coup de grâce.

"You may also tell Mr. Davis that I have six to seven hundred other guests here, all more important than he is."

"Well," said a shaken Steinberg. "You don't mind if I don't deliver that message verbatim."

"Mr. Steinberg, you may do as you please," said the princess, and abruptly hung up the phone.

Steinberg delivered an edited version of the princess's response, and Sammy angrily ordered the captain to sail away, taking Alto-vise and his guests with him but leaving Steinberg behind to inform the Rainiers he had taken ill and wouldn't perform that evening. Josephine Baker served as Sammy's replacement, assisted by Bill Cosby, Burt Bacharach, and others, while Sammy sailed off drunk into the Mediterranean Sea.

As spring turned to summer, the Pocono vacation season was in full swing and the Hillside was a busy place. Each weekend a new group of visitors, usually urban dwellers or poor, inner-city kids from New York, New Jersey, or Philadelphia, would visit to take in the clean air and green surroundings.

One special visitor arrived in June 1995. Her name was Patricia Vann and she was a young lawyer from Hong Kong, the daughter of a British businessman and a Chinese woman. Patricia and Sonny maintained a long-distance relationship for two years. She was only thirty years old, sixteen years younger than Sonny, and a rising legal star in Asia. They were introduced by a mutual friend and often talked for hours on the phone, his phone bills reaching into the thousands of dollars. They were of similar mind, both intellectually curious, and—at least from such a long distance—they were a perfect match. So it came as no surprise to the Judge and Mama when Sonny said he would marry. The wedding was a small affair inside his parents' home, with only the Judge, Mama, Sonny, and his bride present. They celebrated with a dinner at a local restaurant, but conversation centered not on the future of the new couple but on the Hillside.

The clientele at the Hillside, as always, was black, which was fine

with The Judge and Mama. This was their dream, and it pleased them to provide their temporary oasis. But business was down and the Hillside was losing money. The solution, as far as Sonny was concerned, was to welcome a rainbow of ethnicities and races.

But attracting nonblack customers would prove difficult. White and Hispanic couples and families seeking accommodations at the local Pocono visitors center were directed away from the Hillside, which had been deemed a "black" resort. And, all too often, a car filled with white vacationers would pull up to the front entrance only to quickly turn around upon seeing the guests who were lying out in the sun or mingling by the front doors. The quick departures saddened Sonny. These were immediate decisions based solely on race, without a clue as to the warmth and comfort offered by the Hillside's owners. The turnarounds also brought back distant, hurtful memories, like that day in June 1985 when, as an assistant U.S. attorney, he was summoned to Washington, DC, to meet with the U.S. Attorney General Edwin Meese.

The E. F. Hutton investigation was over, and Meese announced to the world that Hutton agreed to plead guilty to two thousand counts of mail and wire fraud. Sonny and his crew, including John Holland from the Postal Inspector's Service, were flown from Scranton to Washington on a government jet. Meese held his press conference and afterward there were handshakes all around and other speeches by other officials commending Sonny, Holland, and the team for their stellar and important work. Meese presented Sonny with a plaque congratulating him for his efforts and a blue-and-white baseball cap that bore the slogan WHEN I TALK, PEOPLE LISTEN. Three long, difficult years produced one of the biggest Justice Department prosecutions in years, and the guilty plea drew international headlines. The plea was made that morning in Scranton, and not by Hutton's attorneys. Instead, U.S. District Judge William Nealon demanded that E. F. Hutton's president, Scott Pierce, personally make the guilty plea. Pierce was the brother of Barbara Bush and brother-in-law to Vice President George H. W. Bush.

"I want the president of the company to stand before me," Nealon ordered.

Pierce appeared in court, pleaded guilty for his company, and that afternoon Sonny and his investigators were in Washington, standing behind the U.S. attorney general as he delivered the news to the world. Sonny dressed for the occasion in a blue double-breasted suit, white tailored shirt, and red tie. When the long day finally ended, Sonny shook hands, said his good-byes, and walked outside and down the front stairs to the corner, where he stood with his green, government-issue briefcase. He could have floated back to his hotel with all the adrenaline still flowing. His photo was being printed in newspapers throughout the United States and all over the world, and the attorney general along with members of Congress hailed him as a hero. Sonny sacrificed three years of his life for his country, and in the end, he believed, it was worth it.

He stood on the corner outside the Justice Department building, looking like any other government lawyer, and he held his right hand out to hail a cab. Five minutes passed, but no cabs had stopped. So Sonny decided to move to the other end of the block. He stuck his arm out again and watched as several empty cabs drove by him. Sonny thought he was standing in the wrong place, so he moved again, this time to the middle of the block, only to see the same result.

Confused, he walked back inside the Justice building and called his friend Peter Clarke, a Justice Department attorney who worked in the fraud section and served as the Washington liaison for Sonny during his investigation.

"What are you doing here, I thought you left?" said Clarke.

"I did, but I'm standing outside and can't seem to get a cab," said Sonny.

Clarke laughed. "I'll be right down," he said.

Minutes later, Clarke stepped out of the elevator.

"You can't get a cab, can you," he said.

"No. What's going on?" said Sonny.

Clarke walked Sonny to the street and stuck his arm out. Within seconds, a cab pulled up, and Clarke opened the door.

"Here you go," he said.

"What just happened?" said Sonny.

"They won't stop for you. Look, just get in and tell him where you're going. I'll see you tomorrow," said Clarke.

Sonny got in, but the incredible high he enjoyed from a remarkable day had quickly been replaced by anger and confusion.

"Hey, let me ask you something. I stood out there for twenty minutes but couldn't get a cab. My white friend is out here for seconds and you stop. Why?"

"No one is going to take you. They think you're going to the black neighborhoods and you'll just jump out and not pay, or worse."

"I'm an assistant United States attorney," said Sonny. "I don't even live here."

The driver, who was black, looked up into the rearview mirror.

"You know that old joke, right?" said the driver. "What do you call a black man with a doctor's degree? A nigger."

Sonny walked into his hotel thoroughly discouraged and depressed. How could he represent his country in court and not even be able to hail a cab on the street, he thought. He felt the terrible sting of racism, and the more he reflected on what just happened the more he thought about the Judge and others like him, proud black men who endured similar situations throughout their lives. It's hurtful enough when it happens once or every now and then. But over a lifetime? Sonny could only imagine how men like his father, who wanted to be judged only as men, buried years of pent-up anger deep inside their souls. But those who judged Sonny today weren't white, they were black. How ironic was that? Sonny's emotions and confusion over the cab ride led to another realization: the black press ignored his E. F. Hutton investigation. Despite the fact it was a black prosecutor who led a major investigation, it was nonetheless a white-collar crime involving chiefly white people.

The hate and ill-feeling was toxic, and Sonny wanted to purge it, regurgitate it, and never feel this way again. But the memory always resurfaced whenever a car pulled up to the Hillside, full of white people, stopped, heads leaned in for a look, and then the car drove away.

The Judge dismissed it with the wave of a hand.

"I wouldn't pay any mind" was his usual reply.

But the Judge's response wasn't sincere. And for Sonny, therein lay the paradox. The Judge and Mama were of a different generation, one that fought for equality. But when they gained that equality, at least by law, it wasn't embraced as a tool to assimilate into the white society, or, as the Judge called it, "the man."

The Judge could step over whatever obstacle or barrier "the man" presented, to achieve his goals. But once he achieved his goals, the Judge maintained the Hillside as a predominantly black business. The Judge may have commented on the lack of white visitors, but he knew that's what his black guests wanted. And Sonny knew that on the rare occasion when a white couple or family would actually stay at the Hillside, they would often endure looks, whispers, and sometimes insults from black guests unhappy with the white intrusion, whose message was clear: *This is our place, and you don't belong here.*

Despite the downturn in business, the Judge still wanted to keep the Hillside black, and knowing Sonny's intentions, the Judge paid a visit to Robert Uguccioni, the executive director of the Pocono Mountains Vacation Bureau. It was an awkward conversation. The Judge had come to see Uguccioni many times before, often complaining of discrimination, whether it be his inability to get milk deliveries or garbage pickups. Even recently, in the late 1980s, it was difficult for the Judge to find a bank that would lend him new construction money. But now, it was the Judge who was seeking advice on how to keep certain people away from the Hillside.

"My guests like the idea that we cater to black people," he said.

"You really can't do that," said Uguccioni.

"I know," said the Judge. "But I can't lose my core business."

The solution came in the form of a simple advertisement, a print ad welcoming potential guests to the Hillside, which featured a photo of Mama at the top. The subtle placement told all that the Hillside was black-owned, and it no doubt would keep potential white visitors to a minimum.

The ad was actually Sonny's idea, to placate his parents, but it distressed him. He continued to believe that the Hillside should reach out

to all people. This was, after all, a business, and one that was not prospering with its regular clientele. Sure, the rooms were filled every weekend, but usually at discounted rates. A large youth group from Paterson, New Jersey, for instance, paid only $9,000 for a weekend that typically cost $22,000. They pleaded poverty and the Judge bought it, which he always did whenever a group said it couldn't afford the usual rate. Even at the discounted price, the group complained about the rooms and the amenities at the Hillside, citing marks on the walls and a couple of dirty carpets. When one woman pointed out a large hole in a wall in her room, the Judge simply scoffed.

"You've got nowhere else to stay, do you? You're black," he said.

To the Judge, the Hillside was flawed, but at least it was something you could call your own.

The Paterson, New Jersey, group, claiming the facilities were poor, deducted several thousand from their already discounted rate. The Judge accepted the payment while Sonny seethed. This is not, Sonny said, how we should do business, especially when he was withdrawing large sums from his own bank account to cover the Hillside's growing losses.

It was not the way to survive.

His business battles with the Judge aside, Sonny was pleased with Altovise's continuing improvement. The intense and rigorous schedule full of daily meetings and evaluations appeared to be helping. During one visit, Sonny and Calvin found Altovise in such good spirits she decided to put her feelings on paper in the form of a poem, "How Is the Blue Sky Treating You Today?"

Along with Altovise's physical condition—she gained weight—her overall improvement brought the promise that, perhaps, she would be discharged in the near future. Yet Altovise suffered an emotional setback in June 1995, when her father died. Her relationship with Joe Gore had always been strained, particularly after her learning years earlier that he had secretly raised another family. But losing a parent, no matter how difficult the relationship, was a jolt.

Sonny was also patiently awaiting a response from the IRS to his

settlement offer. Three months had passed without a word from Daryl Frerking, but that was not unexpected. Sonny knew the IRS would do a thorough job investigating Altovise's finances. In the meantime, Sonny needed to find the money to pay the IRS once they agreed to a deal. Altovise had already created enough ill will from her borrowing spree after Sammy died, which kept her from asking friends like Michael Jackson, Bill Cosby, and Liza Minnelli for more money. Others, including Dionne Warwick and Gladys Knight, had already given smaller amounts, but nothing close to what she needed to pay the IRS.

But one friend did remain, and Altovise told Sonny to contact Yves Piaget.

Piaget and his family owned the famous, century-old Piaget Watch company. Sammy loved their watches and he owned a huge collection that was sold during the Butterfield & Butterfield auction. Piaget would help, Altovise said, so Sonny wrote a letter of introduction along with a request for a loan. Sonny explained that he was retained by Altovise in April 1994 to handle her legal and business affairs. Along with her serious health challenges, she endured tremendous financial strains since her husband's death, losing two homes and all of her personal property to the IRS. Sonny said that for the past ten months Altovise had been a resident of Alina Lodge, a long-term treatment facility for alcohol dependence. He also said that her father recently died, leaving her with no income. But during the past year, Sonny said, Altovise had fought back and was making a courageous comeback and preparing for her discharge. He negotiated a settlement with the IRS that, if accepted, would return Sammy's name and likeness to Altovise, who would then be free to exploit those rights as the surviving spouse and residuary beneficiary of the estate of Sammy Davis Jr.

Sonny said he was seeking $500,000 to cover the IRS tax debt along with the state of California obligation, and payment of all outstanding medical, legal, and accounting bills. The money would also provide rent and living expenses once Altovise was discharged from Alina Lodge, payment to her mother for repayment of a home equity loan, reimbursement of monies loaned by Calvin Douglas, and the hiring of a publicist

and book author. Once the IRS agreement was approved and the levy released, Sammy Davis Jr. would be back in business and Sonny said he was developing ideas, including a film and a book. Sonny sent the letter off in July 1995. Piaget responded two weeks later, calling Sonny personally at the Hillside and offering $250,000. But Piaget said he didn't want it treated as a loan.

"Consider it a gift," he said. "But on one condition. That you find a way to bring this family together."

Piaget considered himself one of Sammy's closest friends and it pained him to see Sammy's family—Altovise and his children Tracey, Mark, and Jeff—at odds with each other.

"Make them whole," Piaget said.

Sonny said he would. The money was half what he requested, but more than enough to pay the OIC, some of his bills, and provide for Altovise's transition to outpatient care. The remaining money would have to come from the sale of assets. But there weren't any, or so Sonny thought. When he asked Altovise what else might be out there, she recalled giving Sammy's extensive film collection to his good friend Jack Haley Jr. For years Sammy and Altovise hosted a "movie night" at their Beverly Hills home, showing first-run films delivered by the studios, in many cases before they were even released to the public. Dramas, Westerns, musicals, comedies, porno, Sammy showed it all. His gatherings were often catered, celebrity-filled events and a must place to be on Saturday nights.

Altovise said Haley had the film collection.

"How do I reach Haley?" said Sonny.

"Through Sammy's son Mark," said Altovise.

Mark Davis was Sammy's oldest son, adopted by Sammy and May in 1964. Another son, Jeff, was adopted in 1965. Altovise told Sonny and Calvin that both sons were Sammy's natural children borne by other, unknown women, probably dancers he had affairs with during his marriage to May. No one inside the family really talked about it,

especially Sammy's children, though everyone could see the clear resemblance between the boys and their father, she said. Their true parentage wasn't important to Sonny, since the boys were legally adopted and considered Sammy's sons. But gaining the film collection was important enough for Sonny to send a demand letter to Haley, and then fly to Hollywood for a dinner with Mark, who worked as a producer for Haley's production company. Haley produced *Ripley's Believe It or Not,* a popular television program hosted by veteran film actor Jack Palance. Mark landed with Haley as an associate producer after spending several years working with his father in the late 1970s and early 1980s as a member of his stage and light crew. On *Ripley's,* Mark's chief duties were keeping tabs on Palance, who had a mischievous way and penchant for getting into trouble. During a taping in China, Palance was tossed out of the country after relieving himself on the Great Wall. Thankfully, taping had been completed.

Sonny's meeting with Mark would also help facilitate Yves Piaget's request to help resolve festering, long-standing issues between Sammy's children and Altovise, and give Sonny another firsthand view of Sammy Davis Jr. through the eyes of a son who, unlike his other siblings, actually spent some time with his father. When Sonny arrived at the restaurant, it didn't take him long to find Mark, who was sitting in a booth. The facial resemblance to Sammy was uncanny. But unlike the smallish Sammy, whose own mother thought he was ugly, Mark was tall, thin, and handsome. He was also much quieter and softer than his sister Tracey, exhibiting an inner sweetness that drew immediate empathy from Sonny, who knew from Altovise of Mark's failed marriages and continuing battle with drugs, which cost him the $500,000 he received from his father's insurance policy. He had also been left out of the Quincy Jones project, since Tracey claimed that she, and she alone, owned her father's rights to *Yes I Can.*

"That's how it was with the old man, he just ignored me," said Mark.

"Well, I wouldn't call half a million being ignored," said Sonny.

"Really?" said Mark. "Try this one."

Mark told Sonny how he flew to Las Vegas to visit his father but was forced to wait three hours outside Sammy's hotel room while Sammy entertained other guests.

"He was too busy to see me, so I just said 'fuck it' and left. He was never around anyway, so it didn't matter," said Mark.

The pain clearly ran deep, and Mark punctuated the conversation with even more poignant tales of an absent father.

"You know I called him once when he was in Europe, and it took him six months to return the call?" said Mark. "We weren't his real family. The people on the road with him were his family."

Mark spoke for an hour about Sammy's failings as a father, and the uncaring manner in which he simply disregarded his children, especially his sons. Aside from infrequent visits and phone calls, there were impersonal, thoughtless gifts.

"He sent me a poster once, some shit with his signature. It wasn't even, 'Mark, I love you.' Just a signed picture. It was kind of stupid. I was like, 'What am I going to do with this thing?'" said Mark. "You know what was even worse? The old man didn't even sign it. Murphy did. I just threw it in a closet."

The ill will and resentment Mark still harbored five years after Sammy's death spewed throughout the dinner, and Mark ended the meal with a story of how he had been banished from Sammy's road crew following a squabble with his father over the affections of one of his dancers. She was a beauty and immediately caught Sammy's eye during a lengthy engagement in Las Vegas. But the dancer was attracted to Mark and she successfully resisted Sammy's efforts to bed her. Sammy learned weeks later that she and Mark began a secret affair, and in a fit of rage he exiled Mark to a dingy hotel on the other side of town. They didn't talk for eight months.

"The old man had this saying, 'That's the sheriff's meat.' He'd pick out the women he wanted and left the rest to his crew," said Mark. "I mean, I didn't even know what I was doing there working for him. He

relied on another guy, Dino Meminger, to do things for him. He loved Dino. They used to call Dino his road son. Go figure. All that time he had his real son with him."

Mark sat slumped in his chair, picking at his food, the scars from his failed relationship with his father all too visible. And there was nothing Sonny could do to help heal the raw, open wounds.

"You know, I never really had anything against Alto," said Mark. "One time she just pushed me into a closet in front of the old man and started kissing me. I was kind of freaked out. And I had no idea what was going on with that kid Manny. She and Dad just said one day that they adopted him. We were all like, 'what the fuck?' I know Alto wanted kids and Dad didn't. I mean, look at us, right? He wasn't exactly father-of-the-year material. In the end she was just looking out for herself. I mean, nobody else was."

"Do you think you could reconcile with her?" said Sonny.

"I can. Jeff would. I don't know about Tracey," said Mark. "Do you really think you can settle this thing, you know, clear it up with the government?"

"I'm working on it," said Sonny. "But I need to tell the IRS what's still out there, and that includes your dad's film collection."

Mark reached into his pocket and pulled out a piece of paper with a phone number.

"That's Jack's number. You know I work for him so I told him you'd be calling. He knows what you want and he wasn't happy about it. Just to let you know, I gave him the film collection. Alto wanted to get it out of the house before the IRS took it. I thought it was a smart idea at the time."

They finished their dinner, said their good-byes, and Mark disappeared into the night. Mark's willingness to help Altovise brought Sonny some relief, yet the dinner also left him uneasy. There were deep fissures within the fabric of Sammy's clan and, given their painful past together, they would be difficult to resolve. The following morning he called Jack Haley's home and told a woman who picked up the phone

he would visit to claim the film collection. When Sonny arrived, he was led through the garage, where he saw Beta videotapes and film reels stacked in boxes. It was Sammy's collection, and it appeared that Haley was ready to let it go.

Sonny was led inside the modest home to the living room, which was filled with memorabilia from Haley's past, and that of his famous father, Jack Haley Sr. Photos of his father as the Tin Man, and of other celebrity friends from the 1930s through 1980s, filled the room and the house. Among them were pictures of Haley and Liza Minnelli, who had married in 1974 but divorced in 1979, and Sammy and Altovise. The home was a museum of old celebrity photos, some collecting dust, and a feeling of sadness overwhelmed Sonny. Life, at least in this house, was about the past. There were no trinkets highlighting current success, or any visual evidence of future dreams.

Haley finally walked inside. He was older, in his sixties, and Sonny could see the facial resemblance to his famous father. But Haley's eyes spoke of a man who clearly liked to have a drink or two or three, and he entered the room with a glass in his hand.

"Can I get you something?" said Haley.

"No, thank you," said Sonny.

The two men sat down and Haley told Sonny of his love for Sammy, the generosity of his late friend, and the many good times and good laughs they shared. Sonny saw the photo of Haley's wedding to Liza Minnelli. He had a full head of red hair and beard to match, and he stood smiling and holding on to Liza, who wore a yellow pants suit and held a small bouquet. Standing next to Haley was Sammy, and off to the other side, third in line from Liza, was Altovise, who wore a tan dress and white bonnet. Haley was personable but argued his case for keeping the film collection, claiming it was what Sammy wanted. But Sonny remained firm.

"No, it was what Altovise wanted in order to hide them from the IRS," Sonny said. "So you either give them back to Altovise, or else I call the IRS, which then brings you into this matter personally. This is part of our settlement."

Haley paused, thought for a moment, and then nodded and led Sonny to the boxes stacked in the garage. Haley reached down and grabbed a couple of the Beta tapes, which were thicker than the more popular VHS cassettes.

"Shows you what a bad businessman Sammy was. He got these when Beta and VHS first came out, and he bet on Beta," said Haley.

A catalog documented the contents of the boxes, and included films whose subject matter was wide-ranging and indicative of Sammy's varied tastes in actors, from John Wayne and Steve McQueen to Eddie Murphy and Denzel Washington.

"You know, Sammy used to have the greatest parties. He had his theater downstairs and we'd all show up, me and Liza and others and we'd come over and watch these movies and he'd serve all kinds of food and drink. They were great times."

"I'm sure they were," said Sonny, his eyes still fixed on the catalog.

As Sonny rummaged through the boxes, Haley told old war stories about his father, who died in 1979. He also spoke fondly of Sammy, whom Haley appeared to have truly loved. It was hard to determine the material value of the collection. Sonny wasn't even sure what Altovise could do with it. But when Sonny was finished, he thanked Haley for his cooperation and said the films would be picked up and placed at Pro-Tek, a local film-storage firm.

When Sonny returned home and delivered the good news to Altovise, she was thrilled. Retrieving the collection was a small victory, and now, as Altovise prepared for her discharge, she wanted more and Sonny wanted to oblige her. So he suggested retrieving the leftovers that remained from the Butterfield & Butterfield auction. The IRS had custody of the unsold items, which were still stored at Butterfield's warehouse in Hollywood. They weren't doing anyone any good inside a warehouse, Sonny reasoned, so there shouldn't be any resistance from the IRS. But he said he'd take care of that later. He had more important issues to deal with, and they pertained to Altovise's pending discharge.

I n October 1995, Altovise was ready for life outside Alina Lodge.

After more than a year of treatment, the daily schedule of Alcoholics Anonymous meetings combined with therapy and prescription medications produced a woman who appeared physically sound and clear of mind, and she was released as an outpatient on "therapeutic leave."

Her new life included a one-bedroom apartment rented for $625 per month in a condominium complex in East Stroudsburg near the Hillside, and a minimum-wage job as a clerk at the Pocono Sweater Mills, a factory about twenty minutes away in Brodheadsville. Along with the apartment and the job came a thirty-two-point continuing care plan that was to be followed without exception. From maintaining sobriety and attending at least one AA meeting each day, the regimented routine was intended to extend Alina's program beyond its walls with a set schedule that would help patients sustain and continue with their recovery.

There were also admonishments to guard against "materialism, status-seeking, and other ego-feeding practices," and to stay away from any emotional or sexual relationship for at least a year in order to direct all energies toward sobriety, a job, and maintaining a balanced and structured lifestyle. Eating habits were also prescribed, with a preplanned diet high in protein, low in fats and carbohydrates, salts and sugars. When Altovise wasn't working, she was required to return to Alina Lodge for regular AA meetings and for dinner, without exception.

Altovise also had to fill out her own continuing care plan stating that on return trips to Alina Lodge she wouldn't smuggle any tobacco items, books, magazines, candy, or food inside for any other residents. Altovise also agreed to keep any correspondence she received from a fellow resident on the premises, and she agreed not to write to any of the residents. Any violation of her outpatient care would result in readmittance as a full-time patient. Helping her maintain her schedule was Calvin, who was pleased that she had successfully battled her demons.

One outstanding issue upon her departure was her bill. Altovise owed Alina Lodge over $20,000. Her parents only made the initial $2,850 payment for admittance, and the $665 weekly bill continued to rise. Alina officials made it clear that the bill was secondary to Altovise's care and good health. But, when possible, they wanted the bill paid in full.

While money remained from the Piaget gift, it had to stay in the bank, since Sonny wasn't sure what the IRS would eventually accept with the OIC. Sonny wrote letters requesting updates, but received no response. He flew to Los Angeles to meet with Daryl Frerking two weeks after Altovise was released. The conversation was cordial, but nothing had been decided, and Sonny remained frustrated. Upon his return, he was surprised to learn that the IRS levied several New York bank accounts he had disclosed in the OIC. They were small joint accounts Altovise kept with her mother, which had only a few thousand dollars each. IRS officials told Sonny they wouldn't take action until the OIC was finalized, but someone there obviously had a change of heart, and several thousand dollars disappeared.

Sonny wrote an angry letter to Frerking, saying that he had been "deceived as to the government's true intentions" and he felt ambushed and blindsided by their actions, which left Altovise with virtually no money.

Frerking didn't respond.

Something was wrong, but Sonny couldn't put his finger on it. Perhaps, he thought, they believed Altovise still had other unreported assets. It was clear they still didn't trust her and, by extension, they didn't trust her attorney. To combat that apparent lack of trust, Sonny

decided he'd modify the OIC, but he would wait until after the upcoming Spirit Award dinner in New York, sponsored by the People for the American Way. Sonny served on the board of directors for the progressive political-advocacy organization started by Norman Lear in the early 1980s. Sonny was a liberal, and he shared many of the organization's political beliefs, particularly its fight against the growing power of the religious right.

A Who's Who of celebrities was scheduled to attend the November 5, 1995, dinner at the Waldorf-Astoria, and Sonny wanted to use the event as a "coming out" party for Altovise. The thirteen months in rehab did wonders for her, and she exhibited a healthy physique and sober mind. Sonny invited the Judge and Mama too, and the four of them drove into New York, the seventy-five-minute drive filled with good talk and plenty of laughs. Altovise could barely contain her nervous excitement. She looked beautiful, her healthy frame carrying the off-the-shoulder gown. When she entered the ballroom with Sonny and his parents, she was immediately surrounded by people she hadn't seen in years. There were lengthy embraces, kisses, and tears.

Sonny couldn't have been happier, and after seating his parents he stood off to the side and watched as Altovise once again morphed into Mrs. Sammy Davis Jr., playing a role she mastered over twenty years. The event was a huge success, and Altovise felt like Cinderella all over again. She was back in her element with the stars and the movers and the shakers, and she loved every second of it, so much so she couldn't stop talking on the drive home. She felt great, she said, and this wonderful night would be the start of her new life, one in which she vowed to remain healthy and sober and carry on the legacy of her famous husband. Mama held her hand tightly and stroked Altovise's arm while the Judge beamed.

Sonny couldn't hide his smile as they drove west on Interstate 80. The night was a huge success, despite the warning from Norman Lear. Sonny thought back to that moment, as he stood watching Altovise holding court with several friends, when Norman walked up from behind and tugged on his elbow.

"Norman!" said Sonny, grabbing him tightly in a big bear hug.

"What do you think?" he said, pointing toward Altovise and her admirers.

"I heard you were bringing her as a guest. Let me tell you something," Lear said, leaning in to whisper into Sonny's ear.

"She's bad news."

On November 18, 1995, Sonny modified his Offer in Compromise to the IRS, including among other things Altovise's wage statements from Pocono Sweater Mills. Two weeks later, he sent the government a check for $105,000 representing "full payment under the terms of the OIC" with a request to officially agree to the settlement by the end of the year. Sonny was hopeful and excited. Bob Finkelstein's warnings that he would never settle with the IRS always remained in the back of his mind, and he wanted to show Finkelstein, and all of Hollywood, that a good lawyer from the East Coast could not only settle the matter but also help Altovise get well.

Still an outpatient, Altovise worked a cash register for minimum wage at the sweater mill. While it gave her the impetus to stay sober, the job was dull and she experienced difficulty with her new identity being simply Altovise Gore. After a few weeks, she'd be seen pulling aside customers and asking if they knew who she was.

When they said no, she'd smile and whisper, "I'm Mrs. Sammy Davis Jr."

The Christmas holidays arrived with the sad news that Dean Martin passed away. His health had deteriorated sharply in recent years, accelerated by the death of his son Dino Jr., a National Guard pilot who died in a crash in 1987. It was Calvin who heard the news on Christmas day, and he informed Altovise, who didn't have much of a reaction. Despite the public perception, Dean and Sammy were friends but never buddies, and Altovise decided against attending the funeral.

The New Year arrived with still no answer from the IRS, and Sonny's frustration was as deep as the snows outside the Hillside. More

than two feet fell during a January blizzard, covering the region in a serene and dazzling white. Deer, unable to navigate through the deep snow, gathered under large bull-pine trees while crows circled the air scouring for their next meal. The weather forced two groups to cancel a rare winter reservation, leaving the Hillside empty for the weekend. No matter to Sonny, who pulled the rope to start the engine on the snow blower and slowly carved out lanes from the front door to the parking lot and road. Sonny enjoyed the manual labor, if only because it gave him a chance to clear his mind and refocus.

Nearly two years had passed since he met Altovise, and his work to date centered on her health and resolving the numerous issues with the IRS, a resolution he believed was close at hand. So his thoughts turned toward a post-settlement, which meant that Altovise controlled Sammy's image and likeness and thus could begin to rebuild his legacy. The possibilities, Sonny thought, were endless, given Sammy's stature as one of the greatest entertainers of the twentieth century. Films, books, television, new albums, endorsements, the potential deals appeared limitless. Sammy could be like Elvis, thought Sonny, and the income streams for Altovise could be impressive.

But the excitement over possible new ventures led to thoughts about Sammy's body of work, specifically moneys due him from his lifetime performing. In his offer to the IRS, Sonny promised to pay a percentage of revenues from Sammy's estate for fifteen years. The problem was Sonny had no idea how much that could be. Specifically, what money did Sammy earn in royalties and residuals from the dozens of albums he recorded, films he performed in, and endorsements he'd given?

Sonny knew about the Screen Actors Guild checks that arrived every month, usually for small amounts, and every now and then another residual check would be given to the IRS from some long-forgotten endorsement. But that was it, and Sonny knew he needed to obtain a complete accounting of Sammy's work over his lifetime. How to get this done was another matter. Altovise had few, if any, records. And what she did have didn't make much sense, since her papers were haphazardly placed in unnamed folders.

Altovise claimed Sammy owned many, if not all, of his songs and the master recordings, but there was little, if any, evidence to prove it. And no one, not even Altovise, had any idea what Sammy really earned in royalties and residuals from a six-decade career that included dozens of albums, appearances in as many television shows, documentaries, films, and Broadway shows. And since he never saw any royalty checks, Sonny assumed the various companies that did business with Sammy were delinquent in their royalty payments. At first glance, assuming that Sammy actually owned all his work, the expected revenue streams from royalties and residuals should be impressive, reasoned Sonny, whose thoughts were interrupted by the beep of a car horn. It was Calvin, who drove by slowly with the wave of a hand. Sonny turned off the snow blower.

"Where you going in this weather, Mr. D.?"

"Altovise. Have to give her the mail. And I'm sure she could use the company."

"Okay," said Sonny. "Tell her I'll call her later. You be careful."

As Calvin drove away, Sonny turned and walked inside to the front desk. He pulled a piece of paper out of his pocket, read the scribbled number, and dialed the office of Jay Shapiro.

Shapiro was the former national director of entertainment and media for the large accounting firm of Laventhol and Horvath and one of only three accountants in Los Angeles who specialized in entertainment forensic accounting. Since royalty payments to a performer were always based on someone else's accounting, Shapiro developed an expertise in what he called CRAP—Contractually Required Accounting Principles. They were a different set of rules for entertainers, based on their individual contracts, and allowed Shapiro to dig deep and recover uncollected monies. So many minor and major stars received less than expected, thanks to loopholes, omissions, and language in their contracts, and Sonny told Shapiro he needed an expert to participate and plan out a computation of Sammy's future revenues in order to give the IRS a true idea of what to expect from Sammy's royalties as well as determine the estate's true income. Sonny also needed to know for

personal reasons, since payment of his growing legal bill was dependent on the income realized from Sammy's estate. With few records, Shapiro said it would take months to complete his work. Still, he promised he would account for every penny owed to Sammy's estate.

The clear, glass gallon jug was half filled with water—or so Calvin thought. But when he opened it and put it to his nose, he knew it was vodka. Only three months had passed since Altovise had been discharged from the Alina Lodge, and despite claims to the contrary, she was drinking again. The initial burst of determination and resolve to put her demons behind her quickly faded amid the drudgery of a minimum-wage job at a sweater shop and a small one-bedroom apartment. Faced with the reality of her life, Altovise buried her head back in a bottle.

Calvin was enraged. Wet snow dripped down his boots onto the floor as he pointed a trembling hand.

"After all Sonny has done for you, and this is how you repay him?" said Calvin.

Altovise didn't reply. Her secret was now out in the open and she poured herself another drink.

"Calvin," she said. "I'm Mrs. Sammy Davis Jr. Do you understand that? Mrs. Sammy Davis Jr.! I had a life. I had a home. I was a star!"

"You're confused," said Calvin. "Sammy was the star."

Altovise paused to take another sip, then looked up to her elderly friend with a menacing, disapproving stare.

"Sit down," she said. "Let me tell you a story."

The luncheon was scheduled for mid-afternoon, and when Betty Ford arrived at the Davises' Beverly Hills home, she was greeted by Altovise, Liza Minnelli, Johanna Carson, Marlo Thomas, and Farrah Fawcett. The first lady was recovering from a mastectomy, following her very public battle with breast cancer, and Altovise was the gracious hostess for a quiet afternoon of finger sandwiches and tea.

It seemed a strange pairing at the least, Sammy and Altovise and

President and Mrs. Ford. But Sammy's close relationship with Richard Nixon and his underlings, particularly Donald Rumsfeld and Bob Brown, paved the way for a similar relationship with the new president and his wife. Sammy wasn't a Republican, but he bought into parts of their platform and thought their efforts to reach out to the black community were genuine. He called them friends, and with good reason, given the trust and respect the Republicans gave Sammy.

It was Nixon who invited Sammy and Altovise over to stay at the White House. They were like two kids in a candy store, exploring from the Lincoln Bedroom to the Queen's Bedroom, jumping from bed to bed, making love along the way and smoking pot, or at least making an attempt. After Sammy lit the joint, he quickly realized he was actually in the White House, and he ran to the bathroom and flushed it down the toilet as Altovise looked on, laughing hysterically. The following morning Altovise had breakfast with Nixon's wife, Pat, while Sammy sat alone with the president, discussing a variety of subjects, particularly civil rights. Sammy felt empowered. Here he was, lacking a formal education, yet talking to the president of the United States about matters of great importance. It was the kind of audience, attention, and true friendship never offered by any of the Kennedys.

That same Republican goodwill extended to the Ford presidency, and at Sammy's urging, Altovise agreed to host a luncheon for Mrs. Ford. Everyone, including Altovise's famous guests, had to provide identification after the Secret Service inspected the eleven-thousand-square-foot home. When the first lady arrived, she was greeted with a big sign and a welcoming call of "Big Mama!" from Sammy. The men retreated to the backyard while the ladies settled in the living room to talk. Altovise was a wreck. It was just a luncheon, but she obsessed over every detail, from the food that was served to her personal tour of her home. Everything went smoothly and Altovise was the perfect hostess. And when it was over, there were hugs all around with Marlo and Liza and Farrah and the First Lady. Sammy watched from the background, beaming with pride.

"I think about that day. I think about a lot of days. And I think

about what I had. And then I think about where I am," Altovise said, drifting off.

"I know, they were good days for you," said Calvin. "But they won't come back if you keep drinking."

"I'm not trying to bring them back."

"Then what?"

"Oh, Calvin," said Altovise, stirring her drink with her finger. "I have so much to remember, and there's so much I want to forget."

Golden Boy was scheduled to debut in London in 1968, and Altovise flew to Chicago to meet its star. She had danced in a show called *High Spirits* after declining to join the cast of *Golden Boy* during its Broadway run in 1964. *Golden Boy* offered the better part, but Altovise stayed on *High Spirits* out of loyalty to the show's producer, Noël Coward. The show eventually ran its course and closed and, looking for a new job, Altovise desperately wanted to go to London.

Sammy was in Chicago to perform his nightclub act when Altovise walked into his dressing room for her initial introduction and interview. Sammy combed his hair, his eyes fixed to the mirror.

"How do you like Chicago?" he said.

"Great," said Altovise. "I got arrested going out on a date with a white guy. The cops thought I was a hooker and they picked me up."

Sammy laughed. "That's what we get for not sticking together."

Altovise smiled.

She knew, along with the rest of the world, that Sammy's marriage to May Britt had finally ended. The Swedish beauty had filed for divorce after word leaked about his romance with singer Lola Falana. Sammy with a black woman was not a bad thing, thought Altovise, and even though it broke up a marriage, it probably mended some hurt feelings in the black community. Hence, she understood Sammy's comment about sticking together.

Sammy liked what he saw in Altovise, particularly her beauty, and several months later she stepped onto the stage at London's Palladium Theatre playing the role of Sammy's sister in *Golden Boy*. Following

Above: The Hillside Inn in Marshalls Creek, Pennsylvania. *Right:* Judge Albert R. Murray, Sr.

Above: The Judge, Mama and Sonny. *Left:* Sonny honored by U.S. attorney general Edwin Meese in 1986 for the E. F. Hutton investigation. *Opposite, above:* Altovise in Pennsylvania with a friend following rehab, 1996. *Opposite, below:* Among the hundreds of items stolen from Sammy's home were twenty-one photographs and nude stills of Marilyn Monroe (seen here with Sammy at a party in 1955). (Photographs courtesy of Davis family)

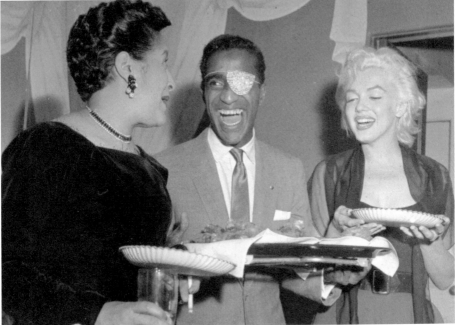

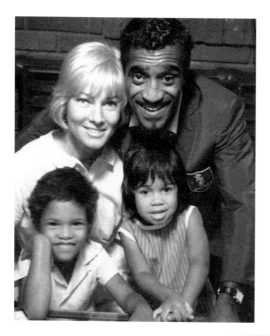

Left: Sammy, second wife May Britt, and children Mark and Tracey, circa 1965. Their marriage in 1960 was illegal in most states in America. (Photograph courtesy of Davis family) *Below:* Sammy's former agent and manager Sy Marsh (seen here with Sammy at the Wailing Wall, Israel) blamed other, ominous forces for Sammy's financial demise.

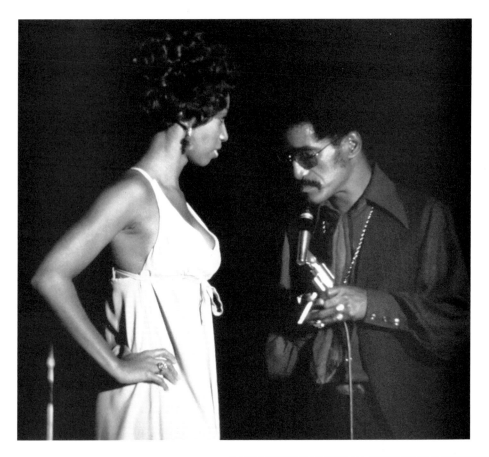

Above: Altovise (performing with Sammy at the Sands in Las Vegas, 1969) was tall, beautiful, and the perfect trophy wife who was subjected to Sammy's lurid demands. *Right:* Sammy standing next to Altovise's Rolls-Royce, which was hidden in Las Vegas after Sammy died. (Photographs courtesy of Davis family)

Left: "The Hug." Sammy embracing President Richard Nixon in 1972, and enflaming black America. (Associated Press) *Below:* Sammy and members of his entourage at the Cocoanut Grove, circa 1974. *Left to right:* Shirley Rhodes, Murphy Bennett, Sammy, publicist David Steinberg, and bodyguard Duane Rice.

Above: Jacqueline Kennedy Onassis, Frank Sinatra, and Jilly Rizzo, 1975. Sammy knew that Jacqueline turned to Frank for help after Bobby Kennedy was assassinated in 1968. (Photograph courtesy of Davis family) *Below:* Sammy with Harry Belafonte, Sidney Poitier, and Quincy Jones, 1970. (Photofest) After Sammy died, Quincy optioned the rights to Sammy's book for a musical, but Sammy's estate tax problems and fractured family killed those plans.

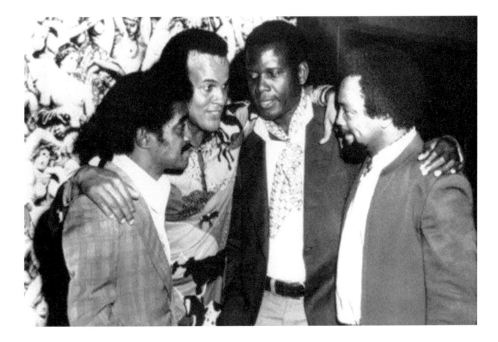

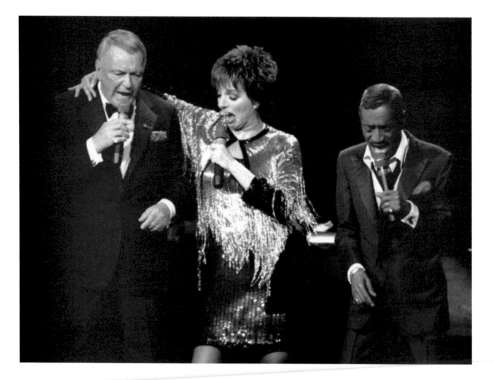

BEVERLY HILLS

FAMOUS ENTERTAINER'S ESTATE. Prestitious area. Gated and private. Circular drive leads to main house which has a multitude of rooms and baths, including large media room with wet bar, huge master suite with step-down living room and luxurious bath. Spacious formal dining room. Separate pool house and separate gourmet kitchen. All on 1.25 acres. Great potential for dream home. Probate sale. $4,250,000

Above: Frank Sinatra, Liza Minnelli, and Sammy performing in London in April 1989. (Associated Press) *Left:* Advertisement for the sale of Sammy and Altovise's home following Sammy's death.

the premiere, the cast and crew returned to Sammy's penthouse at the Playboy Club for an after-show party. Altovise arrived dressed in a long white gown with ruffles in the back, and she immediately drew Sammy's eye.

"Who is *that*?" Sammy inquired.

When he was informed that she performed with him every night, Sammy shook his head.

"Well, she sure looks different."

As the night wore on, Altovise was the last to stay, and she and Sammy talked well past dawn. The conversation shifted from politics to trivia, and Altovise was fascinated with Sammy's knowledge and wide range of interests. He wasn't limited to the kind of gibberish she heard from most other actors, singers, or dancers. Sammy was worldly. He even knew about Shakespeare. Altovise was attracted to Sammy, but not for his looks. She didn't think he was handsome at all. It was his demeanor. Despite his small physique, he had a large ego and carried himself like a giant. And despite his limited education, he had a natural intellectual curiosity.

Within weeks Sammy moved Altovise from a room in a country house to an apartment in the Playboy Club, much to the consternation of his entourage, which thought Altovise was stepping on Lola's territory. Altovise didn't care. She was engaged to a doctor, Jonathan Falk, and didn't see herself as the eventual "Mrs. Sammy Davis Jr." But the more she socialized with Sammy, the closer she was drawn into his circle.

Golden Boy was a hit, and Altovise remained for eight months. Following matinees, Sammy stood at the front of the stage and delighted his audiences by singing a cappella. When the show closed, Altovise joined Sammy's nightclub act and toured Europe and the United States with him. She later joined Sammy on a cruise through the Bahamas with Sidney Poitier and Quincy Jones. Sammy was being pressured to marry again, and everyone thought it would be Lola, whom he had met in 1965 and with whom he maintained a relationship that survived his divorce from May Britt.

Jesse Jackson and Andrew Young, among others, pressed Sammy

to marry a black woman, which Sammy resented. He didn't like being told what to do. He also enjoyed a debauched, freewheeling lifestyle and he knew that a strong-willed woman like Lola would never tolerate his trysts with other women. So, when he acquiesced to the private but growing calls to marry again, his choice was a surprising one. Altovise was buxom and beautiful, and though she was several inches taller, Sammy decided she would complement him nicely. For her part, Altovise never understood Sammy's interest in her or what she really meant to him. Was she a young, naive woman he could mentor? Or was she the Black Barbie he could dress up and show off to the world? Whatever it was, they were together in 1970 in Philadelphia for a golf outing with talk show host Mike Douglas. But it was canceled due to rain, and with nothing else to do, Sammy decided, matter-of-factly, that it was time, so he rushed a surprised Altovise to City Hall, where they married.

There were no photos.

Altovise admired her heart-shaped diamond ring on the flight back to Los Angeles when Sammy reminded her that, as his wife, she would play the most important role of her life, that of a devoted and loving spouse. Altovise said she was ready for the challenge. She had her Hollywood debut weeks later, at a party hosted by Jack Benny and his wife, Mary. Told to dress casually, Altovise decided to wear hot pants. But upon arriving, she was shocked to see the women wearing gowns, so Altovise stood behind a long couch and moved only when prodded by Lucille Ball.

"What are you hiding for?" said Lucy. "If everyone had good legs like you we'd all be in hot pants."

Within weeks, Altovise was a member of Hollywood royalty. Dionne Warwick, Suzanne Pleshette, and Nancy Sinatra became close friends, as did Lucy, who came over to play backgammon whenever Sammy was on the road. Altovise attended Sunday mass with Loretta Young, and the two women went out for sushi every Monday night.

Altovise was also busy overseeing renovations on the home Sammy bought for them at 1151 Summit Drive. Joan Collins and Anthony Newley had lived there, as did Tony Curtis and Janet Leigh. Altovise

barked out orders to the various decorators and designers, and the Spanish-style home was completely renovated. While adapting publicly to her new life, Altovise privately was well aware of Sammy's ground rules that established, without question, his need and desire to pursue a free and open lifestyle that included sex with others, sometimes including men, and plenty of drugs, particularly cocaine. Marriage to Sammy also meant total acquiescence to his wishes, no matter what. So whenever Sammy hosted a late-night orgy and instructed his wife to make love to another woman, she did. And when Sammy decided he wanted to watch Altovise with several women before joining in, she did. And when Sammy instructed Altovise to satisfy other men, she didn't resist. It didn't matter if they were young, old, famous, or infamous. Sammy often found that he had little control over his own life, but he could have absolute control over Altovise, and he paired her with others, particularly the wealthy and powerful. Altovise became a prop, a toy that obeyed his commands, that satisfied his whims, and soothed his anger at the unwanted pressures and demands of his life.

In return he gave her the life of a queen, and her material needs were satisfied in every way imaginable. Altovise had a mansion filled with fine furnishings, expensive paintings, and beautiful sculptures, open accounts at gourmet grocery stores where she ordered lobsters and caviar. Sammy bought her a Rolls-Royce and wrapped her in furs and fine jewelry. He brought her into the Hollywood social world where she found a home with SHARE, the celebrity-filled nonprofit organization that raised money for the developmentally disabled. The major fund-raiser, called the Boomtown, was held in May, and Altovise relished her role as one of the celebrity wives helping with the silent auction and evening entertainment. Altovise was also named an ambassador for the city of Los Angeles by Mayor Tom Bradley.

Seven years as Mrs. Sammy Davis Jr. would pass before the orgies, the drinking, and the increasing use of drugs began to take their toll. Altovise also had to deal privately with the emotional consequences of two aborted pregnancies, one from Sammy and another from one of her many casual affairs. Sammy was adamant when it came to children,

and he didn't want any more. He was a lousy father to the three he already had, and he didn't want to add the same misery to another young soul. Altovise thought she could change his mind, but Sammy exploded when she told him she was pregnant, and they separated for a month.

Upon her return, she continued to perform the public role of Mrs. Sammy Davis Jr. When they opened their home for their "Party of the Century" in 1980, Altovise handed roses to each lady and talked into the night with football players from the Rams, basketball players from the Lakers, doctors, lawyers, and film people of all generations. But privately she had spiraled out of control, and the drugs, booze, and affairs led to a deepening depression that left little room for feelings for anyone or anything. There was no intimacy or sex with Sammy, and other sexual relations were a quid pro quo, while alcohol and drugs were a balm to numb the pain. Adding to her grief were the continuing problems she had with Sammy's employees, including Shirley, Murphy, Brian Dellow, and the housekeeper, Lessie Lee. Relationships with the staff had been poor from the beginning, and they didn't hide their disdain, especially during the 1980s, when Altovise was clearly in her husband's disfavor. He spent his nights with Sue Turner, his new live-in girlfriend. Midwestern, white, and beautiful, Turner was a model introduced to Sammy by his good friend Harvey King.

Altovise was completely alone. When Sammy was away, she tried to resurrect the famous movie nights, pulling out her personal phone book and calling her and Sammy's celebrity friends. The conversations started off congenial and hopeful.

"We're having a movie night on Saturday," she'd say.

The invite would be accepted, but then came the question: Will Sammy be there?

When Altovise revealed that Sammy was out of town, the invitee would suddenly remember a previous appointment and decline.

Somehow, despite their troubled marriage, Altovise talked Sammy into adopting a ten-year-old boy. No one knew where Manny came from. Altovise claimed he was an orphan who lived near her mother in Queens. Others thought that, perhaps, he was Sammy's illegitimate

child. Whatever Manny's origin, he was welcomed only by Altovise. Sammy ignored him, as did his children, who treated him as if he were another interloper.

Other than Manny, Altovise exerted little control over anything in her home, and the pattern remained until the end. Even when Sammy lay dying, she was cast aside and ignored by Shirley and others. When word was quietly sent out to friends to come say their final good-byes, it was Shirley who led Liza Minnelli, Jerry Lewis, Quincy Jones, Tony Curtis, Jack Haley Jr., and a steady stream of friends to the spacious bedroom, which occupied the entire left wing of the home. Actor Robert Blake, who, like Sammy, grew up in show business, cried like a baby during his visit, so much so that Altovise told him to shut up and get out. She was depressed enough, she said, and didn't need Blake adding to her pain. Other entertainers tried to visit to pay their respects, but Shirley denied them access. One afternoon a man rode up to the gate on a motorcycle, bearing flowers. When security at the front gate called inside to tell Shirley that Jay Leno had come to visit, she replied, "Who the hell is that?"

"He says he's a comedian," said security.

"Tell him thanks but he can't come in," said Shirley.

Leno left the flowers and sped off on his Harley.

Altovise was even unaware when close friends, like Frank and Barbara Sinatra, lingered on the chaise in Sammy's room. When Frank left Sammy's side, he was visibly shaken and comforted by Sammy's daughter, Tracey.

"You okay, Uncle Frank?" asked Tracey.

"I'm fine, sweetheart," said Frank.

But he couldn't control his emotions, burying his head in his hands to cry.

After learning of the Sinatras' visit, Altovise angrily escorted Danny Thomas to see her husband over the objections of Shirley, who didn't pre-approve the visit. Altovise barked while leading Danny up the staircase, and Shirley backed down. But small victories were few, and near the end Altovise gave up her fight with Shirley and remained awake overnight

with Brian Dellow. She sat on the chaise, ate a little, prayed a little, and drank a lot. Altovise left briefly to attend a funeral in North Carolina, but returned after receiving a call from Bernard Wilson, Sammy's valet. Sammy's employees were looting the home, said Bernard, and they were taking clothes, jewelry, and memorabilia while Shirley was looking for Altovise's house keys.

"You better get home, child," said Bernard.

When Altovise returned, she was summoned by Sammy. His fate sealed, Sammy reflected on their troubled lives together and he apologized for exposing her to the dark side of his life. He never loved Altovise, but he felt sorry for her, and he knew that with his passing all would be lost.

"They took everything from us, everything," said Sammy. "There's nothing left here but my name. Remember, you'll always be Mrs. Sammy Davis Jr."

Altovise pulled back from her memory and sipped from her cup. "That's what he said, Calvin, that I'll always have his name. And that's all I have left of that life," she said.

"But it's a life you'll never get back. It's a life you don't want. Don't you see? You weren't really his wife. You were a thing, a toy, a possession to please him and other people. Look what it's done to you!"

Altovise tried to lift herself off the floor, but couldn't. She sat there barefoot, her nightgown hanging off her shoulder.

"Help me up," she said.

Calvin walked over, his wet boots squeaking across the floor, and he reached down and lifted her up by the arm.

Altovise placed her glass on the table and took his hand.

"Come with me," she said.

"Where to?"

Altovise didn't reply. She looked at her elderly friend and stared into his eyes. Calvin could see the pain and loneliness and the wanting, so he didn't resist when she gently led him to the bedroom and closed the door.

In March 1996 the IRS finally delivered its answer to Sonny's Offer in Compromise to settle the estate of Sammy Davis Jr., and it wasn't what Sonny expected to hear.

He flew out to Los Angeles to meet with Daryl Frerking, who told him the $105,000 offer wasn't enough and after nearly a year of review the IRS wanted $360,000. Frerking refused to say how the IRS came up with that amount, or disclose the asset values to support their calculations. For two months Sonny tried to negotiate a lower amount, but the message was simple: Take it or leave it.

There wasn't much Sonny could do other than agree to the new amount. The actual tax owed by the estate was now over $7 million, so the new number was still a bargain. The problem, though, was finding the money to pay it. The IRS kept the $105,000 Sonny sent in December, and he needed another $255,000. But only $145,000 remained from the Piaget money, and asking any of Altovise's old Hollywood friends was not an option, as nearly all of them were still owed money from previous loans. Complicating matters was Altovise's health, which was deteriorating again. Sonny's bookkeeper, Ann Hoehne, befriended Altovise and served as a quasi–guardian angel. Following Altovise's discharge from Alina Lodge, Ann helped maintain her tightly controlled schedule, supplying Altovise with the proper foods and ensuring that she attended her daily AA meetings. Ann also paid Altovise's monthly bills, including rent, electric, medical, and any other incidentals from a joint account controlled by Sonny. But on recent visits to Altovise's

apartment Ann could smell the alcohol on her breath, and her mood swings became more pronounced and frequent.

Whenever Sonny broached the issue of alcohol, Altovise denied it. Calvin, who had been unusually quiet over the past few months, said he didn't know if she was or wasn't drinking. Altovise was slipping, and in recent weeks all she talked about was regaining lost possessions, particularly clothing that went unsold at the 1991 Butterfield & Butterfield auction. So Sonny called the IRS and requested they release whatever remained, arguing it was old stuff that no one wanted and was doing no good stored in a warehouse. To his surprise the IRS agreed, and Sonny flew to Los Angeles and drove to the Butterfield & Butterfield warehouse in Hollywood. He showed a clerk the IRS release and was pointed toward the back of the cavernous warehouse filled with hundreds upon thousands of boxes large and small. From there he was pointed by another worker to another warehouse, and as he walked through yet another maze of boxes, he was pointed yet again to the back of that warehouse and a staircase.

"Over there, you should find what you're looking for, somewhere over there," said the worker, pointing to a pile of boxes placed in no particular order under the staircase.

As Sonny drew closer, he could see the boxes were in poor condition. Some were crushed, while several were ripped open and discolored. There were no identifying marks other than the date—9/22/1991— which was the date of the auction. Sonny took his suit jacket off, rolled up his sleeves, and opened the boxes. One by one he pulled out moldy fur coats; broken awards and plaques; several photos; wrinkled shirts, pants, and stage clothes, including a rhinestone-laced jumpsuit. This was all that remained of Sammy Davis Jr., and it had been discarded and forgotten and left to rot in a warehouse. Sonny was struck with a deep sadness and sorrow, and he could feel the anger build from within. Whatever Sonny had previously thought of Sammy, he knew he didn't deserve this. Sammy's legacy deserved much more. So Sonny closed his eyes and vowed that he would complete his task and settle the IRS debt and restore Sammy's estate.

"Did you find what you were looking for?" said a warehouse worker.

"Yeah," said Sonny. "Now pack it up. I'm taking it all out of here."

The furs and other items were shipped in six new, repackaged boxes addressed to the Hillside Inn. When Sonny returned to his hotel, there was a message from Mark Davis. His mother, May Britt, agreed to meet with Sonny.

Sonny long sought a meeting with May. He wanted to learn more about what drove Sammy, and who better to learn from than the one woman whom Sammy truly loved.

May—whose name is pronounced "My"—was a burgeoning actress in the late 1950s, whose credits included starring roles in *Murder, Inc.* with Peter Falk and *The Young Lions* with Marlon Brando, when she fell in love with Sammy and married him in November 1960. The union between the blond, blue-eyed beauty and the African-American/Puerto Rican entertainer infuriated much of the nation and technically violated laws against interracial marriage in thirty-one states. The relationship was so controversial, Sammy waited until after the presidential election to marry, so as not to interfere with the candidacy of John F. Kennedy, whom Sammy had openly supported.

But Sammy's consideration for Kennedy was cruelly dismissed when Sammy and May were disinvited from the newly elected president's inaugural celebrations for fear their marriage would anger his Southern supporters. Sammy was devastated. He had once again broken a color barrier, yet his thoughtfulness and courageousness went unrewarded, even by a liberal Catholic president he vigorously supported through numerous performances and considered a friend.

May converted to Judaism, gave up her acting career, and became a stay-at-home mom. She gave birth to Tracey in 1961 and later adopted Mark and Jeff. The family lived in New York during Sammy's run on Broadway in *Golden Boy,* and they later moved to Beverly Hills after the show closed. But Sammy began to tour again and he was unable to remain faithful to May. By 1968, the marriage was long over. Sammy's carousing, particularly with Lola Falana, and his refusal to spend any time with his family left May with no choice. Her divorce filing cited

the lack of a family life and his neglect of Tracey, Mark, and Jeff. Despite the divorce, May declined several marriage proposals from various suitors. She preferred instead to remain alone while quietly raising her children in Lake Tahoe.

When Sonny arrived for his introduction, May offered a friendly greeting. They spoke briefly about Sammy and his life. At sixty-three, May remained attractive and appeared warm and genuine. She was a devoted mother who was at peace with her decision to give up her show business career. And when she spoke of Sammy, it wasn't bitter or derogatory. Instead, May remembered a gentle, generous, and trusting man.

"You know I wish only good things for Altovise," said May, her distinct accent punctuating each word. "We all know how tragic this has been, for everyone. I hope you are successful."

Sonny drew an immediate respect and admiration for May, who was by far one of the nicer people he had met since taking Altovise on as a client. May ended their meeting the way she began, with a smile, and when she left, Sonny's thoughts turned to Sammy, and all Sonny could do was shake his head and think to himself, "Sammy, how stupid could you have been to give up a woman like May Britt."

When Altovise heard that the UPS truck had finally arrived, she rushed over from her apartment and tore into the boxes like a child opening gifts on Christmas morning. She pulled out the furs, including a full-length spotted fox, a full-length white mink with exotic trim, another white mink trimmed with white fox, a full-length red fox, a Stone Martin full-length coat, a mahogany mink jacket, a beaver jacket, fox bedspread, and chinchilla coat. In addition, there were several pairs of pants, shirts, and jackets. The boxes and their contents were valued at $75,000, and with each fur came a story behind it, of some gala event in which Sammy and Altovise made grand entrances dressed head to toe in fur. Altovise ignored their poor condition and wrapped one around herself, lifting her arm to her nose, searching for a familiar scent. There was none. Sonny later brought the furs to Anthony Akoury, a local furrier who owned a small corner store on Main Street in nearby

Stroudsburg. There, the furs were cleaned, reconditioned, and placed inside a vault. Sonny wished he could fix Altovise just as easily.

While initially relishing the challenges of her new life, Altovise had once again displayed troubling signs in recent months. At work she carried a cup, and customers complained they could smell the alcohol. During her brief tenure there, Altovise had earned the respect of the owners—so much so they entrusted her with the keys to open in the morning and close at night. It was a responsibility Altovise had never experienced in her life. She had always depended on others, yet here people depended on *her*. But it wasn't enough to keep Altovise from drinking, and she eventually lost her job.

Ann told Sonny that she drove Altovise to a visit with the doctor, but Altovise was drunk and along the way threw up all over herself. She blamed it on a can of soda. Calvin and Sonny later found a water bottle in Altovise's apartment, filled with vodka. Calvin called Alina Lodge and told them she had relapsed. Alina officials suggested an immediate intervention. Calvin, Ann, and several staff members from Alina met Altovise at her apartment and forced her to go to the Clear Brook Manor forty-five minutes away, in Wilkes-Barre. Like Alina Lodge, Clear Brook treated alcohol and chemical dependency and it would serve as a short-term respite before she would be transferred back to Alina Lodge.

Altovise's relapse and Sonny's inability thus far to complete the deal with the IRS were personal blows. He spent over two years trying to resolve and restore Sammy's estate while at the same time bring his widow back from what had been a near-death experience. But now, he wondered if a happy ending was even possible. To make matters more complicated, Tracey Davis released a book about her father.

Two years had passed since the meeting in Los Angeles where Sonny and Altovise had the showdown with Tracey and Bob Finkelstein. Sonny's firm "no" to Tracey's request to transfer Altovise's rights to Sammy's estate in 1994 sent Tracey into a tizzy. She warned him that someday Altovise would do to him what she did to so many others. Tracey also promised to do anything in her power to keep her father's name in the

public eye, and she decided to strike out on her own with a book titled *Sammy Davis Jr.: My Father.*

Tracey had never come to terms with her father's life, or death, and the 262-page memoir was a painful retelling of a relationship that never existed with a father she never knew. Tracey painted her father as absent and uncaring, a man who ignored his children throughout much of their lives. She credited her mother, May, for keeping the children together and away from Beverly Hills. May even bought a four-bedroom home in Lake Tahoe for $73,000, with her own money, only a block away from the lake.

Sammy visited only when he performed in nearby Reno or Las Vegas. Christmas and Hanukkah and birthdays would come and go year after year without a visit or even a phone call, the only sign of recognition being a card and cash, which often arrived days late.

On the rare occasion when Sammy did call, and promised to visit, Tracey told him to forget it.

"Why, you don't really care. Why come?"

Sammy didn't argue.

The children attended George Whittell High School and were among the few minority children in the school of three hundred students. The Davis children were also among the few Jewish children in the area. During the holidays May always insisted the children have a Christmas tree to go with a menorah to celebrate Hanukkah. And when Mark and Jeff came of age, they each had their bar mitzvah, which was one of the few events Sammy made time for. But his late arrival for Tracey's high school graduation caused a twenty-minute delay, and he didn't show up at all for her college graduation from California State University at Northridge, where she studied journalism and communications. Tracey was the first Davis to receive a college degree, but two days before her big day, Sammy called from New York to ask if she really wanted him there. If not, he'd prefer to save the expense of chartering a plane.

Tracey was devastated. What father, she thought, would even ask

that question? There are few bigger days in a child's life, but Sammy considered it irrelevant and dismissed it just like he dismissed everything else about his children. May tried to talk Tracey into attending the ceremony anyway, but to no avail, as Tracey raged, became depressed, and decided to stay home.

Despite Sammy's affairs and their divorce, May never spoke ill of her ex-husband. But she didn't try to sugarcoat his actions to his children, and she let them make up their own minds about their father, which were decidedly negative. It wasn't until late in Sammy's life, Tracey wrote, that he finally made an effort to connect with his only daughter. He even gave her away at her 1988 wedding, and they continued to talk right till the end. But two years did not make up for a lost lifetime, and there was no way to mask the simple fact that Tracey really didn't know her father. She did, on the other hand, have some insight into Altovise, whom she described as an alcoholic, egocentric, gold-digging witch, who had paraded around Hollywood as a star and treated Sammy's children with disdain.

Sonny tried to reconcile Tracey's allegations with what he had observed, yet he still wasn't convinced that Altovise was as awful as she had been portrayed. The nasty allegations aside, Sonny feared the controversial book would draw an option from an interested producer or film company, which would end any potential plans he had to sell Sammy's film rights once the tax debt was settled. Sonny had, from his own experiences with Tracey and Mark, privately concluded they had a legitimate grievance in claiming a right to their father's estate. They were, after all, his children, and Sonny was empathetic to their plight. But Sonny's commitment was not to Sammy's children but to Altovise, so he sent another letter to the IRS, in which he copied Calvin, and said that Tracey's new book combined with the delay in finalizing the agreement could very well shut Altovise out of potential deals, particularly relating to film. Altovise's future ability to generate income from the rights she may receive from the estate, said Sonny, was tenuous.

ltovise's stay at Clear Brook ended in September 1996, and she was
readmitted to Alina Lodge and, as during her previous visit there,
the few weeks of sobriety led to some clear thinking. So Sonny and
Calvin visited with her with news that the IRS deal was still at an im-
passe with no word yet on whether the government would accept the
new amount. Even if it did, Sonny said he didn't have the money. The
Piaget gift was down to $100,000, and combined with the initial pay-
ment of $105,000, they were still short over $150,000. They needed to
find more money.

Altovise didn't want to talk about the settlement. A nurse told her
that Sammy was on television the night before, in a movie called *One
More Time,* which aired on cable. It was an old movie from 1970, but
Sammy sightings were very few, and the mere mention that he was seen
on national television brought a burst of excitement. Sonny returned to
the subject matter at hand. Altovise suggested reaching out to Marlo
Thomas, Eddie Murphy, and Bob Hope, from whom Altovise previ-
ously borrowed $10,000. Sonny didn't hold out much hope for any
more celebrity loans. Calvin shrugged his shoulders and shook his head
from side to side. Altovise owed enough people in Hollywood, and it
was clear, at least to Calvin, that well had run dry. Altovise had another
thought. She reached into her pants pocket and pulled out a letter.

"What's this?" said Sonny.

"You're going out to California next week to talk to the IRS again,
right? I wrote you a letter with an idea."

Sonny took the letter and quickly read through it.

Altovise wanted Sonny to fly to San Francisco to meet with Bill
Choulos. Sonny remembered the name from his files. He was an at-
torney from San Francisco who represented Sammy and Altovise on
several unknown matters, and he was the first attorney Altovise turned
to after Sammy died.

When he finished reading the letter, Sonny looked up at Altovise.

"Choulos has Sammy's eye?"

Altovise wrote in the letter that after Sammy's funeral she entrusted
Choulos with his "prosthesis." She couldn't give it to Shirley, or Sam-

my's children. Altovise suggested selling the eye to raise money to help pay the IRS debt.

"He's a lawyer, right?" said Sonny.

Altovise didn't respond. Her disposition suddenly changed, as reality set in. Only it wasn't the reality of the world learning that she wanted to sell the eye. It was something far more ominous.

Sammy had known Bill Choulos for years. His real name was Vasilios Choulos and he was a powerful attorney who gained fame for representing prominent counterculture figures during the 1960s, including Lenny Bruce, Abby Hoffman, Jerry Rubin, Dr. Timothy Leary.

Choulos also represented another high-profile client, Jack Ruby.

Ruby was the Texas nightclub owner who shot Lee Harvey Oswald in November 1963 as Oswald was being transferred to the Dallas County prison following the assassination of President John F. Kennedy. A stunned nation, grieving over the sudden and tragic loss of its president, watched in horror on live television as Ruby lunged, gun in hand, toward Oswald, who fell, mortally wounded. Ruby's alleged mob connections drew cries of a conspiracy, and it was Choulos who immediately flew down to Dallas with famed attorney Melvin Belli to take on the Ruby defense, pro bono.

The flamboyant Belli was the lead attorney when the case went to trial in 1964, but even Belli couldn't argue Ruby's guilt and he was convicted of murder and sentenced to death. The conviction was overturned in 1966, but before Ruby could be given a new trial, he was transferred to a prison hospital, where he died in January 1967 of lung cancer.

Choulos was also involved in the brazen escape of a suspected CIA operative from a Mexican prison. Choulos flew aboard a Bell helicopter that suddenly appeared over Mexico City's Santa Maria Acatitla prison in 1971. Inmates were inside, watching a movie, while curious guards noticed that the helicopter appeared to be similar in design and color to the one used by the Mexican attorney general. Believing it was a surprise visit, many of the guards stood at attention. But as the copter set down in the middle of the prison yard, two prisoners ran out of Cell Block 10 and boarded the copter, which quickly took off. The escapees

were Carlos Antonio Contreras Castro, a Venezuelan counterfeiter, and Joel David Kaplan, who had been convicted in 1962 for murdering his business partner, Louis Vidal Jr. Vidal was involved in drugs and gun-running, while Kaplan was a member of a prestigious family that made its fortune in the 1920s selling molasses during Prohibition. Kaplan's uncle, Jacob M. Kaplan, had formed a fund in his name in 1945 for public and private grants. But the J. M. Kaplan Fund, according to a 1964 congressional investigation, served as a conduit for CIA money to Latin America, and Mexican authorities claimed Joel David Kaplan was a CIA agent whose escape was facilitated by agency officials.

Even within the confines of an alcoholic treatment center, Altovise could see clearly that Sammy knew people she did not want to discuss or even acknowledge, and chief among them was Bill Choulos.

"You know what, you're right. Let's leave this alone," she said. "I need to get back to my room. I'm not feeling well."

The drive back to Pennsylvania was quiet. Neither Sonny nor Calvin had much to say. But as they approached the Delaware Water Gap, Calvin decided it was time to tell Sonny about his startling conversation with Altovise the previous winter, when she relayed the intimate, and shocking, details of her troubled marriage.

Sonny couldn't understand the psychology behind subjecting a wife to such degradation and humiliation. Sammy was always portrayed as gentle, trusting, and generous, yet his cruel treatment of Altovise, as described by Calvin, went contrary to common decency, even if she was a willing partner. Sonny didn't have an answer, but whatever the explanation might be, for a moment, he wished he had never met Altovise.

Sonny returned to Los Angeles for another meeting with the IRS on October 28, 1996. He had written the week before, asking for the meeting to finally agree to terms of the settlement. When he arrived, the IRS asked for additional documents, including Sammy and Altovise's 1983 taxes. Sonny was miffed. The issues at hand included settlement of the outstanding tax bill along with submissions for Altovise's returns from 1991 through 1995. He had no idea why the IRS had a sudden

interest in 1983, and their agent Daryl Frerking wouldn't discuss it. The latest wrinkle was yet another irritant in a long, drawn-out process. When Sonny returned to Pennsylvania, there was an urgent message waiting for him from Ann Hoehne.

"It's Altovise," said Ann.

Ann said she was placed on the visitors list at Alina Lodge and drove over to say hello. It was the first time in weeks the two women had seen each other, and Ann thought Altovise looked wonderful. But small talk morphed into a discussion about the ongoing IRS negotiation. The deal appeared simple on the surface but, at its core, was complicated. The government was considering settling the largest individual tax debt in the nation for what amounted to pennies on the dollar, and there was great debate within IRS circles as to whether to accept the deal.

As Ann explained the situation, Altovise quietly took it all in. But she became tense when Ann briefly diverted the conversation to her visit to Altovise's apartment to place her possessions in storage. The year lease had expired, so Ann bought some bins and, with Calvin, packed some of the smaller items while movers took the furniture away.

"Where's my money?" said Altovise.

"What money?" said Ann.

"The money in my dresser drawer," said Altovise.

Ann said there wasn't any money, only old pay stubs from the sweater mill. And if she had found any money, said Ann, she'd have handed it over.

Altovise didn't want to hear it. She insisted there was $250 in an envelope hidden in her drawer, and she wanted it back.

Ann was irate.

"I came here to tell you about all the work that Sonny is doing and how Calvin and I took our time to empty your apartment, and all you're focused on is some money? Do you know how insulting that is?" said Ann. "You need to start appreciating what people do for you and start focusing on other people instead of yourself."

Altovise didn't reply. She was overwhelmed with paranoia and mistrust and directed her anger at Ann and Sonny.

"I want my money," she said before stomping off back to her room.

Officials at Alina Lodge told Ann that Altovise had been arrogant and abusive to the staff, and the tough-love approach was about to get far tougher. Altovise would have no visitors for either Thanksgiving or Christmas. In addition, she could only receive a total of six presents.

Two days later, Sonny and Calvin visited, and Altovise flew into an obscenity-laced tirade accusing them of conspiring with Alice McTeere, the chief nurse, and other Alina Lodge staff to "invade her privacy." Altovise's confrontational and arrogant behavior drove Sonny and Calvin outside, into the car, and back to Pennsylvania. During the drive back they discussed Tracey and her many warnings about Altovise's true nature. Sonny had been on a mission these past few years, and somehow he dismissed what apparently was obvious to others. Once he arrived at the Hillside, he gathered his thoughts, sat down, and composed a letter, which he sent to Altovise, with a copy to Calvin.

Dearest Altovise,

Well, at our last meeting you were demanding, hostile, accusatory, self-absorbed, and selfish. You brought up your missing money—rather than ask about the well-being of your mother and Calvin. You accused Alice of conspiring with me to invade your privacy rather than praise her for being a caring counselor and continued support and inspiration to your life. Rather than express humble gratitude to Alina for financially supporting your recovery for over two years . . . or thank Ann for all the work and effort she puts into organizing and structuring your life. After that last embarrassing meeting, if that was the real you, I was seriously considering discontinuing my association with you. However, out of respect for Mother Gore, Calvin, your late father, Alina Lodge, and all those who have tried to help you, I will give you my unedited opinion of your present condition.

When will your soul be still, quiet, and peaceful so that you find God? Why do you play roulette with disability and death—is it a desire to be forgiven for the past injuries you've suffered, and those you have brought upon yourself and others? Must you meet God through death? . . . Are you consciously destroying yourself in order to find peace? What is the real reason, Altovise, why do you fool yourself again and again? Are you just a spoiled little girl who wants to recapture her long-lost innocence by numbing herself to her adult reality? I have no answer.

For nearly three years I have witnessed and experienced your dishonesty and deceit, both of which have made me feel violated and disrespected . . . you cheat yourself and others, and justify or rationalize your behavior and become hostile when challenged or discovered.

In the past three years and well before that, all your needs have been met and you have been coddled, taken care of, and pampered—how can I continue to feel sympathetic when we all continue to suffer the ups and downs of life? Are you so different and privileged?

Once you prided yourself on telling me that Sammy said, "The one thing you can rely on is that you will always be Mrs. Sammy Davis Jr. That no one can take that away from you."

That was a very arrogant statement, although surely intended to give you comfort and a sense of financial security. Being Mrs. SD has been more of a curse than a blessing.

Writing the letter was a cathartic exercise for Sonny. He had clearly developed an emotional attachment to his pursuit of reviving Sammy's legacy, one he believed was important. But Altovise's recent actions and accusations made him numb, and he knew he couldn't continue unless Altovise realized the reason for all this work and effort was not to elevate her back into the stratosphere of Hollywood, but to restore Sammy's

estate. Sonny also had to convince his new wife, Patricia, that his cause was just and important. Patricia had traded a thriving law career in bustling Hong Kong for a life in the rural Poconos with Sonny, Mama, and the Judge, and the culture shock, along with Sonny's constant trips to California, put a strain on the young marriage. Patricia was also a lawyer, and while acknowledging Sammy's international appeal, she tried to convince Sonny that Altovise indeed was deceitful and not worthy of his efforts. And from a business point of view, he hadn't been paid a dime. Sonny explained that, for now, it wasn't about the money, and he promised that once the IRS debt was settled, the traveling would stop and he would devote more time to the marriage.

Altovise wrote back a week later. In her letter to Ann and Sonny, she wrote of making snowballs in the kitchen at Alina Lodge and cooking sausage and peppers and zucchini and squash for the fifty other patients there. She thanked Ann and Sonny for their "thoughtfulness in helping emptying [her] apartment" and for helping readjust her feelings and thoughts toward a more positive attitude to "accomplish" a dream, and that was to one day soon restore her husband's rightful place in history.

> To grow and change is a continual transformation and its constant struggling and developing. It's always uncomfortable to change but well worth the results. I thank you all for caring . . . I'm determined to get to the miracle that comes through help from others and suggestions and prayer and meditation.

The letter, at least on the surface, appeared hopeful. Perhaps, thought Sonny, his harsh words and those from Ann finally would help Altovise turn the corner and confront her demons. She had shown this side before, after her discharge from her first stay at Alina. But this could be different, thought Sonny, the breakthrough he'd been waiting for, and perhaps Altovise was finally on a firm road to being sober.

So Sonny spent the Christmas holidays warm in the knowledge that he was on the verge of settling the financial affairs of an international

celebrity and, more important, saving the life of his widow. But with the turn of the New Year came new problems. Calvin received an angry call from Alice McTeere, the chief nurse at Alina Lodge. Altovise had been caught facilitating liaisons between male and female patients, serving as a sort of matchmaker and smuggling people back and forth between the male and female wings. When officials got wind of what she was doing, they conducted a full body search and found lithium hidden inside her panties.

It was the last straw for the nurses and caregivers at Alina Lodge, said McTeere, and Altovise had to go. Calvin tried to call Sonny, but he was in New York for a meeting with Vince McMahon, the head of the World Wrestling Federation. McMahon was considering a public stock offering for the WWF but had several security issues to rectify. A friend, Neville Meyer, suggested to McMahon he talk to Sonny, whom Neville described as a former federal prosecutor. Meyer ran a production company out of Westport, Connecticut, and had pitched Sonny on a Sammy movie as told by Altovise. Sonny didn't think much of the idea, but he took the meeting with McMahon, and it lasted most of the day. When Sonny returned to the Hillside that night, Calvin was waiting for him in the lobby.

"We have a problem," he said.

Sonny drove to Alina Lodge the following day. It was brutally cold, perhaps the coldest day of the year. It was equally chilly when he walked inside Alina Lodge. The caregivers and officials there were fuming. For nearly two years they worked their hearts out for Altovise, caring for her through countless meetings, discussions, and treatments. They didn't even bicker about her unpaid bill, which now topped $30,000. Their mission was to get Altovise well, but they failed, as did Altovise. It was one thing to break a rule, but it was intolerable to break a rule and affect other patients. Alina Lodge did everything it could for Altovise and extended every bit of kindness and love and attention, but she returned that love by destroying everything Alina Lodge stood for. Now, they just wanted her out.

Sonny felt horrible. He saw and heard their bitter disappointment.

Two custodians, their hands filled with several boxes of Altovise's personal items, led her from her room and into the lobby. As she approached Sonny, she looked down toward the floor, unable to look him in the eye, and she said nothing as they followed the custodians to the car, where they placed the boxes in the backseat. Altovise slumped into the front seat, and Sonny slammed the door behind her. He got into the car, turned the ignition, and they drove to Pennsylvania, where Sonny dropped Altovise off at Calvin's home.

"How could you do this," Calvin said. "After all this time, and all this help, this is how you repay Alina Lodge? Do you have any idea how much money we owe them? They virtually did this for free, and this is how you repay their kindness?"

Calvin knew that Sonny, too, was angry. He could see it in his look and demeanor. He had given his time, effort, and good intentions, and Calvin was personally insulted by Altovise's actions. This wasn't about being sick. This was about respect, he said, especially for the people who tried to help her, particularly Sonny.

Calvin leaned in closer to Altovise, whose tears looked like gumballs as they fell off her cheek.

"What did he say to you?" said Calvin.

"He said I had no place to go, that you didn't want me back, and that I was homeless, and that I should remember this day forever," she said.

"And everything you own is here. That's all the stuff you have to your name. This is what's left of Mrs. Sammy Davis Jr.," said Calvin.

Altovise went to her old room, locked the door, and refused to see or talk to anyone for days. She finally emerged nearly a week later, walking over to the Hillside on another bitterly cold night, wearing only a T-shirt, short pants, and knee-high socks, each sock a different color. Oblivious to the twenty-degree temperatures, Altovise walked inside the lobby and stuck out her hand to a woman standing there.

"Hi, I'm Mrs. Sammy Davis Jr."

The surprised guest took a step back, unsure of what to do or what to make of this clearly inebriated woman. Mama saw the exchange from behind the front desk and she quickly ran out into the lobby.

"Altovise!" she said.

Mama wrapped her arms around her and squeezed tight.

"It's so good of you to come visit with us tonight," she said, loud enough for others to hear.

"I want to introduce you to my guests. This is an honor for us, having Mrs. Sammy Davis Jr. in our hotel."

"No, the honor is mine, Mama Murray," said Altovise.

Mama put her arm around Altovise and introduced her to several guests, including the woman Altovise surprised upon her arrival.

"Please say hello to Mrs. Sammy Davis Jr.," said Mama.

"Oh, my," said the woman. "I wasn't sure what to do when you said hello. It wasn't that I didn't believe you, but I'm very happy to meet you."

Mama led Altovise through the lobby and into the dining room for more introductions, and then downstairs to the recreational rooms, where men shooting pool and playing Ping-Pong stopped their games to talk to Altovise, who entertained the guests with Sammy stories long into the night.

Sonny arrived around midnight and rushed inside to find Altovise sitting in the dining room surrounded by a dozen people, all listening intently as she relayed details about the 1980 "Party of the Century."

"We had Liza and every sports star you can imagine, like Namath and O. J. and Chamberlain. It was simply fabulous!" she said.

Sonny turned to Mama, who stood near the doorway.

"She showed up here a couple of hours ago looking for you. I thought I'd introduce her. The guests love her, the poor soul," said Mama.

"Mama, she's drunk," said Sonny.

"I know, but she's enjoying the attention," said Mama. "Look at her."

CHAPTER 13

The group of youngsters sat six wide and five deep. They ranged in age from seven to fourteen, and all had their eyes and ears directed toward the tall man with the piercing eyes and deep, booming voice.

The Hillside had another full house—including a church group from The Bronx—and the Judge, as he always did, gathered the children in the dining room to deliver his usual speech about pride, education, and ownership.

It was a speech Sonny had heard a million times—Don't complain, do. Stay in school, all the way through college. If you can't afford college then find a way to pay for it through grants, tuition reimbursements, scholarships, financial aid, whatever it takes. Education, said the Judge, was the key to success. And once you finished schoolwork, save and then own.

The Judge told the children that they, like their parents, were consumers, people who spent every hard-earned cent on goods and services. But they weren't building wealth, and it was important to understand that education and ownership were the keys to success.

The Judge bent over, his hands to his knees, and leaned toward the children for effect.

"Give a man a fish, he eats one meal. Teach a man to fish, he eats for the rest of his life. Ownership," whispered the Judge, "lasts forever."

The letter Sonny received from the IRS in February 1997 brought a rush of hope and excitement. After nearly three years of negotiations, the government was ready to settle the tax case between the United States of America and Sammy and Altovise Davis.

Altovise would pay $350,000 to the IRS, of which $105,000 had already been paid, leaving a balance of $245,000 to be paid in installments over two years, at 6 percent interest until paid in full. The deal also included a Future Income Collateral Agreement, or FICA, in which the IRS would receive 40 percent on all earnings over $100,000 until 2003. Sonny said he still had no idea as to what Sammy's estate really owned, which greatly limited an accounting of what he could possibly earn. In return the government would agree to settle the $7.2 million tax debt and release all liens placed on Sammy's name, likeness, and estate, as well as turn over the name and likeness to Altovise. She would also receive the rights to Sammy's books, music, and movies. Once signed, letters would be mailed to Herb Sturman, Shirley Rhodes, and John Climaco, informing them they no longer controlled the estate for the IRS. Money that had dribbled in over the past seven years would now go to bank accounts controlled by Altovise.

The end of a lengthy battle to resolve the IRS debt was at hand, and Sonny could feel the rush of excitement. Once the IRS fight was over, Sonny could begin to restore Sammy's legacy, and his head was full of ideas, and he envisioned immediate success.

Quincy Jones still owned the option to produce a Sammy Broadway musical, and discussions were under way with producer Gary Smith for a television mini-series based on Sammy's life, which could pull in $1 million. It was Mark Davis who introduced Sonny to Smith, who knew Sammy back in the 1960s when he produced the musical variety show *Hullabaloo* and later worked with Sammy a dozen more times on various shows and specials. Smith and his partner Dwayne Hemion were two of the most experienced and powerful producers in Hollywood, their extensive credits including dozens of variety shows, the Tony Award shows, and the People's Choice Award shows. Their lack of feature-film experience didn't discourage Sonny, who liked Gary immediately.

Sonny also expected to fetch $1.5 million for a theatrical film deal, at least $500,000 for advertising, $250,000 for Sammy's film collection, and $250,000 for Altovise's book rights.

In all, Sonny envisioned grossing over $5.3 million in one-time fees for projects using Sammy's name and likeness. Still in limbo were expected revenues from Sammy's royalties and residuals from his extensive record and film catalog. Several record companies apparently stopped sending royalty statements soon after Sammy died, one of which was Curb Records. Owner Mike Curb was a former singer and record producer who produced Sammy's 1972 megahit "The Candy Man." Sammy hated the song and did only one take. But when it was released, it reached the top of the charts and became his most recognizable hit. "The Candy Man" remained popular through the years on the radio and it was also heard in various television and film productions. Every time the song was played on the radio or optioned for a film, it generated a royalty.

Forensic accountant Jay Shapiro, who had been working to determine what Sammy owned and didn't own, found that Curb, not Sammy, had the rights to "The Candy Man" and the only royalty Sammy received was for his performance, which was far less than it would be had he owned the song. Altovise claimed that she spoke with Mike Curb about the absence of the royalty statements following Sammy's death, and despite several promises to correct the situation, he didn't. Altovise said Curb then claimed his royalties department didn't have a current address for Altovise and thus nowhere to send the statements and checks.

Shapiro demanded that he be allowed to audit all royalty statements issued since Sammy's death. Curb initially resisted but eventually gave way to Shapiro's audit, which by law allowed for a review of a recent two-year period. Shapiro selected an auditing window of 1993 to 1995, but the audit started off slowly, because Curb kept its records in different offices, which took time for Shapiro to track down and compile. But when it was completed, the audit revealed that Sammy was owed over $75,000. Shapiro also determined that Curb had shorted Sammy: the

royalty statements amounted to 35 percent less than what Sammy was really owed. The practice had apparently gone on long before Sammy's death, said Shapiro, but by law he was only allowed to demand shorted monies from the audit window, even though it was clear that Curb had been shorting Sammy's royalty check for years.

Shapiro thought it was insulting. Sonny thought it was representative of how Sammy was typically treated. Curb didn't agree with Shapiro's assessment and promised a legal battle.

"We'll deal with that later," said Sonny.

Sonny was busy with other matters in preparation for the final release by the IRS. He hired a writer to complete a book proposal on Altovise's life, which he planned to sell once the OIC was settled, and he was working with Quincy Jones in preparation for a Sammy musical, in which Altovise could legally take part. Sonny also wanted to prepare Altovise for the onslaught of media questions that would surely follow once the settlement was announced. Sammy Davis Jr. had been out of the public eye for seven years, and Sonny knew there would be great media interest. He also knew that Altovise often had difficulty remaining focused and could not coherently answer random questions about her life. To help her prepare for the expected interviews, Sonny, Calvin, and Ann drew up a lengthy list of questions, many of them deeply personal and probing, and Altovise sat down, pen in hand, to answer.

Did Sammy ever abuse you?
Physically, no. Mentally, I think we all fight.

Did you ever cheat on him?
No. He knew when I went out with someone. He encouraged it.

Did Sammy have a dark side? Devil worship or anything like that?
Sammy was a man who wanted to know about everything. Read about devil worship, read about Shakespeare, art work, poetry, etc. He was interested in devil worship. Went to an occult museum in London. It was a brief passion.

What about the complaint in the Los Angeles Police Department claiming you stole jewels, furnishings, and other valuables from the estate. Where are those things?

I don't know what that was about. IRS said some of those things were mine. Shirley had a caravan of 250 people looking at the house. It was listed by two different realtors. One of the realtors was the cousin of John Climaco.

Where is Sammy's glass eye? His guns?

Bill Choulos in San Francisco is holding his glass eye. Shirley wanted it. Murphy wanted it. Bill said he would keep it safe. IRS took the guns. I gave two or three to Carter, two dueling pistols and a Smith & Wesson. I was a very good shot. I shot someone who got over the fence, saw him on the surveillance camera.

How much of Sammy's jewelry do you have?

If I get Al Carter, I guess I can get the rest of it back.

Is Manny Sammy's natural child?

Don't want to get into that right now.

Is Jeff Sammy's real child?

No.

Is Mark Sammy's natural child?

Up for grabs. Pass on question.

How much money do you have now?

None. Living on SSI and minimum-wage jobs.

Did you go to Dean Martin's funeral?

No.

Did Frank Sinatra give you money? How much? When? What did you do with it?

No.

Didn't Sammy leave you insurance? How much?

Yes, one million. I bought a house and the IRS took it.

Who participated in the orgies at the Summit House?
No answer.

We heard you were in a mental institution?
Every day of my life.

Who is Al Carter? Did you and he steal money from charities?
Al Carter was someone Sammy hired to work as a performer. He was a singer with his wife, Patrice. Both were hired. Did we steal from charities, no. Al Carter stole money from me. Quite a bit from me. He said he would hold it and it would be safe.

Did Sammy have girlfriends?
Sammy had a lot of friends. Lots of girlfriends.

Who is John Climaco?
One of the executors, a lawyer from Cleveland. Don't know how they met. He was working for the Teamsters. Sammy hired him to represent us and corporation. He got us into a lot of bad deals.

People say you were a bimbo?
Thought that only applied to blondes.

People say you deserve what you got?
Got the greatest entertainer in the world. Yes, I deserved that.

Who are the celebrities you still consider your friends?
Liza Minnelli, Clint Eastwood, Suzanne Pleshette, Madlyn Rhue, Burt Reynolds, Nancy Sinatra, Dionne Warwick, Gladys Knight, Leslie Uggams, Michael Jackson, Carroll O'Connor, Vidal Sassoon, Fred Hayman of Giorgio's.

Sammy liked white women, especially blondes. How do you feel about that? Was he like other black entertainers who like white women?
Sammy liked all women. He was a womanizer. He would tell a woman walking down the street she looked great today.

What was the worst time in your life?
When Sammy isolated himself with the Nixon thing.

The list and Altovise's answers were reviewed, critiqued, and updated three days later with additional questions about her relationship with Sammy's children, which she said was lukewarm, and her and Sammy's drug use, which she admitted to.

"Everybody did drugs," she said.

Some of Altovise's answers were honest and poignant while others, particularly those about devil worship, her affairs, and the true parentage of Sammy's sons, would have to be edited down to "no comment."

Sonny also devised a mock television interview and had Altovise sit down and verbally answer a similar list of far-ranging questions. Her answers to more than half of the one hundred questions were a "No comment," "That's too personal," or "I don't recall." Clearly, there was work to be done to get Altovise comfortable discussing her life in public. So Sonny hired a "media coach" to help Altovise crystallize her answers to thirty-second sound bites. Near the end of the session at the Hillside, Sonny was told he had an urgent phone call.

It was the IRS, and the deal was done.

Hilliard Elkins was sitting in his office next door to the Majestic Theater in New York when the phone rang. It was Harry Belafonte calling, and he had a special request. Dr. Martin Luther King Jr., he said, was marching in Selma, Alabama, and Dr. King would be grateful if Sammy would join him in support.

"We need him, Hilly," said Harry.

Civil rights leaders were in the midst of their fifty-five-mile walk from Selma to Montgomery, the state capital, where Dr. King planned to carry a petition to Governor George Wallace, demanding voting rights. But Wallace had refused a permit for the march and he put the state police and highway patrol on alert, and on the first day, a Sunday, state troopers attacked the marchers using tear gas and batons and clubbed many to the ground. Bloodied and battered, the marchers retreated on that "Bloody Sunday," but they planned to march again, this time with Dr. King leading the way. They were met by the state troopers, shots were fired, and a white pastor was killed.

Dr. King sent out a dire message for help, particularly from high-profile people, black or white. And that included Sammy, who had joined Dr. King for several previous events, including the 1963 March on Washington for Jobs and Freedom. That march drew over 500,000 people and was made famous as the occasion on which Dr. King delivered his seminal "I Have a Dream" speech, expressing his vision for a world without racial barriers. Now Dr. King was call-

ing again, only instead of peaceful protests, Sammy and millions of others saw on television the violence that marred the Selma march.

At the time, Sammy was starring on Broadway in Golden Boy, *a play about a black boxer who falls in love with a white woman, which earned raves from the critics. Despite a rigorous schedule of nightly performances and matinees, Sammy still found time to rehearse, and he was on stage when Hilly took Belafonte's call in his office next door to the theater.*

It was Hilly who persuaded Sammy to return to Broadway nearly a decade after his success in Mr. Wonderful. *Hilly was an agent at the William Morris Agency and one of many with whom Sammy had worked in the 1950s. Hilly sought a career change and turned to producing, and he took a popular 1930s story about a boxer following his ambition but losing his soul and adjusted the role to Sammy and the turbulent racial times.*

The play featured the first kiss on stage between a white woman and a black man, which Hilly dubbed "the assassination scene"—for all the death threats Sammy received. The song lyrics also provided social and political commentary on the state of race relations, with Sammy singing: "Who do you fight/when you want to break out/but your skin is your cage?"

Following weeks of rehearsals, Golden Boy *was a hit, and Sammy was comfortable performing live on Broadway while living in New York with May and his children. So when Hilly walked into the theater to deliver Dr. King's request, Sammy's response was cold and direct.*

"No fucking way," said Sammy, images of bloodied protesters being mauled by Alabama state troopers still fresh in his memory.

"But Sammy, it's Dr. King himself that's asking you," pleaded Hilly.

"I'm not going to Selma, Alabama, or anywhere else in the South. I don't want to get killed," said Sammy.

"You're not going to get hurt. Every major show business celebrity will be there. I'll be there with you," said Hilly.

"Tell you what. Tell them you can't afford it and we can't leave the show. Got it?" said Sammy, and returned to his rehearsal.

Dejected, Hilly walked back to his office next door to the theater. He and Sammy had disagreements before, particularly over Sammy's burgeoning relationship with Lola Falana. Hilly couldn't understand it, and he'd ask Sammy, "What the fuck are you doing?"

"Waddya mean?"

"You got a beautiful wife at home. I don't get it."

"Nothing to get."

Hilly picked up the phone and called Harry.

"We have a problem," said Hilly. "Sammy won't do it. He's frightened. He wanted me to tell you we can't afford to leave the show."

"Can you?"

"Of course we can't afford it."

"Okay," said Harry. "I have an idea."

Minutes later Hilly walked back downstairs into the theater and stood quietly at the front of the stage.

"What?" said Sammy.

"Harry bought out the show," said Hilly.

"He did what?!" cried Sammy.

Now Sammy had no choice but to board a plane with Hilly for the quiet yet stressful flight to Alabama.

President Lyndon Johnson called the events in Selma an "American tragedy" and promised to send a voting rights bill to Congress. And despite objections from Governor Wallace, Johnson federalized the Alabama National Guard along with two thousand U.S. Army troops and ordered them to protect the marchers.

Sammy arrived following a changeover in Atlanta and he and Elkins were met by Bull Connor, Birmingham's former police chief. He was also a member of the Ku Klux Klan, a self-described segregationist, and currently Alabama's public service commissioner. Sammy dove into a waiting car, and the drive to meet the marchers, who were nearing Montgomery, was nerve-racking. Racist

posters and billboards lined the road, and many people carried handguns and rifles. Sammy and Hilly plunged straight into fear-tinged chaos. Thousands of people had joined the march, which was scheduled to culminate the following day with a speech by Dr. King on the capitol steps. Yet the festive atmosphere and goodwill present during the March on Washington was replaced by sheer terror as rocks, eggs, and other projectiles were thrown at the crowd. State troopers stood ready, dressed in riot gear, and on occasion a car would drive onto the road and into the marchers.

An impromptu concert was arranged that night, and Sammy joined other performers on a makeshift stage where he sang "God Bless America" before he was escorted to his "blacks-only" hotel. For the final march, Sammy joined Dr. King, Belafonte, Leonard Bern-stein, Tony Bennett, and thousands of others in the assembly area, and when they finally arrived at the capitol steps, they were greeted by a Confederate flag flying high above, next to the American flag. Dr. King slowly walked up the stairs of the capitol building, turned to the masses, and delivered another speech that mesmerized the nation. Sammy was awestruck. His shoes were covered in dirt and mud, and his shirt was wet with sweat, but his fear and terror were replaced by inspiration brought on by the sight and words of Dr. King.

Sammy was deeply moved, and thankful to Hilly that he didn't miss one precious moment of this historic event. On the flight home to New York, Sammy remained by a window, staring into the sky and smiling, his thoughts still back in Alabama.

April 24, 1997

To Whom It May Concern:

The Internal Revenue Service is providing this letter to Altovise Davis for her use in exercising her rights as the residu-ary legatee of the Estate of Sammy Davis Jr. Altovise Davis has entered into an Offer in Compromise with the Internal Rev-enue Service concerning the collection of certain taxes. In that

regard, the Internal Revenue Service has or is in the process of releasing all levies made prior to the date of this letter.

Please cooperate with Altovise Gore Davis, a/k/a/ Mrs. Sammy Davis Jr., concerning any and all rights she has as residuary legatee or in any other capacity in exercising control over the assets of the Estate of Sammy Davis Jr. including, but not limited to, the following:

The rights and claims to the likeness and image of Sammy Davis Jr.

The rights and claims to the residuals and royalties of Sammy Davis Jr.

Sincerely yours,
Los Angeles District Director
Internal Revenue Service

Media from around the world carried the news: The estate of Sammy Davis Jr. had finally been settled. After seven long years, Sammy's name, image, and likeness were returned to his widow. The news stories included quotes from Sonny, who blamed the tax problem on a coal tax-shelter that was disallowed by the IRS in a ruling by the United States Tax Court. Altovise also provided a comment in a two-page press release announcing that "Altovise Gore Davis, widow of Sammy Davis Jr., settles with IRS."

"Sammy was a fighter and I know he would have wanted us to reach a settlement with the government rather than declare bankruptcy. He loved this country and the people in it, and recognized his responsibilities as an American. Although I have my personal challenges and still grieve over his loss, it is important that I use my best efforts to amicably resolve the various financial liabilities of Sammy's estate."

The announcement spurred a tidal wave of phone calls and faxes from television and film producers, advertising agencies, entrepreneurs, the famous and not so famous, all now looking to do business with Mrs. Sammy Davis Jr. In the ensuing months dozens of offers, large and small, were presented to Sonny and Altovise. Among those expressing inter-

est was the former Los Angeles Lakers basketball star Magic Johnson, who had a television division at Twentieth-Century Fox, Magic Johnson Entertainment, and wanted to produce a movie based on Sammy's life story as well as explore other "opportunities" that might be available. Merv Griffin Entertainment was also interested in acquiring the rights to option Altovise's life story for a film, along with publishing rights to a book. Tri-Star Television producer Stanley Brooks, and Hilliard Elkins, who produced Sammy's *Golden Boy,* also vied for film and television rights. Premier Artists Services wanted the rights to any available Sammy recordings, while Bill Cosby wanted to finalize a deal to release *Two Friends,* a video of the 1983 Broadway show by the same name starring Cosby and Sammy. Cosby told stories and jokes, Sammy sang and danced. Cosby already paid a $25,000 advance to Sammy's Transamerican Entertainment in 1988 and wanted to work out a new deal.

Others called or sent letters inquiring about a variety of Sammy-related issues, from negotiating record deals to gaining permission for use of Sammy film clips to marketing and licensing. Mark Roesler, who headed Curtis Management Group, sought to represent the legal, marketing, and financial business of the Sammy Davis Jr. estate. Roesler, who had recently testified as an expert witness on behalf of Fred Goldman in the O. J. Simpson civil trial, said he represented a large group of deceased individuals who "shaped the twentieth century," including Marilyn Monroe, James Dean, Humphrey Bogart, and Greta Garbo, and he wanted to add Sammy to his client roster.

Ron Weisner, who had co-managed Michael Jackson, called to inquire about putting together a box set of Sammy's music. Weisner said he'd handle everything from getting the record contract to remastering the tapes, creating the package and commemorative book, coordinating all press, and giving Sonny and Altovise a say in the final selection of songs that would be included in the set. In return Weisner sought 10 percent of the gross deal, which he believed could fetch upward of $400,000.

Oprah Winfrey's Harpo Productions wanted permission to use a film clip of Sammy kissing actor Carroll O'Connor in the famous 1972

episode of *All in the Family*. Another production company, LMNO, wanted permission to use a clip of Sammy from an appearance he made on the soap opera *One Life to Live* to use in an *Intimate Portrait* program on actress Judith Light.

An artist, Tina Allen, wanted to create a twenty-five-foot-tall bronze statue of Sammy that would be part of a memorial in Las Vegas. The statue would be mounted on top of a wading pool with fountains and washed in reflecting lights. Another firm, Virtual Celebrity, wanted the rights to make a computer-generated "digital clone" of Sammy for future licensing. The technology had been successfully used in the film *Forrest Gump*, where images of Presidents John F. Kennedy and Lyndon B. Johnson, along with John Lennon, were successfully intertwined in the narrative. While the technology was new and still being perfected, Virtual Celebrity sought to license the rights of several stars, including Sammy, and offered a $50,000 advance and 30 percent of any profits.

Other, more minor requests, also followed. The Mighty Mighty Bosstones, a platinum-selling ska band from Boston, asked for permission to use Sammy's likeness in a music video that would feature other members of the Rat Pack, including Frank Sinatra, Dean Martin, and Peter Lawford. The producers of the upcoming film *Lethal Weapon 4* planned to reunite Mel Gibson and Danny Glover yet again and offered $50,000 for the use of Sammy's song "I've Gotta Be Me" for the movie soundtrack.

Perhaps one of the more unusual, exciting, and possibly bizarre opportunities came from a firm called Global Icons. A licensing and marketing company based in Los Angeles, Global Icons represented the estates of a select group of dead celebrities, including James Cagney, George Burns, and Clark Gable, and wanted to pitch Sammy as a spokesman for the M&M/Mars candy company. The idea was to use Sammy's most popular and successful song, "The Candy Man," as the soundtrack for commercials featuring a Sammy cartoon character that would sing, dance, play instruments, and entertain. The smiling Sammy cartoon could also appear on candy wrappers as a "seal of approval" for Mars. Another, more controversial idea, centered around

the M&M's brand. The candy-coated chocolate came in several different colors, but Global Icons said it noticed that the brown-colored M&Ms were conspicuously absent from advertisements and merchandising. To rectify that, Global Icons suggested introducing the brown M&M with Sammy's voice, mannerisms, and personality. Global Icons offered Sonny a $50,000 advance and the bulk of the profits. Global Icons would charge a fee of 10 percent of all revenues up to $5 million, and 12.5 percent of profits over $5 million. The deal could easily reap seven figures, they said.

After three years of Sonny's toiling in virtual darkness, the IRS settlement served to flip the switch that turned on the light, and Hollywood responded with the quickness of a python, latching its jaws around Sammy. Sonny was overwhelmed by the offers, and his future income projections for Sammy's estate soared. But the overwhelming yet unexpected interest created a major problem. Since the IRS settlement required Altovise to pay a percentage over any gross income of $100,000 during a single tax year until 2003, Sonny decided he needed to minimize her exposure and keep her gross earnings as low as possible. That meant structuring deals that would, legally, begin with minimal payments over the life of the five-year FICA. Once the five years were up, Altovise could reap 100 percent of all income. The plan, on the surface, was a good one. The problem was convincing Altovise.

With the IRS finally off her back, Altovise saw the settlement as her ticket back to a world she hadn't seen for seven years. She immediately flew to Los Angeles to reconnect with old friends and later interviewed with *Variety*'s Army Archerd, who reported that she had several lucrative deals under consideration. When Sonny read the story, he was furious. The IRS had no idea of the wide interest in Sammy Davis Jr., and Sonny braced for the angry phone call calling off the settlement. The call never came, but Sonny reminded Altovise that she had to maintain a low profile and not say anything that might be construed as a violation of the settlement, or else the IRS could terminate the deal and the $7.2 million debt would be reinstated. Sammy's name and likeness would once again revert back to the IRS, and most likely never return.

Sonny's concern also extended to his growing legal bill, which now topped $416,000 due for his three years of representation. He charged a discounted rate of $200 an hour, and to date hadn't collected a cent. From the onset, during that first meeting on Calvin's backyard deck, Altovise and her parents agreed to pay Sonny once he resolved her debts. Now that the IRS debt was settled, Sonny knew it would take at least a year or two before any substantial income would flow into the estate.

Sonny made the $25,000 down payment to the IRS on July 18, 1997, which left only $23,000 remaining from the Piaget loan, and $200,000 was needed within two years to pay the remainder of the debt. Given the possibilities now before him, he was sure the final payments would be made. There were still several other issues to settle, particularly the $1.7 million owed the state of California for back taxes. Sonny made an offer to settle, one that was similar to the IRS deal. But California required a FICA that Sonny deemed excessive, and he rejected the offer. Since California had jurisdiction only over contracts executed within the state, Sonny decided all business would be conducted outside California, leaving that tax debt in limbo until an agreement could be reached. Besides, Sonny knew the IRS settlement was far more important, since it held jurisdiction throughout the United States and the world.

With the next payment due the IRS in 1998, and some money remaining from the Piaget loan, Sonny created a budget he believed would hold Altovise over until he could complete some of the pending deals. The budget included payment of Altovise's bills, including rent, auto insurance, telephone, cable television, food, and a small down payment for a new home for her in Pennsylvania. Altovise was still drinking, and her health was still a major concern, along with her mental stability. She was working two part-time jobs for minimum wage, and her weekly income of $120, together with a monthly social security check of $1,100, gave her some money. The jobs also provided much-needed structure, and she continued to attend daily AA meetings.

But the IRS settlement spurred a troubling change in her demeanor. Altovise clearly wanted her old life back, but Sonny explained that was a life that was gone forever, a life that died along with Sammy. Instead,

Sonny told Altovise to prepare for a successful, though modest career maintaining and expanding Sammy's legacy. After all, Sonny said, it was Sammy who was the star, and it was Sammy who was loved and admired worldwide.

Anticipating the new revenue streams, Sonny also created a company for Altovise called AGD Enterprises. Another organization, the Sammy Davis Jr. Foundation, a nonprofit charity, was also formed. The idea for the foundation was to have members of Sammy's family, including Altovise and his children, participate. But it required a truce between the family members, which had yet to be reached. Tracey Davis claimed that she and her siblings owned the rights to Sammy's books, and Sonny was taking legal steps to preserve what he believed were Altovise's rights to her husband's works.

Sonny was also involved in a dispute with HBO. When Tina Sinatra, whose company handled all the licensing for her famous father, called to congratulate Sonny on the IRS settlement, she said HBO was planning a Rat Pack movie and she wanted to quash it, since HBO didn't reach any type of agreement on payment for the use of Sinatra's music.

She hoped Sonny, as representative of Sammy's estate, would follow her lead.

Tina also told Sonny he had a mountain of work ahead of him gathering Sammy's music, since notices had to go to each company informing them of the settlement. Sonny said he had already begun the process of investigating what, exactly, Sammy owned, and he was expecting an answer in the near future. In the interim, Tina suggested that Tracey, not Altovise, was the best person to help Sonny. But since the longstanding ill will between Tracey and Altovise had not been resolved, Tina encouraged Sonny to call Quincy Jones to see if he could finally bring the two women together. Quincy, said Tina, was a genius and if anyone could bring healing to the situation, it was the powerful Quincy Jones. Tina also told Sonny to contact Mort Viner at International Creative Management. Mort was Dean Martin's longtime agent and continued to control Dean's business affairs for his estate. Unlike

Sammy, Dean Martin died a rich man and his estate was worth tens of millions. If anyone could help Sonny navigate the shark-infested waters of music publishing, it was Mort Viner, said Tina.

Upon receiving notification from the IRS that a settlement had finally been reached, attorney Herb Sturman began the legal process of terminating the reign of executors Shirley Rhodes and John Climaco. In his filing to the Los Angeles Superior Court, Sturman reported that the executors paid the IRS $387,711 over the five-year span from the date the estate was declared insolvent in August 1992 to the present, less their commissions and legal fees. In addition, Altovise would receive what was left of the estate, which included 6.8 shares of Transamerican Entertainment Corporation stock, a 100 percent interest in the Will Mastin Trio, Inc., 250 shares of Monsanto Company, limited partner interests in several ventures, and miscellaneous items consigned to Butterfield & Butterfield, which Sonny had already recovered.

While the health of the Sammy Davis Jr. estate improved, the fortunes of the Hillside were going in an opposite direction. Business had been good since the new construction in 1989, with every room filled from spring to fall and most weekends during the winter. Often, the problem was a room shortage, which meant lost profits. Sonny had begged the Judge prior to the new construction to build more than the thirty-three rooms, but the Judge just wanted to build what he could and open it. The Judge always thought Sonny was a dreamer and never one for practical decisions.

"I know you see the future, but I don't have the money for the future. I got $2.2 million and I can only build with what I got," said the Judge.

So the Judge built his thirty-three rooms, an indoor pool, recreation room, and dining room, and he and Mama couldn't have been happier. But the Judge didn't pay attention to the upkeep of the Hillside. For many of his guests, the Hillside was all they had, and the Judge reasoned that the demand would always be there, so why put money into something if you didn't have to, even when guests began complaining

about the condition of the resort. Some rooms weren't cleaned properly—some needed a fresh coat of paint—but the Judge would always respond with "Where else you gonna go?"

The Judge felt strongly about the Hillside and its history and believed he and Mama were owed a debt of gratitude. His stubborn management style and personality prevented him from entertaining a firm offer in 1997 from the Marriott Company, which approached the Judge about buying the Hillside. Marriott sought diversification in the operation of their properties and was actively seeking minority-owned hotels. The idea was to buy the Hillside, give it a facelift, and then let the Judge, Mama, and Sonny run it. Marriott officials even came to visit, but the Judge was inflexible. He refused to listen, was hard-headed and controlling. He wanted to keep the Hillside as it was, which to him meant keeping chicken and ribs on the menu. So he said no. When he reconsidered months later, the offer was off the table, and the Judge's failure to keep up with promotion and marketing began to take its toll. Adding to his woes was the lack of a computer reservation system, and no database of mailing lists. More important, business was beginning to falter.

The Judge told Sonny that he and Mama were tired of the grind of running the Hillside and they wanted him to select a management team to take over. But the timing wasn't good. In addition to representing Altovise, Sonny was building a clientele that veered him further into entertainment and entertainment law. Sherry Lansing at Paramount wanted to begin production on the Double-Dutch film *Jumpin'* Sonny was producing with Norman Lear, and Vince McMahon hired Sonny to work on a security issue within his World Wrestling Federation. Sonny was also representing Shelby Starner. A local recording engineer who recorded the then eleven-year-old heard about Sonny's entertainment connections and thought he could do something. Sonny was floored by Shelby's age—and voice—and he helped produce a demo tape he took with him on a trip to Los Angeles for a meeting with the People for the American Way. Following the meeting, he attended a party at the

home of another PFAW member, David Altschul, who was a vice president with Warner Bros. Records. During the party, Sonny quietly took Altschul outside to his car and played Shelby's demo, which Altschul thought was fabulous. They rushed back inside and Altschul played the tape for several other music people, and they all agreed that Shelby was a budding star. But Altschul wanted his New York people to opine, so Sonny set up an audition at Shelby's parents' East Stroudsburg, Pennsylvania, home, where she played the piano and sang original compositions. The executives immediately agreed to finance the recording of more demos, which Sonny produced and delivered to Altschul.

While Sonny awaited word from Altschul and Warner Bros., he was being wooed by Dionne Warwick, who had her own tax problems and knew about his success with Altovise. Sonny met with Dionne at her home in California and they talked about her past career and her future. Dionne was one of the most successful female singers in America, with several Grammy Awards and numerous Top Ten hits to her credit. The engagement ended when Dionne refused to pay Sonny and finalized the settlement herself.

Amid all of his business dealings, Sonny also thought about his promise to Yves Piaget to bring Sammy's family together. The anger and resentment ran deep, especially between Tracey and Altovise, and it was interfering with Sonny's ability to close several deals, particularly a film on Sammy's life. Tracey's ownership claims of Sammy's books led to the original deal with Quincy Jones, who still wanted to produce a musical. Sonny decided to meet with Quincy at his Los Angeles home to press Altovise's rights to the books. Sonny believed that copyright laws clearly gave Altovise 25 percent of the books, with the children splitting the other 25 percent. Together, the percentages made up the 50 percent Sammy owned. Burt Boyar owned the other half.

Quincy and Sammy had been friends for years and were part of a small group that included Sidney Poitier and Bill Cosby. Amid rows of gold records and Grammy Awards, Quincy talked for several hours about his love for Sammy and his sadness over Sammy's fate.

"There are no good managers in the world anymore. The music business is the same. There are no honorable people to help and manage," Quincy said.

Quincy said Sammy was one of his best friends and he only agreed to option Sammy's books through Tracey and Burt Boyar because of Altovise's IRS troubles. But now, under no circumstances would he move forward without Altovise.

"I'll never, ever cut out Altovise," said Quincy.

Sonny was relieved. He'd been told by Tracey and others that Quincy had a history of optioning books and properties but never doing anything with them. He assured Sonny that wasn't the case with the Sammy musical. Quincy did have one request: peace between Tracey and Altovise.

"This family deserves better," said Quincy.

So Sonny called Tracey, told her about his visit with Quincy, and said he wanted a settlement on the rights issue or he would go to court to press his claim. Tracey explained that her prime goal had always been to resurrect her father's legacy, and if giving 25 percent of his book royalties to Altovise meant they'd accomplish that goal, then so be it. Tracey also agreed to help facilitate a meeting between the children and Altovise to heal old wounds. Sonny was thrilled.

He drove to Herb Sturman's office to arrange for the transportation of all of Sammy's financial papers, probate material, will, and tax returns. Sturman congratulated Sonny on resolving the longstanding debt with the IRS, and promised to have all the paperwork filed in boxes, securely sealed, and sent cross-country to Pennsylvania.

That night, David Altschul took Sonny to a Dodgers game, and they had prime seats behind the first-base dugout. Sonny caught a foul ball hit by third baseman Todd Zeile, and he stood holding his prize high to the cheers of fifty thousand people. When he returned to his hotel room, he jotted down a note on a yellow legal pad: "Today was one of the greatest days in my life."

The following day he met with Hilly Elkins, Sammy's old Broadway producer, to discuss a possible deal. Hilly, like Quincy, wanted

to produce a Sammy musical. Sonny already had an agreement with Quincy, but he told Hilly he was in the running. He didn't want to lie to him, but by the same token he didn't want to lose him, just in case the rumors about Quincy failing to move on projects was true. Hilly was old-school Hollywood and he knew how deals were born and died. He also knew from his industry contacts about Quincy's ongoing interest. But he made his pitch anyway and then mesmerized Sonny, who soaked up Hilly's stories of Sammy and *Golden Boy* and civil rights and Selma.

CHAPTER
15

Nearly two dozen boxes arrived at the Hillside in October 1997, all addressed to Albert R. Murray Jr. The sender was attorney Herb Sturman, and inside was all the paperwork left from the estate of Sammy Davis Jr., including probate documents, Sammy's will, tax returns dating back to the 1970s, SYNI documents from the 1970s, Altovise's depositions during the lost years following Sammy's death, records from the Butterfield & Butterfield auction, and minutes from Transamerican corporate meetings.

Thousands of documents sent cross-country, and Sonny flipped through each box, looking again at the probate material, will, and tax returns, which he read when he first visited Sturman's office in the fall of 1994. He fingered through each file, and pulled out the folders marked TRANSAMERICAN CORPORATION MEETING MINUTES. They were minutes from Sammy's corporate meetings from 1987 through 1990, and Sonny was stunned when he read that among Transamerican's officers, which included Sammy, John Climaco, and Shirley Rhodes, was E. William Hall.

The 1989 U.S. Tax Court decision that denied the bogus tax shelters, particularly the shelter that invested in a fraudulent coal enterprise, described Hall as one of the principal characters. Hall supposedly had been terminated as Sammy's "business manager" in 1983, but here was Hall's name listed as one of the four corporate officers of Transamerican Entertainment, and he was a principal in several ongoing business deals.

During one corporate meeting in November 1987, Hall and Sammy's

accountant George Louis discussed finding a new insurance representative to replace Max Gomberg, an insurance agent from Pittsburgh. Hall also conceived a plan to produce a line of foods called "Dixie Barbecue," which would carry Sammy's endorsement. In addition, Hall was working on a refinancing of a shopping center purchased for Transamerican with what remained of shares from the Cannel City coal venture.

Sonny hadn't thought much about John Climaco and Shirley Rhodes in recent months. There was a time when he wanted to bring suit against them, but Altovise didn't want any part of it and Sonny turned his energies to resolving the debt and moving on.

But the minutes from the Transamerican meetings were disturbing. Why, thought Sonny, did William Hall continue to work for Sammy? According to the 1989 U.S. Tax Court decision, Hall was a hustler who created the bogus coal company and took investments knowing it was a scam. Hall remained a member of the four-person board of directors until his resignation in November 1989, which followed Sammy's cancer diagnosis. With Hall gone, the remaining directors included Sammy, Climaco, and Shirley, and according to minutes from another meeting, the desperate condition of Sammy's estate forced them to terminate pension and profit-sharing plans offered by Transamerican, with the assets to be distributed into Transamerican's bank account. During another meeting, in April 1990, just weeks before Sammy's death, the directors changed several life insurance policies totaling $1.5 million and naming as beneficiaries Tracey, Mark, and Jeff Davis.

The policies had originally listed Transamerican Entertainment as the beneficiary, and despite promises by Climaco and Shirley that the children would be taken care of, Sammy clearly didn't believe them. Lying on his deathbed, he called for a special board meeting and demanded the change in beneficiaries. It was the only business conducted during Sammy's final board meeting. He died four weeks later.

In October 1990, Climaco, Rhodes, and a newly appointed board director, Nancene Cohen, met to discuss several issues related to Sammy's estate, including the dissolution of Transamerican Entertainment. They agreed to liquidate all corporate assets, including furniture, yet at

the same time agreed to prepare a memorandum outlining "prospective projects" for justification of expenses the corporation said it would incur, including Climaco's travel to and from Cleveland.

They also discussed a request by Herb Sturman to return all the "gifts" made by Sammy prior to his death, which meant returning all the items that had been taken from the home. Sturman explained that given the estate's insolvency, it was illegal to give away property considered assets by the IRS. Shirley said she'd return a single necklace but refused to return any other items in her possession. She also declined to ask others to return any items, claiming they were given as "mementoes" and she felt uncomfortable asking for them back. The "board" also agreed that they needed special accounting help for estate purposes, and Climaco insisted on using Ernst & Young in Cleveland. Retaining an accountant would also be a justified expense of the estate, and George Louis could assist.

One final item discussed during that meeting was perhaps the most disturbing, and it had to do with an annuity promised to Sammy's road manager and close friend Murphy Bennett. Minutes from a November 1987 meeting revealed that Sammy mandated that funds from his life insurance policies designating Transamerican as a beneficiary should be invested in an annuity to provide an income for Murphy. Climaco was authorized to prepare the documentation necessary to open the annuity whenever that time came. But following Sammy's death, during that October 1990 meeting, Climaco claimed after the policies were cashed, Transamerican had only $1 million in its account, which was not enough to provide for the annuity. If Murphy had a problem with it, he should get an attorney and file a claim against the estate, Climaco said.

Sonny was angered, especially given that Transamerican received nearly $4 million in life insurance proceeds. Murphy Bennett, who had been with Sammy since the 1950s, had not only been denied his promised $1 million life insurance payout, but he had also lost his pension. Sonny had never met Murphy Bennett, but he took the blow to Murphy personally. Since taking on the task of representing Altovise in 1994, Sonny had remained single-minded in his quest to settle the IRS debt

and restore Sammy's estate. But along the way he also came to realize, as a former federal prosecutor, that some of the business surrounding Sammy's life was suspect, and the more he learned the worse it seemed. He also knew that Altovise's innocent-spouse claims were, in layman's terms, accurate. No doubt she spent like a demon during her marriage, but the mismanagement of Sammy's business during his life and after his death was not something Altovise could have been involved with.

Sonny continued to rummage through the paperwork and found another surprise, an unsigned Proof of Subscribing Witness form that had been sent to David Steinberg in August 1990.

Steinberg became one of Sammy's closest friends after arriving in California from Wisconsin in the late 1960s. He served as one of Sammy's publicists during the 1970s and later became a powerful entertainment manager who counted Robin Williams and Billy Crystal among his clients. During Sammy's final weeks, Steinberg visited every morning, bagels in hand, and he and Sammy watched *Golden Girls* together.

Steinberg's signature was one of three that appeared on Sammy's will, the same will dated March 12, 1990, that Sammy's security chief Brian Dellow alleged had been fraudulent. Aside from similar allegations by others, including Tracey Davis, Sonny couldn't find any tangible evidence that the will had in fact been tampered with, until now. The Proof of Subscribing Witness form, which was in Sonny's files, was unsigned by Steinberg. The signature portion was blank. How then, thought Sonny, was Sammy's will probated without Steinberg's acknowledgment that he did, in fact, sign the will? And if Steinberg refused to sign the form, then Sammy's will, Sonny believed, may have been tampered with.

But there was nothing Sonny could do now with the will, so after finishing his review of the paperwork, he focused on his upcoming meeting with author Burt Boyar.

Burt had recently returned to Los Angeles, following the death of his wife, Jane, in March 1997, after a forty-plus-year marriage. The couple left the United States in 1970 and lived in Marbella, Spain, where they

remained inseparable. The Boyars cowrote *Yes I Can* and *Why Me?* with Sammy and considered themselves his official biographers. They owned half of each book and, with Jane gone, Burt's cooperation was required for any deals that were dependent on either book. Since producers were interested in a film on Sammy's glory years during the 1950s and 1960s, it made sense to attach the bestseller *Yes I Can* to the project.

After Sonny negotiated a deal with Tracey to split Sammy's 50 percent between Altovise and all the children, Sonny exchanged several letters with Burt, which centered around the Quincy musical. Sonny also inquired about Burt's interest in cowriting a book with Altovise. Burt agreed, but insisted on terms similar to those he had with Sammy, which included an equal share of the copyright, a fifty-fifty split of all income, and author's credits done in equal size. Burt also demanded creative control and made it clear in several letters to Sonny that he would only be a party to "maintaining or enhancing Sammy's and Alto's images." Burt said he had over 150 hours of taped conversations with Sammy recorded while researching *Why Me?* in the mid-1980s and he knew Sammy's deepest secrets. Burt said in one letter that Sammy told him how he plucked a "wholesome" girl who grew up in a fine family that protected her into adulthood. Quoting from the tapes, Burt wrote that Sammy told him:

"Then I married her and brought her into a world she'd never seen. I put her in David O. Selznick's mansion in Beverly Hills, gave her a Rolls-Royce with her name on the license plate, and I made that name famous by constantly mentioning her and featuring her on network television."

Burt said that Sammy described how Altovise fit perfectly in his Beverly Hills social life, how the Jack Bennys found her charming and refreshing, how Lucille Ball virtually adopted her, and how she became the head of the film world's chic charity SHARE.

But Sammy also shared the deeper secrets about his marriage.

"Then I showed her the darker side of life. The drugs and the partying. I destroyed her. I could enjoy all that and walk away from it. But Alto could not. I did that to her."

Burt thought a book with Altovise could be important, perhaps even on par with Betty Ford announcing she had a mastectomy. But Burt said he would not go into any detail he believed would injure Sammy's image in the eyes of the American public. Sonny thought that was disingenuous and not in the best interests of Altovise. What if, he thought, Altovise wanted to write in detail about her sexual exploits with Sammy and others? Would Burt write an honest account as given by Altovise, or would he defer to protecting Sammy's image?

Sonny was unsure, and he put the book aside, and turned his attention to the Quincy Jones Broadway musical.

Since the release of *Yes I Can* in 1965, Burt said, he and Sammy had experienced much frustration in turning the book into any type of production, film or otherwise, with nothing to show but thirty-two years of talk. *Yes I Can* was originally optioned by Warner Bros. in 1967 but that deal fizzled after the studio was sold. Motown made an offer in 1988 before Sammy died, seeking to steal the rights forever for $250,000, and that came only with a $50,000 advance. The remaining balance would only be paid if the movie went into production during the following twelve months, after which they could produce the movie without paying another single cent.

Burt said he agreed to the Quincy Jones deal in the belief that he and Tracey owned the rights, and when Quincy's first option expired, Tracey became frustrated and wanted to take the book and "test the waters" with other producers. Burt said he had no choice but to go along with Tracey, and when she couldn't cement another deal Quincy was still interested and entered into another series of options. But here they were, near the latter half of 1997, and still no production. And with Sonny pressing Altovise's rights to the book, the project had come to a halt.

Sonny explained he contacted Tracey and negotiated a deal, and with Tracey's cooperation in hand, Sonny decided to meet face-to-face with Burt at his Wilshire Boulevard penthouse in October 1997.

"I'm glad you're here to clear things up," said Burt.

The penthouse was filled with life-size photos of Sammy and other

celebrities and it immediately reminded Sonny of Jack Haley's home—that same celebration of a bygone era. While others would have been enthralled by the photos, Sonny found them depressing.

Burt was a former newspaper columnist during the 1950s, who later carved out a career writing two books, twenty-three years apart, with Jane and Sammy. Sonny read them both and, intimately familiar with Sammy's life and troubles, he thought they were interesting but somewhat disingenuous, particularly *Why Me?*, which glossed over Sammy's financial affairs and left the impression that, just a year before he would die, Sammy had finally achieved financial stability. Burt and Jane had been gone for sixteen years and only knew upon their return to the United States what Sammy told them during their interviews in 1986. The Boyars loved Sammy and lived with him at the Summit Drive home and the superstar suites provided to Sammy at casinos in Las Vegas and Lake Tahoe during the three months they spent interviewing for the book. The Boyars enjoyed the attention, especially at Harrah's, where the star attractions were treated better than anywhere. If you asked for red wine you got Lafite Rothschild, or if you asked for champagne it was Dom Pérignon or Cristal. The Boyars interviewed Sammy after performances or mid-afternoon, after Sammy woke up. But Sonny could sense that Burt's close connection to Sammy left him leery of others in Sammy's life, including Altovise and Sammy's children. Burt believed Altovise was a damaged drunk whom Sammy said on tape he never loved and wanted to divorce. The children, particularly Tracey, were a mess, Burt said.

With little good to say about Sammy's family, Burt gushed in his praise of Sammy, describing him over and over again as "sensational."

But as Burt talked, Sonny developed a decidedly negative opinion of the author. Sonny thought Burt was arrogant and unctuous, a sycophant whose life's work hinged on Sammy's celebrity. It was only a first impression, and as Sonny eyed Burt's penthouse and studied the many photos of Burt's late wife, Jane, Sonny thought, perhaps, that Burt's cold indifference was nothing more than a reaction to the tremendous grief of losing a life partner. Sonny admired Burt's love for his wife, and

the length of their relationship. They had no children, yet remained devoted to each other until Jane's passing. By the end of the conversation, Sonny realized he and Burt had little in common other than they both wanted to get a deal made—any deal. Burt agreed to work with Sonny, Altovise, and Tracey together on the Quincy Jones–planned Broadway play. Burt also suggested that Sonny and Altovise meet with Quincy to allay any fears on his part. The books were key assets to Sammy's estate, and despite Sonny's initial impression of Burt Boyar, he thanked Burt for his time.

Once outside, Sonny stood on Wilshire Boulevard, thinking about the pitiable history of trying to turn *Yes I Can* into a feature film. Three decades of failure, and Sonny saw that as karma. There was so much damage related to Sammy Davis Jr., and perhaps it just wasn't in the stars for a movie or a Broadway play. But Sonny went ahead anyway and scheduled another meeting with Quincy Jones. He arrived at Quincy's home with Altovise, and they spoke for three hours about old times with Sammy, his vision for a musical, and the rights issues, which Sonny said had been resolved. Sonny gave his verbal support to the project, but while awaiting the paperwork that would bring Altovise into the deal, Sonny received a treatment for another play based on Sammy's life, which promised the participation of the Nederlander family, the preeminent Broadway producers. When Burt got wind of the other deal, he sent a letter to Sonny questioning his ethics and demanding proof that he did, in fact, reach an amicable resolution with Tracey Davis. He also reminded Sonny that Quincy provided the best hope for getting the play to Broadway.

Thankfully, the issues arising from producing a musical didn't overshadow the completion of a record deal with producer Ron Weisner. Weisner, who managed Michael Jackson during his *Thriller* years, had pitched Sonny on a Sammy CD box set and, following a meeting, the two men shook hands on a deal. Unlike the musical with its ongoing problems, the Weisner project moved quickly and immediately drew interest from Rhino Records, which offered $445,000 for all of Sammy's recordings plus royalties. The deal was a good one and would pay off

the remaining money owed to the IRS. It would also pay off a portion of Sonny's growing legal bill, which now topped $500,000. Sonny told Weisner he'd put together a complete listing of Sammy's recorded music, believing the Rhino box set would be the first major step toward revitalizing Sammy's posthumous career.

In December 1997, thirteen-year-old Shelby Starner signed a six-album record contract worth over $5 million.

The deal included $350,000 for the first album, and up to $650,000 for the second album, both guaranteed. Warner Bros. held an option for the remaining four records. The contract was signed in Los Angeles with Sonny, Shelby, and her parents present, along with David Altschul, who compared Shelby to other teen queens, including another newcomer, named Britney Spears. Shelby, said Altschul, was the future of Warner Bros. Records. Because of Shelby's age, the contract had to be approved by the Monroe County court, and President Judge Ronald Vican expressed several concerns, particularly the value of the contract, and he sought guarantees that the money would remain in trust for Shelby and that she had proper representation. Vican had known Sonny for over twenty years, and despite other concerns about her age, he gave his approval.

Sonny was ecstatic. He found Shelby, produced her two demos, introduced her work to Warner Bros., and was now her attorney and, he believed, soon to be her manager. Not only was she signed to Warner Bros. Records but Liz Rosenberg, a powerhouse publicist who counted Madonna among her clients, was enlisted to work with Shelby. But within just a few short weeks of signing the deal and gaining court approval, Sonny received an e-mail from Shelby's parents, terminating his representation and association. The parents, Ray and Kathy, were divorced but both said they believed they knew what was best for their daughter and they wanted to guide her career. Sonny was confused, hurt, and angry. He called David Altschul at Warner Bros., who was furious. But there was little Altschul could do to convince the parents to change their opinion that Sonny outlived his usefulness. Sonny eventually received a settlement check for his two years of work nurturing and

guiding and producing Shelby. He considered filing a lawsuit but didn't. He believed Shelby would be a bona fide star and didn't want anything, even his own misfortune, to stand in her way. He wanted to say good-bye to his young protégée, but the parents wouldn't allow it, so he let it go. He had new issues to deal with. One involved Frank Sinatra, Dean Martin, and the Rat Pack, and the other Sammy's family.

A meeting was finally scheduled in March 1998 at May Britt's condominium on Beverly Glen, near Wilshire Boulevard, between Sammy's children—Tracey, Mark, and Jeff—and Altovise. Sonny and May were there to guide them through years of ill will. They had already agreed to work together on the musical, and the children, led by Tracey, pleaded with Altovise to find some common ground, bury the hatchet, and come together as a family to work on other projects. For five hours they talked, argued, and cried as they each unleashed decades worth of anger and frustration. Sonny and May tried to referee, and they lunched on pizza before the meeting finally ended with an agreement to work together. After Altovise and Sonny left the apartment, May, Mark, and Jeff appeared pleased with the result.

"Looks like something is going to happen," said Mark.

But Tracey didn't buy into any of it.

There was too much history with Altovise, and too many arguments and broken promises. No matter what Sonny promised in cooperation, as far as Tracey was concerned, Altovise hadn't changed. Tracey also believed that Sonny was just another lawyer in a long line of lawyers who made promises on behalf of Altovise that would ultimately be broken.

"What are we, stupid?" said Tracey. "I didn't believe one word she said. And Sonny's stupidity is that he still doesn't realize what a wild card Altovise is. I told him she doesn't have a motherfucking friend anywhere. Not one person will do anything with her, and here we are saying let's work together? If you guys think she's going to work with you, that's fine."

Tracey looked at May.

"Mark my words, Mother, not a fucking thing is going to happen. Don't get your hopes up. I know I'm not. I'm done with her," said Tracey.

CHAPTER 16

In January 1960, Frank Sinatra dubbed his gathering at the Sands with Dean Martin, Sammy Davis Jr., Peter Lawford, and Joey Bishop "The Summit," but the press loved the name "Rat Pack," and the world couldn't get enough of it. A cigarette in one hand, a drink in the other, jokes all around, and arguably the best male vocals ever assembled on one stage.

Five grown men with Las Vegas as their playground performed and drank and caroused at night, and filmed *Ocean's Eleven* by day. Fans and celebrities flocked to Vegas just to catch a sight or even be near them. The national press covered every step, and the Rat Pack took on mythic proportions, growing larger even through decades of social change. By the 1990s cigarettes were considered cancer sticks and women more than arm candy, but the name Rat Pack still carried great recognition from the older generation who grew up with Frank, Dean, and Sammy. And there were new, younger generations to school on the meaning of hip and cool. And now, with Sammy's estate finally free from the choking grip of the IRS, Mort Viner wanted to do business.

During a long career at ICM, Mort was a preeminent figure in entertainment circles, a man who secured a sterling reputation, which was unusual in the rarefied air of successful Hollywood agents. Among Mort's many clients were Shirley MacLaine, Michael Crawford, and Dean Martin.

It had been more than a year since Dean's passing, and Mort continued to represent his estate, which, unlike Sammy's, was healthy and

wealthy. Dean and Mort had forged a longstanding and lucrative business and personal relationship that made Dean a very rich man. Smart investments, ownership of his work, and good management left an estate that, upon Dean's death, continued to churn out dollars. Now Mort wanted more, and he saw a gold mine in reviving the Rat Pack name. New records, licensing deals, and even performances by impersonators were among the ideas for Frank, Dean, and Sammy. There had been previous attempts to do some Rat Pack business, but the ever-present shadow of the IRS prevented any ideas from expanding past talk. But soon after hearing that Sammy's estate had finally been settled, Mort and Sonny began what would become weekly discussions, and finally a face-to-face meeting in Los Angeles. During the ensuing months, Sonny made a point of stopping by Mort's office on each trip to L.A. to talk about Sammy, Dean, Frank, and the Rat Pack. Sonny liked Mort immensely. He was a bear of a man and a straight shooter, who spoke plainly and clearly held his ground in negotiations. If someone pressed too hard, Mort went after them with both barrels. Like a teacher talking to a student, Mort took Sonny behind the glitter of the famous names, the booze, the broads, and the manufactured excitement to the real business of the Rat Pack, which over the years had been simple: Frank Sinatra got the lion's share of everything, most often 50 percent. Dean got 25 percent, and Sammy the other 25 percent.

Those were the terms, said Mort, when they reunited in 1988 for the Together Again tour. Frank's "people," which included his attorney Bob Finkelstein and manager and promoter Eliot Weisman, always argued that since Frank was by far the biggest attraction, he deserved the bigger fees. Actually, said Mort, it wasn't an argument. Weisman simply stated what the cut would be, and everyone listened. That was usually the way with Frank and his people, said Mort. They bullied, cajoled, and intimidated nearly everyone, except for Dean.

Despite a carefully cultivated image as a boozer and ladies man, Dean Martin was a quiet introvert who stayed away from the carousing and wild parties that Frank and Sammy enjoyed so much. For Dean, his relationship with Frank and Sammy was all business, said Mort, and his

participation was nothing more than a well-crafted shtick. Dean considered Frank and Sammy friends, but never buddies, and unlike Sammy and the rest of the world, Dean never allowed Frank to overwhelm him or his life. While Sammy said "How high?" every time Frank yelled "Jump," Dean distanced himself from Frank and his "people," particularly Frank's many friends from Chicago. Frank's cultivated image as a man who counted high-ranking members of organized crime in Chicago and New York among his friends served him well over the years, allowing him to wield a very big stick at a time when the mob controlled Las Vegas and nearly every theater and venue across the country. Even the threat of tapping into those relationships in his business and personal dealings brought most people to their knees. But Dean couldn't care less about Frank's friends.

"Dean Martin," said Mort, "was a man's man."

Sammy, on the other hand, always remained indebted to Frank for wielding his power in the 1950s to gain Sammy entry into clubs he otherwise would have been excluded from. It was Frank who stood up for Sammy when he married May Britt, and it was Frank who brought Sammy into his group of playmates with Dean, Peter Lawford, and Joey Bishop. And that's how it remained throughout their friendship. Sammy had always been loyal to Frank, and he readily acknowledged that without Frank, numerous doors would have remained closed to him. But for Frank, friendship was always on his terms, and it always centered on control. When Frank spoke, people listened, and when anyone, particularly a friend, refused to obey his "requests," Frank turned his back on them. After all, said Mort, he did it famously in 1968 with his own wife, Mia Farrow. They married in 1966, when she was twenty-one and he was fifty. Frank was filming *The Detective* and Mia Farrow was offered the lead in *Rosemary's Baby*. Filming of both movies coincided, and Frank demanded that Mia work with him. She refused, and Frank filed for divorce. It was no different with Sammy. Boozing and adultery were okay in Frank's book, but cocaine was unacceptable. And rumors of Satanism? That didn't fly at all with Frank. When Sammy refused

Frank's "request" to stop using cocaine, a furious Frank closed the door on their quarter-century-long friendship.

"Fuck him," said Sammy, who had his own life, his own desires, and his own secrets.

They finally settled their differences in 1980, and eight years later they were on tour again. Their reuniting with Dean, and then Liza, in 1988 proved enormously successful, and now Mort and Frank's representatives—Finkelstein and Weisman—wanted to revive one of the most famous names in show business.

Sonny told Mort of his one meeting with Finkelstein in August 1994, and how he warned Sonny that trying to settle the IRS debt was futile. Despite the warning, Sonny said he admired Finkelstein's smarts and smooth manner.

Mort had other ideas.

"Respect the man, but don't trust him," said Mort.

Sinatra business, he said, was always a bare-knuckled brawl, with Frank always coming out on top. Frank was eighty-two and in failing health, and his daughter Tina was among several family members overseeing the Sinatra estate. But the major deals were being done by Finkelstein and Weisman, who had been with Sinatra for years. Sonny said he never heard of Weisman.

"You were a federal prosecutor, and you never heard the story of Eliot Weisman?" said Mort. "Sit down. If you're going to do business with Sinatra, you need to know who you're dealing with."

The Westchester Premier Theater was a 3,500-seat venue located in Tarrytown, just north of New York City. From the day Diana Ross opened the theater in 1975, top-name acts followed. Frank Sinatra performed there three times, in April and September of 1976, and with Dean Martin in May 1977.

But in November 1977 the theater fell into Chapter 11 bankruptcy proceedings after its president, Eliot Weisman, resigned amid a federal racketeering investigation. Weisman and seven others were indicted in

1978 and charged with stock fraud for failing to disclose that organized crime figures, including then–New York crime boss Carlo Gambino, invested heavily in the theater.

Weisman was a securities salesman who joined two New York mobsters—Gregory DePalma and Richard Fusco—in drawing a prospectus for a public offering in 1973 of $2.25 million in stock to build a concert hall over a landfill. Comedian Alan King and singers Steve Lawrence and Eydie Gorme were listed as stockholders, but that did little to spur public interest in the stock. So the trio bought their own stock with a 10-percent-a-week loan from Gambino, and got others, including executives at Warner Communications, to buy shares on condition that their money would be refunded later. Once the theater opened in 1975, the trio skimmed nearly $800,000 from the profits in the first year alone, much of the money used to pay back Gambino and the other investors. Skimming, or taking money off the top before it's accounted for state and federal tax purposes, was business as usual for the mob, which owned, managed, or had a business interest in nearly every club and theater in every major city in the country, as well as casinos in Las Vegas.

Weisman, DePalma, and Fusco not only skimmed off the revenues from the ticket sales, they skimmed from the parking, bar, restaurant, candy concession, souvenir and program stands, and T-shirts. They even scalped tickets and sold others for seats that didn't exist. The FBI inadvertently learned of the scheme through wiretaps involving another investigation, and after the theater eventually imploded from the pressure of paying back the costly mob loans and bogus stock purchases, indictments were handed down.

DePalma and Fusco eventually pleaded guilty to racketeering charges while Weisman was convicted by a federal jury and sentenced to six years in prison. But Mort said there was more to the story.

The investigation into the Westchester Premier Theater produced wiretaps that implicated Frank Sinatra in the skim, and prosecutors claimed he received $50,000 in cash under the table from the 1976 concerts. They also said that Mickey Rudin, Frank's manager, received

$5,000 while Jilly Rizzo, Frank's longtime bodyguard, also received $5,000. Federal prosecutor Nathaniel Akerman offered Weisman a deal: testify against Frank or go to jail.

Weisman took the prison term.

Akerman convened a grand jury in 1980, focusing specifically on Frank and his associates, and he brought out several witnesses who testified that Frank not only took the money, but he agreed to make three visits over less than a year, knowing his appearances would provide packed houses to fuel the skim. Prosecutors even showed that infamous photo of Frank backstage during one of his 1976 appearances, arm in arm with eight mobsters, including Carlo Gambino and Paul Castellano. Sonny was still a federal prosecutor when Castellano and his bodyguard were shot and killed on a New York street in 1985 by a crew led by John Gotti.

"So Weisman gets out of prison, and in gratitude Frank gives him a job," said Mort. "You should take a look at Jilly Rizzo."

Jilly Rizzo was considered Frank's best friend and did a variety of jobs for him, from bodyguard to gopher. Born and raised in the Bensonhurst section of Brooklyn, Rizzo was a member of a tough street gang in the 1930s, which stole cars, burglarized homes, and terrorized the neighborhood from their base on Bay 50th Street. By the 1950s Rizzo, who had the rough appearance of a prizefighter, opened a restaurant at 256 West 52nd Street in Manhattan, which he called Jilly's Place. With a large, round white light positioned over the front awning, Jilly's was known not only for the high-powered celebrities that visited, including Frank, Sammy, and Dean, but for the one-eyed cat named Joey, who table-hopped into the early morning hours.

After Jilly and Frank met in Miami in the 1950s, the two men struck a close friendship. Rizzo became a part-time actor, playing bit parts in movies and a regular turn on *Laugh-In*. He closed Jilly's in the 1970s and remained at Frank's side, becoming his closest confidant.

In 1990 Rizzo was convicted with five others in federal court for their involvement in a scheme that fleeced $8 million from a New York bank, the Flushing Federal Savings and Loan Association. The bank

collapsed in 1985 and was the first of many that would eventually close as part of the savings and loan fiasco that ripped through the country in the 1980s. Billions in assets were wiped out due to insolvency of the banks, and Flushing Savings & Loan was one of the most notable failures, with total losses over $100 million. One of its many bad deals involved a $5.5 million loan to Rizzo, who announced plans in 1983 to build a $50 million Jilly's Resort and Sports Complex in the Poconos, just a few miles from the Hillside Inn. But Rizzo and his partners, who were alleged mobsters, acquired the loan by giving shares of their company, World Wide Ventures, to the wife of the bank's president. The resort was never built, after the Securities and Exchange Commission got wind of the deal. Rizzo was charged and convicted of fraud. He avoided jail time because of his age, and was sentenced instead to community service.

Rizzo was killed in 1992 near his home in Rancho Mirage, California, when his Jaguar was hit by a drunk driver and exploded. Rizzo, seventy-five, couldn't escape and burned to death.

Frank mourned the loss of his longtime friend, said Mort, while others, like Weisman, continued the Sinatra business. Following his prison term, Weisman went to work for Frank, and it was Weisman who promoted the Together Again tour with Frank, Sammy, and Dean.

This was all new territory for Sonny. He knew, like the rest of the world, that Frank Sinatra had long been dogged by gossip, innuendo, and even published reports that he was in some way connected to the underworld. Mort talked about Frank's close friendship with Chicago mob boss Sam Giancana, and the familiar story of how Frank leaned on that friendship to help gain votes for John F. Kennedy in 1960. Frank's association with the mob was a powerful tool, and one Frank used to its fullest, said Mort.

"Remember, kid," said Mort. "Respect the Sinatras, but don't ever trust them."

Sonny parked the suggestion in the back of his head. But now, with Sammy's estate settled, there was business at hand, and plenty of it. *Frank, Dean and Sammy: An Evening with the Rat Pack* was a new video

produced from a long-forgotten concert. Originally called *The Frank Sinatra Spectacular,* the trio performed in St. Louis in 1965 to benefit a halfway house for ex-convicts, with the show hosted by Johnny Carson, who filled in for Joey Bishop. A copy of the performance was found years later in a closet in the halfway house.

In addition, HBO announced plans to film a Rat Pack movie that would star Ray Liotta as Frank, Joe Mantegna as Dean, and Don Cheadle as Sammy. HBO was relying on public domain for its material, and the producers didn't approach any of the performers about assignment of rights or payments. Finkelstein, Mort, and Sonny warned that using the trio's name and likeness and music required a deal. Finkelstein suggested a cease and desist order and cautioned HBO about potential legal action unless an agreement was reached. Tina Sinatra called the movie a "blatant raping, not only of my dad but of all those other brilliant performers."

Sonny too, as Sammy's representative, warned HBO in a March 1998 letter to Molly Wilson, HBO's vice president and chief counsel, against using Sammy's image and material, and the image of Altovise. Wilson replied that the film was based on a "variety of reliable sources." She also said that Altovise was not depicted in the film, which takes place in the early 1960s and before her marriage to Sammy.

Despite the chest-beating and legal threats by Finkelstein to "shut this down," it appeared there was little anyone could do legally to force HBO to play ball, and the issue was grudgingly dropped. Instead they moved to other pressing business, including plans to market the long-lost Rat Pack performance as well as coproduce a Rat Pack album and promote a tour of Rat Pack impersonators.

Sonny flew to Las Vegas to meet with Mort, Finkelstein, and Weisman at the Mirage hotel. Weisman greeted Sonny warmly and, with Finkelstein, congratulated Sonny for his work settling Sammy's estate. They knew he was a former federal prosecutor, exchanged small talk about E. F. Hutton over a couple of drinks, and then quickly got down to business. Despite Mort's previous warning about accepting past splits, Sonny said he had some other ideas about a more equitable distribution of any and all Rat Pack income, and he suggested that future splits be

cut evenly at 33 percent each. Mort froze, while Finkelstein looked at Weisman, who simply shook his head.

"No, that's not the way we do it," Weisman grunted.

Frank was the star, said Weisman, and Frank always dictated terms. It was Frank, going way back to 1960, who decided to pay Sammy $100,000 for appearing in *Ocean's Eleven*. There was no negotiation. Frank simply showed Sammy the contract with the six-figure number, and that was it. There were no royalties or future payments. Sammy was grateful and would have acted for peanuts. Frank was a businessman and saw the future.

Weisman laid out the usual 50/25/25 deal. Sonny remained mum after his initial ill-advised suggestion, and he simply nodded his head in agreement as Weisman and then Finkelstein suggested other plans and potential Rat Pack business deals. Only the "suggestions" were clearly orders and directions more in line with "This is what we are going to do, and you're just along for the ride."

Other "suggestions" included assembling Sammy's recordings to determine what songs he did and didn't own for a potential Rat Pack album, licensing of Rat Pack images, from pictures to caricatures and figures, and approval of the initial airing of the long-lost film, which was scheduled to premiere on the TV Land cable network in April. Other issues revolved around individual projects, and whether they could be incorporated as a Rat Pack deal. Mort was working on a *Dino* movie with director Martin Scorsese and his *Goodfellas* screenwriter Nicholas Pileggi. Early discussions mentioned a cast that included Tom Hanks as Dean and John Travolta as Frank.

Another matter concerned some minor bickering within the Sinatra family. Mort said that Frank's ailing health and the future of his estate caused tension, with daughters Tina and Nancy at odds with his wife Barbara and son Frank Jr.

"Not a problem," said Weisman. "I'll take care of it."

If there was one minor victory for Sonny it was that Finkelstein agreed that anyone can void any deal at any time. But it was a small token, and Sonny left the meeting completely overwhelmed and iso-

lated, with no one to complain to and no avenue for recourse. Walking out of the hotel with Mort, he suddenly realized this was how Sammy must have felt as a member of this esteemed group. Weisman was Frank barking out orders and Sonny was Sammy, saying "Yes, sir" and "Thank you." It wasn't a good feeling, and following the meeting Sonny pulled Mort aside and told him so.

"Is this how it's always done? I mean, that's not a negotiation," said Sonny.

Mort smiled.

"Look, kid, I make sure Dean's estate is part of any deal knowing in advance what the terms were and always have been," said Mort. "It ain't fair, and it never was, especially for Sammy."

Mort said Dean's estate grossed millions, so a Rat Pack deal would not make or break Dean's estate. Sammy's estate, on the other hand, could surely use any revenue that resulted from a Rat Pack project. Mort said he didn't believe Sammy owned many, if any, of his masters. In most cases, Sammy was simply brought in to sing, as was the case with his most famous hit, "The Candy Man." Dean and Frank, he said, owned their masters and the publishing, and it amounted to a virtual gold mine. Sammy may have been one of the most famous names of the twentieth century, but Mort was stunned that Sammy was so inept when it came to business.

"I don't think that's right," said Sonny. "I have someone auditing the record companies now and I'm expecting a full breakdown soon. But Altovise told me that Sammy owned much of his work."

"I hope so," said Mort. "Sammy was wonderful and I just loved him, but he didn't have good people around him."

"Who, exactly, are we talking about?" said Sonny. "Shirley Rhodes? John Climaco?"

Mort said Shirley was clearly out of her depth, and he only heard bits and pieces about Climaco.

"You should talk to Sy Marsh," Mort said. "He can tell you more."

"I will," said Sonny. "But first I've got to figure out Sammy's recording contracts."

CHAPTER 17

In the years following Sammy's death, his estate received only $360,000 in income, which went to the IRS. Money dribbled in from the Screen Actors Guild, or a royalty check from some long-forgotten deal, or a few bucks from a commercial endorsement using Sammy's image. Sammy's executors, Shirley Rhodes and John Climaco, accepted $5,000 from The Gap in 1993 to use Sammy's image in a national print advertising campaign for khaki pants. The full-page black-and-white ad, which appeared in the *New York Times* and other newspapers, featured a photo of Sammy from the 1950s clicking his heels in the air. But the payment to Sammy's estate was far less than what was paid to the estates of other celebrities, including James Dean, Humphrey Bogart, and Norma Jeane Baker, aka Marilyn Monroe. Tracey Davis was furious with Shirley for accepting such a small amount. Shirley simply figured it would be good to get Sammy's name out to the public. She also reasoned that no one else was calling and the money was going to the IRS anyway.

But during the seven years that Shirley and Climaco managed the estate for the IRS, they only took in a little over $50,000 annually. Given the magnitude of Sammy's stardom, Sonny thought there should be more, much more, considering his lengthy recording career. So for two years forensic accountant Jay Shapiro dug deeply into each real and rumored deal Sammy had been involved with. But to Shapiro's great surprise, he could find few contracts or any other paperwork detailing

Sammy's deals. And in those he did find, Sammy had no ownership of his work. Aside from perhaps a small performance royalty, the far greater percentage of the royalties usually went elsewhere.

Dating back to the 1940s, Sammy's record deals were simple cash payments, with small sales royalties. From what Shapiro could find, that arrangement extended to most of Sammy's business dealings, including his television and film work. Sammy's long and storied career was based on a cash advance and was indicative of a lifestyle that was in the here and now, not the later. When it came to business, Sammy was caught in the Sinatra syndrome: pay me what you think I should earn and I'll be thankful for it.

Luckily for Sammy, the recording industry mandated signed contracts with performers, and Shapiro retrieved some of those contracts, including those from Reprise and Decca, which revealed terms that were decidedly in favor of the companies. One of Sammy's earliest contracts, with Decca, in April 1954, was for a minimum of twenty-four records that paid him a 5 percent royalty against 90 percent of sales. Sammy received a $150 advance for each recording, which was recoupable by Decca against Sammy's royalties. Sammy was also an employee, a singer/musician for hire, and the contract stipulated that all recordings were the property of Decca, not Sammy.

The contract was extended several times through the 1950s and Sammy had no ownership over any of the dozens of songs he eventually recorded for Decca, including "That Old Black Magic," "My Funny Valentine," and "The Birth of the Blues."

Shapiro was greatly disappointed. He began his review believing he'd find streams of Sammy Davis Jr. income hidden somewhere but instead he found that Sammy was, for the most part, a cash business, which left nothing for the future.

When Shapiro delivered the bad news, Sonny was crestfallen.

"A star like Sammy required professional management to fill the void of his own informality, and money should have been streaming from so many different areas," said Shapiro. "I was surprised and shocked because when you compare it to the rest of the Rat Pack, and I

mean Sinatra and Dean Martin, they owned their work, made far more money, and invested wisely. I really thought Sammy's body of work would have been more lucrative."

"So did I," said Sonny.

Shapiro's audit severely dampened Sonny's revenue projections and his belief that Sammy's estate could be a major financial success. Sonny was also mystified. Why didn't Sammy have ownership in his work? Why didn't he appreciate the potential enormity that ownership provides and, if part of a successful project, the revenues would stream in perpetuity? It didn't make financial sense to simply take whatever fee was being offered, no matter how lucrative, and give away the rights to the kingdom.

Without ownership of his work, and the revenues that come with it, Sammy left little to work with, forcing Sonny to change his strategy, particularly with Altovise. Despite Sonny's admonishments, Mrs. Sammy Davis Jr. believed once the IRS debt was settled, she could pick up where she left off before Sammy's death, rejoin the Hollywood social scene, perhaps buy a new home in Beverly Hills. But even with plans to keep revenues minimal until 2003, it appeared that, aside from a couple of one-shot, big-ticket deals, there were no large continuing streams of income to depend on.

After pitching a Sammy CD box set to Sonny in August 1997, music producer Ron Weisner spent countless hours researching Sammy's voluminous body of work. Weisner, the industry veteran, had an impressive list of credits. Along with his work with Michael Jackson, Weisner managed Gladys Knight and produced a slew of music projects, including Eric Clapton's 1993 album, a tribute to Curtis Mayfield, which featured performances from Whitney Houston, Bruce Springsteen, and Elton John. Weisner's sterling reputation helped him strike a deal with Rhino Records, which planned to release the Sammy Davis Jr. catalog post-1964. The $445,000 was a substantial offer, and given the bad news from Jay Shapiro, it was the only tangible deal on the table, since the Broadway musical and television mini-series were still far off.

But when the Universal Music Group heard of the deal, they came in with an offer for $1 million. Bruce Resnikoff, a Universal executive, sent a letter to Weisner on March 9, 1998, confirming the offer, which included $850,000 up front and another $150,000 once certain sales were reached. The offer also included a 10 percent royalty payment, payable to the estate of Sammy Davis Jr. in perpetuity once all advances were recouped. Rhino, upon learning of the Universal offer, matched it immediately.

It was, on paper, a million-dollar deal, and would be the first and last for Sammy's music. But Sonny and Weisner encountered great difficulty trying to determine the extent of Sammy's recording career. Sammy had recorded dozens of albums for a number of labels, and he had eight Top Twenty hit singles, but no one knew the exact number of recordings.

Sonny searched through the estate records and found some references and information, and he even visited several record stores searching for Sammy material. But all he found were bootlegs. The IRS debt prevented the rerelease of any Sammy material, and the market was flooded with illegal compact discs and other recordings that gave no indication as to the original date of the recording, the author, or the record company. Sonny even contacted Frank Sinatra's people for information on songs Sammy recorded with Dean and Frank. Bob Finkelstein told him they owned the rights to those and to all the Rat Pack material.

Weisner used his industry contacts to dig deeper, and by April 1998 he developed a lengthy and comprehensive discography. The music of Sammy Davis Jr. spanned several decades and featured more than fifty original albums, from *Starring Sammy Davis Jr.* in 1955 to *Closest of Friends* in 1982. Sammy had recorded for several labels, including Reprise, Warner, Universal, EMI, Decca, and Motown. Within his body of work were hundreds of songs, many standing the test of time and recognized as American classics, including his versions of "Mr. Bojangles," "I've Gotta Be Me," and the pop-slick, 1972 AM radio classic "The Candy Man."

But just when Sonny and Weisner thought they had finally come

to the end of their search, they discovered they didn't have the master recordings. Sonny thought Weisner knew how to get them, and Weisner thought they were kept in storage by each respective record company. They weren't. They also learned that two of Sammy's bestselling albums, including the 1972 *Sammy Davis Jr. Now* and *Portrait of Sammy Davis Jr.,* could not be part of the deal since ownership remained with the labels. The *Portrait* record was of considerable concern, since it included "The Candy Man." Rhino also wanted Sammy's television theme show covers, but questions over ownership of those prevailed. Was it the Sammy estate, Polygram, or Twentieth-Century Fox?

When Rhino learned of the difficulty in finding the masters—without which Weisner and Sonny had nothing to sell—Robert O'Neill, Rhino's vice president and general counsel, sent a letter to Weisner expressing his serious concerns about the direction the project was taking. Rhino was led to believe Sammy's estate had possession of the masters Rhino thought it was buying. O'Neill said Rhino made its offer in the belief that Weisner and Sonny had custody or knew the whereabouts of all the post-1964 recordings. Rhino, said O'Neill, would only move forward if the deal included all those tapes. Desperate, Sonny went back and searched again through the estate records, but there was no paperwork for any masters, or any indication where they were. Sonny met with Weisner in Los Angeles and delivered the bad news. The masters were somewhere, he said, but without them, they had no deal.

The Hillside Inn was empty and dark, save for a single light in the office. It was after midnight, and Sonny sat thumbing through reservation lists. The resort was sold out for every weekend during the upcoming summer season, and there were plenty of midweek bookings as well. Many of the names on the reservations were familiar; the usual family from New York, the church group from Philadelphia, the youth group from New Jersey. And, as usual, the families and groups were black.

Nothing had really changed since the Judge broached the idea of Sonny putting together a management team to take over the Hillside. His actions notwithstanding, the Judge regretted his behavior toward

the Marriott people and, after reconsidering, realized he lost a golden opportunity that would have allowed him and Mama to take it down a notch, to do some traveling and enjoy some sort of semiretirement. Instead, the Judge and Mama remained in charge, and daily expenses, including food and fuel, continued to rise while the Hillside's rates remained the same. Knowing his clientele, the Judge couldn't raise his rates if he wanted to, since many of his bookings, particularly the group business, still received deep discounts. Losses were mounting, and the Judge turned to loans from Sonny, whose legal work provided him a good income.

Aside from his work with Altovise, for which he was now owed over $600,000, Sonny managed to bring in a considerable income from his many other clients and projects. Despite his sudden and sad break from singer Shelby Starner, he received a settlement. He also sold his interest in Scrub Island, a small Caribbean island he bought with several partners years earlier. The plan was to build vacation homes and condos there, but Sonny cashed in his interests and eventually opted out with a seven-figure settlement, which he reinvested in the Hillside. He had also been hired by the local Monroe County commissioners to investigate the murder of a nine-year-old girl who was beaten to death by a caregiver. The county's Children & Youth Agency had apparently been warned the girl was subject to regular beatings prior to her death, and Sonny was asked to get to the bottom of the tragedy. His "Murray Report" led to dismissals within the youth agency.

To bring in more revenues the Judge opened the Hillside to the general public on Saturday nights, offering dinner, a DJ, and dancing. He also sent out feelers to the local business community, seeking their group or meeting business. He reached out to Monroe County government, United Way, Pocono Mountains Vacation Bureau, and Pocono Medical Center, among others, with invitations to hold their meetings or special events at the Hillside. The business events usually took place midweek, when the resort was less than filled, so it didn't matter if a few dozen white faces settled in for just a few hours. The Judge wasn't a racist. To him it was just good business. The Judge and Mama also resorted to

driving along local roads to other hotels, resorts, and bed-and-breakfast inns to see if any black guests were registered there. They'd drive up to the front of the lobby and Mama would peer inside. Often, they'd enter the facility, approach a black family or individual, and hand them a business card.

"You know, there is a black-owned resort here in the Poconos, and we're just down the road," Mama would say, with a smile and a touch of the hand.

Sonny urged them, particularly the Judge, to get their minds out of the 1960s and look toward the future. A new century was fast approaching, and catering to a specific clientele simply wasn't good business. The Judge didn't want to hear it, and that was fine with Sonny, whose thoughts remained on Sammy Davis Jr., particularly the inability to locate Sammy's masters, which seriously jeopardized the Rhino deal. Other money had trickled in, following the settlement announcement thirteen months earlier. Sonny and Altovise signed the deal with Global Icons, which paid a $50,000 advance. And there were a few thousand here and there for rights to certain film and television clips. But the big deals, chiefly film and television rights, had yet to materialize, and the book project for Altovise had also hit a road bump. Burt Boyar's interest notwithstanding, he didn't respect Altovise, and Sonny didn't want to pair her with a writer who didn't like her and who, in Sonny's mind, could sabotage the project. Burt cared only about Sammy and maintaining his image, and if he was given editorial control over Altovise's manuscript, Sonny believed that her story would be distorted. There was no way, Sonny felt, that Burt would give an honest account of Altovise's life with Sammy. All that, however, wouldn't matter unless he found Sammy's master tapes. Without the Rhino deal, Sonny knew he'd be hard-pressed to make the next payment to the IRS. That, in turn, would negate the tax settlement.

As he half-heartedly flipped through the Hillside's paperwork, he heard the front door open, and then the familiar footsteps, which drew closer and closer and stopped only when the Judge stood in his robe in the doorway.

"I saw the light on," he said.

"Just looking at the books, Judge," said Sonny, closing the reservation list. "We really have to talk about updating things around here."

"I don't want to talk about business right now. We can argue about that tomorrow."

"I don't feel like arguing at all, tonight or tomorrow," said Sonny, his voice filled with resignation. "I've got other problems. I can't find those tapes. I can't find anything anywhere that even references Sammy's masters. It doesn't make any sense."

"Well, that hasn't stopped you before from finding things, has it?" said the Judge. "Maybe you already have what you're looking for, but it's just not easy to see. What's that you tell me all the time? Expand my mind? Think out of the box? Maybe that would help."

Sonny shook his head in agreement and smiled slightly.

"Yeah, maybe, Judge. Maybe."

The Judge turned to leave but stopped.

"Oh, I forgot. I came here for a reason. I was watching TV. They just announced that Frank Sinatra died."

Sonny reached Altovise at her mother's home in Queens the following morning. She'd already heard the news and was considering attending the funeral in Los Angeles. Sonny thought it was a good idea and said he'd have Ann make the flight and hotel reservations. Altovise told Sonny she hadn't been feeling well in recent days and wasn't sure if she could travel, but at Sonny's urging she agreed to go. Sonny sent a condolence card to the Sinatra family on behalf of the Sammy Davis Jr. estate and then called Mort Viner to check funeral arrangements. Sonny was also curious to know if Frank's death would have any effect on their ongoing Rat Pack business.

Mort laughed.

"Nothing stopping this engine, kid," Mort said.

Frank Sinatra enjoyed a spectacular career, recording nearly two thousand songs over sixty years. Fifty-one of his albums broke the Top Forty *Billboard* charts, more than any other artist, including Elvis. A

Frank Sinatra song could be found on the charts for thirty consecutive years, from 1965 to 1995, which was another record. Frank also had dozens of film credits, a Best Supporting Actor Academy Award won in 1954 for his role as Pvt. Maggio in *From Here to Eternity*, nine Grammys, and a Medal of Freedom in 1994—the highest civilian award in the United States. Sinatra was also an astute businessman who built Reprise Records and earned countless millions from smart investments in various ventures, from real estate to gaming.

Mort said that Frank Sinatra was an ongoing concern that ranked with the very best Fortune 500 companies, an enterprise that wouldn't stop for one second even with the death of its namesake. Bob Finkelstein, said Mort, planned everything down to the single dollar, and Frank Sinatra in death would be just as lucrative as Frank Sinatra in life.

Sonny thought Frank was brilliant.

"He was a hothead," said Mort. "An arrogant control freak. Dean loved him, but he'd never let him get away with any shit. And your guy? Poor Sammy just couldn't say no to Frank."

Sonny told Mort that Altovise was flying out for the funeral, and Mort said he'd keep an eye on her. But the following day, Altovise appeared for an interview on the CBS *Saturday Morning Show,* and she was incoherent, offering incomprehensible answers to basic questions centering on the relationship between Frank and Sammy. When asked what she thought brought Sammy and Frank together, Altovise talked about how "wonderful it was to reach for the stars."

And when asked what, if anything, Sammy would say if he were alive to eulogize Frank, her answer was even more nonsensical.

"You may be my leader, but don't hit me anymore."

It was a terrible interview, but there wasn't anything Sonny could do but make sure she boarded her flight for Los Angeles.

The boxes were laid out in no apparent order throughout the room, and Sonny carefully flipped through one of the many containing the estate and other records he received months earlier from Herb Sturman. Sonny had been down this road before, having searched through all the

documentation. He didn't recall any reference to Sammy's master record-ings, but he was desperate. And with no other clues and nowhere else to go, he decided to once again rely on his previous experience more than a decade earlier, when he searched for three years through 7 million docu-ments. Here, with Sammy's records, he only had to deal with thousands.

He piled the boxes one by one inside a vacant room at the Hillside and slowly and carefully read through each piece of paper, interrupted only by phone calls from a frantic Ron Weisner. Day turned to night and back to day, and the cycle continued again and again with noth-ing, not a single reference to any master recordings whatsoever. Weary and depressed, Sonny pulled a folder labeled TRANSAMERICAN from the next-to-last box and pulled out a single pink sheet of paper, which said BEKINS MOVING & STORAGE on top. Below, under GOODS RECEIVED, was handwritten: SYNI. It was some kind of invoice and it was dated 1973. Sonny picked up the phone, called the California operator, and asked for the number for Bekins in Los Angeles.

He dialed the number, and when the call was answered, Sonny asked if, by chance, Bekins might have something left over from the 1970s?

"I doubt it," said the voice on the other end of the phone. "What are you looking for?"

"Do you have anything there for SYNI?" said Sonny.

"Hold on a minute."

Sonny heard what sounded like the ruffling of papers. Then the voice returned. "No, we don't."

"How about Transamerican?" said Sonny.

The clerk put the phone down and looked through the papers again before picking up.

"Yeah, I think we do. It's from really long ago, but I think we still have it in one of our other storage facilities. I'm going to have to get back to you."

Sonny left his name and number, and waited.

———

More than four hundred friends and relatives bid a tearful farewell to Frank Sinatra on May 20, 1998. Tony Curtis, Joey Bishop, Lee Iacocca, Tom Selleck, Red Buttons, Larry King, Jack Lemmon, and Quincy Jones were among the mourners. Kirk Douglas and Gregory Peck spoke, as did Frank Sinatra Jr., who took umbrage at the long-standing controversy over his father's alleged mob ties and announced that President Clinton ordered that the casket be buried draped in an American flag. Honorary pallbearers included Tony Bennett, Ernest Borgnine, Wayne Newton, Steve Lawrence, Eliot Weisman, and Don Rickles.

Mia Farrow and Liza Minnelli both sobbed as they filed out of the Church of the Good Shepherd in Beverly Hills. Sonny saw snippets of the funeral on CNN. He thought it looked like a tribute to royalty. His mind was elsewhere, patiently awaiting word from Bekins. In the interim he helped his parents prepare for the upcoming weekend, which promised a full house. In the midst of cleaning chickens and inspecting rooms, he received an urgent call from California. It was the Bekins clerk, and he had good news. Two large storage containers belonging to Transamerican Entertainment had been located at one of their suburban storage facilities. The account had been opened under the name of SYNI in 1973, when four file cabinets, contents unknown, were stored.

"Who was paying for it?" said Sonny.

"No one. It's been delinquent for a while."

Sonny couldn't believe his luck. What storage facility, he asked himself, would keep something that hadn't been paid for? Especially when the unknown items in question belonged to Sammy Davis Jr.

The clerk said sixty-two more items were added to the storage lot in April 1977. The inbound inventory described the contents as "trunk," "case," "dish ctn," "trans file," and "cartons." All the items were classified as PBO, which indicated they were prepackaged by the owner, and the contents unknown to Bekins. The property was relocated by Bekins to another warehouse facility in 1979. In January 1982, the corporate name of the storage container was officially changed from SYNI

to TRANSAMERICAN ENTERTAINMENT. In July 1985 five more cartons of unknown, prepacked items were deposited into what were now two large containers. At different times, particularly during the late 1980s, various people were authorized to move items in and out of the containers. But in November 1989 the account was marked delinquent, because the most recent bill, for $1,077.16, had gone unpaid.

Shirley Rhodes, representing herself as president of Transamerican, informed Bekins that due to Sammy's unfortunate illness, the account could not be settled. Under the terms of its contract, Bekins had the right to sell the goods at auction. Instead, knowing who owned the property, they kept the containers in storage, where they gathered dust for nearly ten years. No one had any idea what was inside the containers, but the storage bill now exceeded $18,000, and for Sonny to gain access, he had to prove Altovise had ownership by faxing a copy of the Compromise of Claim and Indemnification Agreement and negotiating a compromise settlement of $5,000.

On June 5, 1998, Sonny faxed the paperwork and wired the money, along with a promise of another $3,500 in the event there were any valuable items inside. Three days later, he received a fax from Bekins, acknowledging receipt of the paperwork and money. All Bekins needed was advance notice prior to inspection to move the containers from their current location to Bekins' suburban Carson, California, warehouse. Two days later, on June 10, Sonny arrived in Los Angeles and rushed there from the airport. When he arrived at Bekins, he was led to the middle of the vast warehouse, where he stood before two large metal containers, positioned next to each other, each roughly eight feet high and ten feet wide. Each was covered in a thin layer of dust and marked with a label: TRANSAMERICAN.

Sonny watched nervously as a Bekins employee used a bolt cutter to slice through the lock of one container. But the double doors wouldn't open. A crowbar was used, and Sonny watched as the doors slowly were pried open, with a sound like a squeaking sonnet, while white light bathed the containers and illuminated the dust particles. Once the doors were opened, Sonny squinted, but he couldn't see past the fall-

..ig dust. He moved closer and stood in the doorway. It was musty, but Sonny could see boxes and clothes and other items lined up on each side, and he was speechless.

Inside the containers were many of Sammy's outfits he wore on-stage, and other custom clothing. There were audio and video tapes, and black leather portfolios with SDJ monogrammed in gold, which were used as scrapbooks. Some dated back to 1952 and included news-paper and magazine reviews of Sammy's performances. Sammy kept the books himself, and he had one for the years covering *Mr. Wonderful* and for *Porgy & Bess,* and another one for the Rat Pack years of 1960–1961. Other portfolios featured stories and reviews going back to the 1950s. Each portfolio was meticulously arranged, with the story or review neatly cut from the publication and carefully glued in perfect position.

One portfolio included clippings of news stories from 1967. It began on April 22, 1967, with a clip from *Where* magazine, touting "Sensa-tional Sammy Davis Jr. Highlights the Entertainment" at the Palestra in Philadelphia. A *San Francisco Examiner* story from May 30, 1967, was headlined: "May Britt Says Marriage Ended Her Film Career." Sammy's name, mentioned only once in the story, was underlined in red pencil. Sammy underlined his name in every story. And he collected anything and everything that mentioned his name or had some tie to him from dozens of newspapers and magazines throughout the United States, including the *Daily Sun* in Miami Beach, the *Chicago Defender,* the *Evening Star* in Washington, DC, the *Cincinnati Post,* and *Rocky Mountain News* in Denver.

Sammy also kept lyric and song sheets from performances dating back to the 1960s, along with conductors' lists. Each sheet contained a song list for the evening's performance, along with standbys in case Sammy didn't feel like singing a particular song.

There were countless photos, many of Sammy performing or ac-companied by some other star, such as Dean or Frank or even Jerry Lewis. Others were warm family photos of Sammy with May and their children when they lived in New York in the mid-1960s while a separate

portfolio included racy photos of showgirls taken by Sammy himself. An avid photographer, Sammy took hundreds of pictures of women in various states of dress and undress, posing on couches, in beds, and in bathtubs.

It was a treasure trove of Sammy memorabilia that also included reels of recording tape, which, like everything else, were kept safely wrapped in boxes and identified by year and label.

The two containers were filled with important, historical Sammy Davis Jr. items that no one, not even the IRS, knew about. Sonny couldn't believe his good fortune. But he was also confused. How, he thought, could this happen? This was Sammy's legacy, a mother lode, yet it was abandoned by the very people charged with handling his affairs. People who claimed they cared for him just let it all go.

Sonny immediately asked to be taken to the office, where he called Ron Weisner. When Weisner arrived and saw the tapes, he knew what they were.

"Holy shit," said Weisner. "The masters!"

Weisner cataloged the tapes one by one, removed them, and placed them in a separate storage facility. The following afternoon, Sonny returned to Bekins with Mark Davis.

Mark's troubled history with his father drew great empathy from Sonny. And despite his anger, Mark made a concerted effort to help Sonny, who was grateful, and he wanted Mark to be among the first to see the previously unknown treasure he discovered.

"Looks like a bunch of shit to me," said Mark.

But his initial bravado quickly faded as he browsed through the many items, and his hurt and anger morphed into wonderment and surprise, and within minutes Mark was like a child rummaging through Christmas presents. He read through several scrapbooks, touched the clothing, and yelled "Wow!" as he dug into the boxes containing Sammy's photos. His father's history was here, and it was the closest he had felt to him in years. He held one framed photo of his smiling father and wept. It was a younger Sammy, taken in the mid-1960s, and he

was posed in a sea of white women. Mark caressed the frame with his fingers, and then stroked the front of the photo as tears fell from the corners of his eyes. Mark spent hours inside the containers combing through the material, placing each item carefully back in its original position.

Altovise's arrival produced a far less emotional response. She was businesslike, and looked upon the contents like an insect inspecting its prey.

"Can we sell it?" she said.

Sonny said they found the masters, which meant the Rhino deal would go forward. And the memorabilia could, perhaps, be placed in a Sammy Davis Jr. museum, maybe in Las Vegas. Sonny said he would contact Sotheby's to have it all appraised.

"Well, make sure we put my name on the ownership ticket," she said.

Sonny placed Altovise's name on the Bekins log book as the owner. He had some reservations, given that his legal bill had climbed above half a million dollars. He had the pledge agreement with Altovise, which gave him ownership and interest in Sammy's estate in the event of non-payment of his bill, and he could have placed his name on the contents as a coowner, but he didn't.

The Rhino Records contract was finally signed on August 28, 1998, and it gave Rhino all publishing rights to Sammy-owned post-1964 recordings. Ownership of many other songs, including "The Candy Man," still remained with their respective record companies. In the case of "The Candy Man," that was Mike Curb. But the fortunate discovery of the masters yielded other Sammy recordings, the earliest a 1949 single called "Smile, Darn Ya, Smile." There were dozens of other tracks Sammy recorded in the 1950s, many for albums under the Decca label, including "That Old Black Magic," a 1955 single, and "The Lady Is a Tramp," from his 1960 album *I Gotta Right to Swing*. Sammy's old friend Morty Stevens conducted the orchestra for those and many of Sammy's other early recordings.

The wealth of music found in the containers spurred Rhino to include the pre-1964 recordings. Sonny and Weisner still had to negotiate the release of Sammy recordings owned by various record companies, in order to include them in the planned box set, but with the promise of new royalties there was little resistance.

By the end of 1998, Sonny had negotiated several other deals for Sammy's estate. Along with the Rhino and Global Icons money were checks for $20,000 for Sammy's share of "The Summit" video, another Sinatra endeavor in which Sonny simply received a check from Eliot Weisman with no explanation other than "this is what you get."

There was also $67,171 from Curb Records, which was an initial payment on monies due from delinquent royalties, along with smaller

checks from others, including $3,500 from Coca-Cola for the use of Sammy's image in a television commercial. Sammy's estate received over $850,000, by far the best year Sammy Davis Jr. had, dead or alive, since the Together Again tour a decade earlier.

Expenses included a final payment of $253,000 to the IRS and $248,000 in legal bills, including a small payment to Sonny, who was finally able to recover some of the money owed to him for his four-year representation. Other expenses included over $50,000 for Altovise's bills, including her rent, car, and medical insurance, and the balance sheet for the year saw the estate ahead $135,056. Sonny was more than pleased. The only monies due the IRS for each of the next five years would be 40 percent of earnings over $100,000. For 1998, that meant another payment of $14,022.

The debt was settled, and Sammy's estate was under Altovise's control. For 1999, Sonny estimated revenues would top $1 million due mostly to planned ventures with the estates of Frank Sinatra and Dean Martin with ideas to create Rat Pack hotels and a revival of Rat Pack shows.

Sonny also incorporated in October 1998 the Sammy Davis Jr. Foundation, Inc., a nonprofit that would perpetuate Sammy's name through donations to various charities. The foundation would appoint a board of directors, solicit start-up money, and prepare to fund-raise and produce Sammy-themed programs. The best part for Sonny was that Altovise agreed to make the foundation a family affair and sought participation from Sammy's children. Sonny even offered Mark Davis a paid job, contingent on current projects coming to fruition. Along with the planned Broadway musical and TV mini-series, and with Sammy's seventy-fifth birthday coming up in 2000, Sonny believed the foundation would help reestablish Sammy's position as one of the, if not the, greatest entertainers of the twentieth century. And ever-mindful of the 40 percent payments to the IRS, Sonny envisioned deals that would accrue payments over several years, at least through 2003, at which time the IRS would be finally gone and every penny would go to Sammy's estate.

It was a good plan. At least Sonny thought so. Altovise had different ideas. For the past year, and ignoring Sonny's advice, she returned to the role of Mrs. Sammy Davis Jr. with a vengeance, agreeing to numerous interviews to discuss her late husband and his career while planning to resurrect her own career as a dancer and actress. But she hadn't danced in years, and her acting "career" amounted to bit roles in 1970s television shows like *CHiPs* and *Charlie's Angels* and several forgettable movies, among them *Kingdom of the Spiders* with William Shatner in 1977 and *Can't Stop the Music* with Bruce Jenner and Valerie Perrine in 1980.

Altovise was still drinking, and she was becoming increasingly agitated over her lifestyle, which had improved considerably, given that all her bills were being paid and she had spending money. But she wanted more, and that was a return to her previous lifestyle and reclaiming her role as a celebrity. Sonny warned that wouldn't happen again, especially since her income had to remain at a workable level until 2003. But Altovise couldn't—or wouldn't—see it Sonny's way. All she saw was that Sonny had paid himself, even though it was a small amount, and she grew resentful. It was money owed to Sonny for years of work, but Altovise saw it as a hand dipping into *her* pool of money, and her paranoia returned, along with thoughts of Al Carter, Shirley Rhodes, and John Climaco.

Sonny had once been a dear friend and savior. But now, after so many years, she had come to see him as the enemy.

"Fucking Sinatras!"

The screaming, angry voice on the other end of the phone belonged to Mort Viner, and Sonny couldn't understand one single word from the profanity-laced diatribe.

"Calm down. What's going on?" said Sonny.

It was HBO, said Mort, and they cut a secret deal with the Frank Sinatra estate over the Rat Pack movie.

A year earlier, Mort, Sonny, and Bob Finkelstein all agreed there was little they could do to attach their clients' estates to the picture,

which HBO said was based on public domain. The film aired in August 1998, with a storyline focusing on events that transpired during the early 1960s, from the Rat Pack's appearances at the Sands in Las Vegas and the filming of *Ocean's Eleven* through the 1960 presidential election. The storyline also included Frank's close relationship with Sam Giancana, and Frank's introduction of Giancana's mistress, Judith Exner, to John F. Kennedy.

But Mort said he just learned that Finkelstein negotiated a deal that paid the Sinatra estate $250,000 based solely on assurances they would not sue HBO.

"He knew all along they were going to get some money out of this and they just played us along!" Mort screamed.

Sonny didn't know what to say or do. He remembered the meeting in Las Vegas, and orders were given, with no room for negotiating. Even in death, Frank Sinatra got what he wanted, and Sonny listened as Mort continued his rant. When he was finished, both men realized they had little recourse.

It was, said Mort, typical Sinatra business.

"Ah, I'm never going to deal with them again. They've screwed us. I can tell you this, they will never control me," said Mort.

"That's easy for you to say. Dean's got millions in his estate. I don't have any money. I'm starting from scratch," said Sonny.

"Yeah, I know that, but stay strong," said Mort. "And listen, kid. Remember what I told you in the beginning. Respect the Sinatras, but don't ever get too close to them. And don't ever, ever trust them."

Another long flight from New York to Los Angeles arrived in the late afternoon, and, as he had many times before, Sonny simply jumped into a cab at the airport and headed straight for his destination, which this time was Burt Boyar's penthouse.

The Quincy Jones musical had stalled after it was announced to the world in 1997. Quincy was busy with other projects, as was his co-producer on the musical, famed lyricist and composer Leslie Bricusse.

Burt was none too happy with yet another start, then stop. And he was also displeased that the potential book deal with Altovise fizzled. But Sonny's visit had nothing to do with movies, musicals, or books.

It had to do with tapes.

With no Broadway musical and no serious bites for film rights, Sonny gave television producers Gary Smith and David Wolper exclusive rights to produce a six-hour television mini-series on Sammy's life. Smith had produced seven variety shows featuring Sammy dating back to *Hullabaloo* in 1965. Altovise and Sammy's children would have a financial stake in the series, and Altovise and Sonny would coproduce.

To sell the project to a network, Sonny and Gary decided to produce a short film with video highlights of Sammy's career. But they wanted to overlap the video with Sammy's voice, and the question of the day was: Where is Sammy's voice?

Altovise recalled that Burt Boyar had roughly 150 hours of unedited, recorded conversation between himself, his wife, Jane, and Sammy, taped during research for the 1989 book *Why Me?* It was raw, unfettered, and uncensored conversation between the authors, on which Burt and Jane would draw to complete the book. Sonny thought Sammy's tapes could also fetch a fair price, or even be used as part of a museum, and given that Sonny believed that Sammy owned the rights to half the tapes, they were now coowned by Altovise. Sonny wanted the tapes, but when he arrived at Burt's penthouse and explained his plans, Burt refused to give them up.

"I'd destroy them first, before they were ever made public," Burt said.

Sonny was miffed. What, he said, could there possibly be on those tapes that the world already didn't know about Sammy Davis Jr.? Drugs? Adultery? Devil worship?

"I think you'd be surprised," said Burt.

"Surprise me," said Sonny.

Burt said Sammy talked in great detail about his relationship with Altovise, about the guilt that had overwhelmed him at what he sub-

jected her to, and how he never truly loved her. Altovise was simply an object Sammy controlled, said Burt.

But there was more, and Burt paused for a moment before leaning forward. What he had to say had to be said in a whisper.

"Sammy," said Burt, "knew who killed John F. Kennedy."

Sonny pulled back, shaking his head in disbelief.

"What?" said Sonny. "That's ludicrous. How in the world would Sammy Davis Jr., of all people, know who killed Kennedy?"

Burt reminded Sonny of wide and diverse circles in which Sammy traveled. One day he'd be having lunch in Mexico City with Sam Giancana, and days later he'd be talking national affairs over breakfast with the president of the United States. Burt said it was fair to say that Sammy knew people, many people, and that despite his reputation he was a very serious man. Burt also said he would never talk about the Kennedy assassination again.

Sonny was taken aback and unsure what to believe. If true, this was a profound revelation, and one that came out of left field, and beyond. But a revelation that struck Sonny hard. Sonny quickly collected himself, and his tone became vastly more serious as the old federal prosecutor emerged.

"I need to hear those tapes," said Sonny.

"Absolutely not," said Burt.

"We can take this to court," said Sonny.

"Do it, and I'll burn them," said Burt.

The two men were at a loggerheads, and Sonny didn't know what to do. He was still processing the Kennedy revelation and his mind raced in different directions.

"I don't understand something," said Burt. "From what you tell me, you haven't really been paid, yet you continue on this quest. People are thinking that you are involved with Altovise, that you are having a relationship with her."

"What?" said Sonny. "That's ridiculous. Who would even suggest something like that?"

"Shirley Rhodes, others who were close to Sammy," said Burt.

Sonny's eyes were on fire.

"Shirley Rhodes? I've never spoken to her. But I'm assuming you have?" said Sonny.

"Shirley's always been a good friend to me. And she really cared about Sammy," said Burt.

Sonny didn't realize until now that Burt had been and still was close to Shirley Rhodes. Burt played all sides of Sammy's family in his quest to continue to exploit his work with Sammy, and Sammy's legacy. His wife gone, it seemed like Sammy was all Burt had left in the world. But his offensive question about Sonny's relationship with Altovise crossed the line.

"I do this because I represent the estate of Sammy Davis Jr.," said Sonny. "And I will tell you, I want those tapes!"

Sonny was incensed. He and his family had cared for Altovise, nurtured her, spent years and money trying to get her well. Yet the sum result of those efforts was a scurrilous remark. And Sonny couldn't get his mind off what Burt said about Sammy and Kennedy. Sonny knew that Sammy, indeed, traveled in very diverse circles. But could he have had that kind of contact with the true power brokers, and did he really have insight into America's greatest mystery?

Sonny wanted to know more, but then he didn't. He knew this was sensitive territory. But he had so many other questions, and when he returned to his hotel, he hesitantly picked up the phone and dialed the number of the person he hoped would have some answers.

CHAPTER 19

The voice on Brian Dellow's answering machine was Sonny's, and he asked if they could talk again.

It was March 1999, and it had been four years since Brian and Sonny had spoken. Brian watched from the sidelines as Sonny regained control of Sammy's estate from the IRS. And he thought his discussion with Sonny about Sammy's will, especially the insurance policy for Sammy's road manager Murphy Bennett, would lead to some sort of investigation into Transamerican Entertainment. Yet no investigation materialized and Brian, disappointed, continued on with his own life, providing security for Quincy Jones. Now, there was yet another plea from Sonny Murray for help from Brian, the former British intelligence officer to whom Sammy bared his soul.

It began with conversations about the Kennedys. Not even Frank Sinatra could come to Sammy's aid after he married May Britt. But the bitter, and public, disappointment over the Kennedy flap didn't stop Sammy from calling Ethel Kennedy years later to express his condolences following Bobby Kennedy's assassination in 1968. Sammy always liked Bobby and even campaigned for him. He waited several weeks for the appropriate time to make the call, which Ethel received. But Sammy told Brian how Ethel immediately hung up the phone, refusing to hear Sammy's words and leaving him with a click and a dial tone. Sammy couldn't explain it. Ethel, of all the Kennedys, had always been kind. No doubt she lumped Sammy in with Frank and the darker elements

of his associations, people Ethel believed were involved in her husband's murder and the assassination of her brother-in-law.

Jacqueline Kennedy also believed those same people were involved in her husband's death, and fearing the Kennedys were targeted, Sammy told Brian that after Bobby's death Jacqueline turned to Frank Sinatra for assurances that her two children, John Jr. and Caroline, would not be harmed. Frank promised her the children were safe, but Jacqueline didn't believe him. She married Aristotle Onassis just months later and dropped her Secret Service protection. And for good reason, said Sammy. It was the Secret Service, he said, that took part in the assassination of John F. Kennedy.

Sammy told Brian that following his election, Kennedy had Secret Service protection every second of every day, which meant they were with him during his clandestine, extramarital romantic trysts, particularly with Judith Exner. The young brunette was Frank Sinatra's former lover, and it was Frank who introduced her to Kennedy during the 1960 campaign. But Frank had also introduced Judith to Sam Giancana, the Chicago mob boss. Secret Service agents assigned to Kennedy knew of his affair, and the FBI later learned of it through wiretaps of Giancana. When Kennedy was informed in February 1962 that the FBI knew of his romantic liaison with Judith, and her relationship with Giancana, he ended the affair and canceled his stay at Frank Sinatra's Palm Springs home in March 1962. It was a national security nightmare, a sitting president sharing a woman with a major mob boss.

When Kennedy's motorcade left Love Field on November 22, 1963, the Secret Service called off the Dallas police detail usually assigned to accompany presidential visits, saying it would handle all security. Others were involved in the assassination, said Sammy, and Brian could only surmise who they were. Sammy didn't say and he never told Brian how he knew it or who told him. As ludicrous as it may have sounded—Sammy Davis Jr. knowing some of the details of the Kennedy assassination—Brian believed every word of the story. He had his own share of national security secrets while serving for British intelligence, and he

knew from experience that Sammy traveled in very powerful circles. Sammy was among the select few who could claim personal relationships with presidents, kings, and queens on one hand, and gangsters, scam artists, and murderers on the other. In 1972 Sammy visited with Giancana in Mexico City, where he lived in exile in a villa near Cuernavaca. Following the reunion with Giancana, Sammy was a guest at the White House, visiting with President Nixon.

Sammy told Brian about his first meeting with Nixon at the Copacabana in New York in the 1950s. Unlike the Kennedys, Nixon seemed to genuinely respect Sammy, or at least Sammy's talent, which is why Sammy agreed to work for the Nixon Republican administration. But the pairing inflamed black America, and those flames turned into a wildfire when, on the final day of the Republican National Convention in 1972, Sammy stepped out of the shadows after giving a performance and wrapped his arms around Nixon. It was a momentary outpouring of genuine warmth between two friends, but black America saw "the hug" as a traitorous act and it only served as affirmation of a longstanding view that Sammy indeed was an Uncle Tom.

"I wouldn't tell you I'd do it again and I wouldn't tell you why I did it," Sammy told Brian. "It was just something I did at that moment."

Sammy was always doing things in the moment, but by the 1980s the moments were few and far between. Sammy's fees had declined and his expenses had risen, leading to even leaner times. By 1985 employee payroll checks were sometimes delayed, as was an occasional alimony check to May Britt, who still received $2,500 per month. Sammy had hip replacement surgery in 1985 and later announced he had overcome addictions to alcohol and cocaine. But he couldn't overcome his failing financial health, which despite his earnings had been on life support for so many years. Now it was about to flatline. He turned to E. F. Hutton for a $1 million loan and borrowed off the equity from his home while tapping his myriad of life insurance policies. When George Rhodes, Shirley's husband and Sammy's conductor, died suddenly from a heart attack in 1985, a despondent Sammy asked his good friend Jesse Jack-

son to come to Los Angeles to perform the eulogy. Jesse agreed, but for a price. He demanded $5,000 in cash, four first-class plane tickets, and two suites at the Four Seasons. When Jesse arrived, Sammy didn't have any cash on hand, so he turned to Brian, asking him to take a $5,000 cash advance off his credit card. Brian complied without question.

Sammy's home life remained as turbulent as his finances. When Altovise returned from the Betty Ford clinic where she underwent treatment for her alcohol addiction, she was forced to share her home with Sammy's live-in lover Sue Turner, along with a bevy of other characters who wondered in and out of Sammy's home.

Harvey King was still there, running his games while watching over Sammy. Burt Boyar arrived from Spain with his wife, Jane, to begin their research for Sammy's next book. Donald Rumsfeld was also there, spending his nights at the pool house, while other, more ominous characters lurked in the background. Among them was Martin Taccetta, a high-ranking member of New Jersey's Luchese crime family, who came to California to build up the family's porno and video business. It was Al Carter who introduced Taccetta to Sammy and Altovise.

It wasn't until 1988 that Sammy's finances improved, thanks solely to the reuniting of the Rat Pack for the Together Again tour. It was Frank Sinatra's idea, for the aging Rat Packers to reunite for a final fling around the world, and Brian was at one of the first organizational meetings with Sammy, Shirley, Mort Viner, Eliot Weisman, and Bob Finkelstein. Finkelstein said Frank knew about Sammy's poor financial situation and, knowing his friend wouldn't take a handout, thought a tour would clear Sammy's debts and provide a few laughs.

"Frank wants to do this so Sammy will make some money," said Weisman. "He'll make money, we'll all make money."

Dean initially resisted the tour. He still suffered greatly from the loss of his son Dean Paul earlier that year and he was in no condition emotionally nor had the desire to tour arenas and stadiums around the world. But Frank insisted, arguing it would be good for Dean to get away. Dean grudgingly agreed.

For Sammy, deeply in debt or not, there was no choice.

The order came from Frank and Sammy of course said yes. But Sammy did like the idea that he was with the "big boys" again, and he embraced the tour. They dressed in tuxedos to announce the tour at a press conference at Chasen's Restaurant in Los Angeles on December 1, 1987, and they opened on March 13, 1988, before a full house at the Oakland Coliseum. Dean performed first, but problems with the sound system muted his voice. Sammy followed, announcing that he had been sober for three years, before singing a thirty-five-minute set of his famous standards. Frank came out last, sang for thirty minutes, and then, after a brief intermission, they came out together for a medley to close the show. Dean's heart clearly wasn't in it, and during that first week Frank became increasingly annoyed at Dean's poor performances. He forgot lyrics, sometimes didn't sing loud enough, and had a blasé attitude toward the entire endeavor. Dean was also agitated about Frank's insistence that they party like they did years ago. Frank, even at seventy-two, wanted to drink, carouse with women, and, of course, throw cherry bombs in the hotel hallways, something he learned long ago from Sam Giancana. Dean, now seventy, wanted to sleep at night, as did Sammy, who at sixty-two couldn't keep up with his old ways and preferred instead to get to bed early.

But as he always did when it came to Frank, Sammy gave in and joined his old friend for the late-night gatherings. Dean's continued reluctance sent Frank into a tizzy. After their arrival in Chicago, Dean was given a suite on a separate floor from Frank and Sammy. Frank wanted everyone together, just like old times. But Dean wanted to stay put. Frank called Mort and lost his famous temper, ridiculing Dean for his poor performances and for not pulling himself up and out of his emotional funk. Frank wanted Mort to straighten Dean out, and he was to start by ensuring that Dean would attend a party at Frank's suite that night. Sammy was there, but Dean was nowhere to be found, and Frank yelled over to Brian, who was talking to Jilly Rizzo.

"Hey, where's Dean?" said Frank.

"I thought he was coming down," said Brian.

"Don't think. Go upstairs and get him, right now," Frank ordered.

Brian went to Dean's room and knocked on the door, but there was no answer. Brian pressed his ear against the door but heard nothing. He returned to Frank's suite.

"He's not in his room," said Brian.

"Well where the fuck is he?" Frank bellowed, causing an immediate halt to the party.

People flew out of the suite to find Dean Martin, and within minutes word came back that Dean had left the hotel for the airport, where he boarded a private jet for Los Angeles. When he arrived there, he checked himself into Cedars-Sinai Hospital, complaining of kidney ailments. In reality the pain was Frank Sinatra, and Dean had had enough.

Hours later, as dawn broke, Brian sat in a chair in Sammy's suite, listening to Frank, Sammy, Eliot Weisman, and several others discuss whom they could get to replace Dean. The tour was a cash cow and had to continue. The overwhelmingly popular choice was Liza Minnelli, who was represented by Weisman, and after a brief pause the tour continued under a new moniker, The Ultimate Event. It was a spectacular success, and Sammy's financial fortunes had finally turned, even at a performance-contracted rate. Frank's people, as always, set the fees and Frank, as always, took the lion's share, and that included a major piece of the souvenirs and concession revenues. But the numbers reported for tax purposes, and to be split with Sammy and Liza, were far less than actually received. Brian watched as Frank's people skimmed off the top of everything, stuffing bags of cash into suitcases, which were taken out of each arena or stadium before it could be counted. Sammy knew of the skim but said nothing, and Brian wondered just how good a friend Frank Sinatra really was.

The tour, and Sammy's cash flow, came to a sudden halt in August 1989. For months Sammy endured a persistent sore throat, and he had difficulty singing. He was in Orlando when, his voice breaking during simple conversation, he decided to fly to Los Angeles for tests at Cedars-Sinai Hospital. A biopsy produced the cancer diagnosis. The doctors suggested surgery to remove the tumor, saying there was an 80 percent

chance of survival. But they'd have to remove Sammy's larynx. Sammy declined, opting instead for radiation and chemotherapy even though they offered only a 30 percent chance of success.

"What can I do? If I can't sing I can't do anything," he said.

Brian suggested that Sammy could dance or direct or do something else in entertainment. But Sammy was pragmatic and had a clear grasp of his situation, particularly his dismal financial affairs. He reasoned that if he couldn't perform live and earn, then he might as well be dead. Without his performance income, whatever remaining money he had would quickly dry up and force Sammy to file for bankruptcy, sell his home, and seek handouts from friends, which was something Sammy said he would never do.

"If I can't sing, I can't be Sammy Davis Jr.," he said.

Brian thought long and hard about what he knew, and he thought even longer about Sonny. What would Sonny do with all this information? Would it really help Sammy if the world knew? Prior to his one conversation with Sonny, Brian had never talked about Sammy or his affairs to anyone. His training wouldn't allow it. And he again decided against sharing it.

Brian never returned Sonny's call.

CHAPTER

20

Sy Marsh strode briskly up the Avenue of the Stars and toward the Century Plaza Hotel. Even at eighty years of age, he still worked out regularly at the Century West Club, where he reminisced about the old days, and the old clients.

Sy was once a preeminent agent at the William Morris Agency, whose client roster included Elvis Presley, Marilyn Monroe, and Steve McQueen. But Sy's favorite client was Sammy Davis Jr. Sy watched as Sammy exploded into stardom in the 1950s and continued on his upward rise through the 1960s, only to see his career come to a near standstill by 1970. Sammy still commanded high fees for his live performances, but he couldn't find a music role, or a hit record, or a meaty television role. And despite millions in earnings, Sammy was always broke and living off of advances from various Las Vegas casinos. Sy knew Sammy was borrowing a hundred thousand here and another hundred thousand there to pay for a growing gambling habit, a private jet he leased from MGM studio head Kirk Kerkorian, and a weekly overhead of $25,000 for his entourage whether he worked or not. The loans began in the late 1950s, when Sammy borrowed $100,000 from Chicago mobsters associated with the Chez Paree club. The loan was interest-free, but in return Sammy promised to pay 20 percent of his earnings for fifteen years. To oversee the loan, a Chicago attorney Joe Borenstein was assigned to represent Sammy. Borenstein remained with Sammy through the 1960s, and by 1971, in a desperate bid for solvency, Sammy asked Sy to become his partner.

Sy had been with William Morris for years, and planned on retiring from there a millionaire. But Sy was intrigued by Sammy's offer, which included a 50 percent split of the profits. So after a discussion with his wife, Molly, he accepted it. Sammy and Sy formed a corporation, SYNI, and each drew on their individual expertise—Sammy on the stage, Sy in business—to make their partnership a success. Sy immediately slashed expenses—which included getting rid of the private jet—and he sought to create and capitalize on other opportunities aside from the $100,000 a week and more Sammy earned performing in Las Vegas. He got Sammy an Alka-Seltzer commercial that paid $250,000 for a single day's work. He also got Sammy his own television show, *Sammy & Company,* and negotiated a new recording deal with Berry Gordy's Motown Records.

Sammy had recorded for Frank Sinatra's Reprise label throughout the 1960s. But since Sammy didn't write his own songs and the good tunes were always given to Frank, Sammy was left with a mediocre catalog and dismal sales. His work for Motown didn't fare any better, and Motown owner Berry Gordy gave Sammy his master tapes following their breakup. Sy had them placed in a storage facility with other valuables important to Sammy, such as personal photos and scrapbooks, which Sonny found years later.

Aside from *Sammy & Company,* Sy tried to find other vehicles for Sammy, but there was little interest. And despite a two-year run, *Sammy & Company* was roundly panned by critics, who ridiculed Sammy for everything from his poor interviewing skills to a penchant for laughing too hard at bad jokes and comments. Sammy's bread and butter remained live performances. Their partnership dissolved in 1981, when Sammy turned to Shirley Rhodes and John Climaco.

Sonny saw the slight old man with the sprightly step walk into the hotel lobby, and they sat on a couch to talk. It was Sonny who asked for the meeting, calling Sy at the suggestion of Mort Viner, and the hotel was near the health club. Sonny knew the conversation would produce no material gain for Sammy's estate, but he was troubled. Sammy's estate documents revealed issues with financial planning and the

decision-making involved. Not once, Sonny believed, did the executors, John Climaco and Shirley Rhodes, make any attempt to save the estate. Sonny needed to hear more, and since it wouldn't come from Brian Dellow, Sonny reached out to Sy, who was eager to talk.

Sy told Sonny about his early relationship with Sammy, how he was in awe of Sammy's talent, and how he tried so hard to deliver on television shows, movies, and records. He took credit for talking Sammy into doing "The Candy Man," and took the blame for getting Sammy another shot at his own television show. But the partnership was fraught with problems from the beginning, he said. While Sy concentrated on the entertainment, others took over the business side.

Sy told Sonny how he bought into the tax shelters with Sammy and, upon their breakup, he was forced to sell his $2 million Beverly Hills home to pay his IRS debt, after which he moved into a much smaller, $600,000 home.

"You know I didn't have anything to do with those tax shelters," said Sy.

"But you got the blame. Why did you let that happen?"

Sy paused, and thought long and hard.

"There were other people who were always involved with Sammy," said Sy. "And they controlled Sammy. I didn't know it when we went into business, but when I found out I thought I could work around it. In the end, they destroyed me, just like they destroyed Sammy."

In May 1973, the National Highway Safety Foundation held its very first and only telethon. Famed game show host Monty Hall joined Sammy in hosting the event, which featured appearances by Muhammad Ali, Ray Charles, Dick Clark, Howard Cosell, Jerry Lewis, and a slew of others. Steve Allen was there with his wife Jayne Meadows, and Steve, as he was apt to do, talked into a little voice recorder, which he often carried with him.

Steve noted into his recorder the heavy presence of organized crime figures lurking backstage and mixing in with Sammy and his extended entourage. Steve had seen mobsters before, but never in these numbers.

And Sammy seemed to embrace them, even accepting a $10,000 check from Joe Colombo Jr., son of a New York Mafia leader who had been shot and critically wounded two years earlier.

Also mingling backstage was Richard Wayman.

Wayman was a partner with Ernst & Ernst, a major accounting firm in Cleveland. Aside from numbers, Wayman's real love was shooting photos of auto wrecks. Beginning in the late 1950s, Wayman suddenly appeared at bloody crashes on Ohio's highways with a handheld color camera and took pictures of the grisly aftermath of horrendous car crashes, body parts and all. Wayman gave appreciative police departments copies of his photos, and the somewhat ghoulish hobby turned into a full-time endeavor, with Wayman forming the National Highway Safety Foundation and producing films that were shown throughout high schools during the 1960s. *Signal 30* won a National Safety Council Award, and *Mechanized Death* and *Wheels of Tragedy* were just a few of the other bloody gore-fests shown to students nationwide as part of their driver's education courses. The NHSF was a nonprofit agency Wayman funded through bank loans, state, and federal grants. But in 1972 Wayman came up with another idea to raise money: adding Sammy Davis Jr. to his board of directors.

Everyone knew that Sammy had lost his left eye in a car crash in 1954, and given Sammy's national celebrity, his association would legitimize the foundation and help gain approval for additional state and federal grants. Wayman also needed star power to legitimize a telethon, and Sammy's drawing power would not only entice other major celebrities to appear but it would elicit millions in pledges from the public. Sammy would be to highway safety what Jerry Lewis was to muscular dystrophy.

Sammy agreed to lend his name to the foundation, and articles on highway safety bearing Sammy's byline appeared in newspapers across the country. Soon after, in May 1973, Sammy hosted the NHSF telethon. The event raised a disappointing $1.2 million in pledges, yet Wayman reported receiving only $500,000. Wayman considered the telethon a success and scheduled another one for 1974, but he was

forced to cancel it amid allegations that he and the NHSF received millions in bank loans using forged documents. Wayman's accounting firm, Ernst & Ernst, which later became Ernst & Young, mysteriously agreed to pay over $5 million in defaulted NHSF loans to a Cleveland bank, but the state attorney general had already begun an investigation, probing whether the foundation was a front for organized crime to use the foundation's nonprofit status to siphon millions in federal and state grants. Fearing prosecution, Wayman fled to California, where he immediately took on the role of Sammy's business manager.

Throughout his career, Sammy watched firsthand as Frank Sinatra built his reputation around talent and muscle, with the latter provided by Frank's underworld friends from Chicago and New York. Frank didn't ask, like everyone else, he ordered. And people responded. Sammy admired Frank's power and his ability to make things happen. Sammy also liked the idea of associating with the same unsavory characters. Being feared meant being respected. But unlike Frank, who kept his business dealings with the underworld at arm's length, Sammy jumped in headfirst, from borrowing money from Chicago mobsters to allowing his name to be used in various business ventures. Such was the case with Wayman, an eccentric who lived in a bus and dressed in tacky polyester suits.

It was Wayman, not Sy, who took over Sammy's career after his arrival in California in 1974, and it didn't take Wayman long to involve Sammy in a number of business deals, one of which was the purchase of a building to house a television studio. They called it TAV, otherwise known as Transamerican Video, and Sammy taped his talk show there. They also opened Command Video, which was a production facility for new Beta and VHS formats, which had just been introduced to the market. Sammy, as was his usual way when it came to business, bet on the larger, Beta tape format. But the American public showed a clear preference for VHS, and Beta quickly fell out of favor.

While the venture appeared to be a total bust, it wasn't. Wayman's affinity for blood and severed body parts on film transformed into a love for pornography, which he shared with Sammy, and Command Video,

aside from its advertised business of producing television commercials and duplicating video tapes, was also used to duplicate porno movies onto video to be sold to stores around the country. During one embarrassing moment, executives from a major auto dealer visited Command Video to view their new television commercial. But when the commercial was played, a skin flick appeared instead.

Sammy maintained a rigorous tour schedule and didn't know—or didn't want to know—what was really going on. There wasn't much he could do anyway, given the people he was involved with. Wayman, for instance, gave a $50,000 check to one of Sammy's employees to deposit into his personal account. The idea was to hold the check until it cleared, and then return the money to Wayman. But the FBI and IRS, investigating Wayman on a number of fronts, swooped down on the poor employee and charged him with money laundering. It took months before the employee could clear his name.

Wayman became a corporate officer of SYNI and he concocted a number of other ideas and scams, from investing in a gourmet quail farm in Texas to Sammy's sponsorship of the Greater Hartford Open golf tournament. Sammy was also involved in Daniel Boone Chicken, a fast-food chain in Tennessee designed to compete against Kentucky Fried Chicken. The chicken idea was nothing more than a ruse to use Sammy's great name to entice investors unaware that the business was destined to close as quickly as it opened. The golf tournament, on the other hand, survived more than a decade, and was one of Sammy's few legitimate business ventures. Sammy loved to play golf and he took great delight in the fact that his name was attached to an official Professional Golf Association event. Wayman also created the Sammy Davis Jr. Foundation for Highway Safety, yet another questionable nonprofit with no discernible purpose other than to collect proceeds from a two-record collection of Sammy's greatest hits in 1975.

Sy explained that all anyone had to do was say to Sammy, "You'll be my partner," and in his own innocent, childlike way Sammy would jump at the chance. But no one ever defined "partner," and Sy grew increasingly frustrated with Sammy's business dealings away from en-

tertainment. He was also troubled by John Climaco, the young attorney from Cleveland, who was introduced by Wayman.

Climaco graduated from law school in 1967 but within a few years he had built an impressive clientele that included many of Cleveland's power brokers. He also represented a Cleveland civil service association, the Cleveland Police Patrolmen's Association, and the city council. By 1974, Climaco had a new client: Sammy Davis Jr. It was Climaco who represented Sammy in a federal lawsuit alleging that he had personally taken part in the Daniel Boone Chicken scam. The lawsuit was eventually dismissed on a statute-of-limitations technicality, and it was Climaco who represented SYNI in various legal matters and who introduced Sammy to another famous client, Jackie Presser.

A powerful Cleveland union leader, Jackie was the son of Bill Presser, a vice president of the Teamsters union and protégé of famed Teamsters leader Jimmy Hoffa. Together, the Pressers were among the most powerful members of the Teamsters union and served as trustees of the Central States Pension Fund, which was the richest Teamsters pension fund in the country, known to law enforcement as the "mob's bank."

Throughout the 1960s and 1970s the Central States fund had secretly lent over $1 billion in real estate loans for various projects in and around Las Vegas, from money for spanking-new hotels and casinos like Caesars Palace, the Stardust, Fremont, Aladdin, and Circus Circus, to golf courses and a hospital. But the fund was controlled by organized crime, and trustees like the Pressers took their orders from various mob families in Cleveland, Chicago, Milwaukee, Scranton, and Kansas City, and they directed tens of millions to Las Vegas. Organized crime held control over many of the casinos, which raked in tens of millions each year. And to fatten their profits, skimming had become the bread-and-butter operation. And to help propel the skim, the mob employed entertainers, particularly Sammy and Frank Sinatra, whose drawing power brought in more people than even the most popular conventions, which produced millions more for the skimming operations. Aside from taking their cut before taxes from all gambling receipts, the mob took money any other way it could, from parking, concessions, food, and placing

loan sharks in the casinos to loan money to gamblers short on cash. They even reduced the winning percentages programmed into gambling machines, especially when Sammy or Frank performed. Their ability to draw large crowds increased the skim by millions, and by the late 1970s Sammy was among the mob's most prized possessions. Along with Frank, Sammy was considered to be one of the mob's best "earners."

The Central States fund propelled two decades of unprecedented growth in Las Vegas, and the Teamsters leaders held the kind of power and influence that allowed them to move freely within national political circles. The confluence of politics, entertainment, and organized crime served as a moving force in American culture. Presser and Teamsters president Frank Fitzsimmons played golf with President Nixon, and they regularly rubbed shoulders with senators, congressmen, and titans of business and entertainment, including Sammy, whose great celebrity continued to be exploited.

Deil Gustafson, a Minnesota banker who headed a partnership that controlled the Tropicana casino, announced in 1974 he was going to buy the Tropicana outright. One of his partners, he said, was Sammy, who had agreed to invest $800,000. Sammy was ecstatic over the possibility of becoming the first black man to have an ownership position in a Vegas property. But in reality, Sammy was used, as he was in so many other deals, as nothing more than a front. Behind the scenes, Gustafson sought a $49 million loan from the Central States fund on behalf of Edward and Fred Doumani, the Tropicana's silent landlords. Publicly attaching Sammy's name to the purchase served as the perfect foil to gain approval for a loan for the Doumani brothers, who had longstanding ties to Midwest organized-crime families. The loan had the support of Sammy's new friend Jackie Presser, who approached other Teamsters officials, including Teamsters president Frank Fitzsimmons, for their support. But the real powers overseeing the loans, the heads of the various crime families, negated the loan and the deal, since they had already gained control of the skimming operations at the Tropicana.

After the Tropicana deal went sour, Sammy signed a contract—negotiated by Wayman—with Caesars in 1975, which paid him $150,000

a week to perform at its brand-new Circus Maximus theater. Sammy's impressive earnings were a sign of respect to his talent and drawing power, and he was also bathed in drugs and women. But the crime families respected little else about him, believing he was nothing more than a dumb black entertainer with a bad cocaine habit. And they considered their investment in his six-figure weekly contracts minimal, given the millions they were making from the skim off the packed houses Sammy drew. He even returned a portion of his earnings back to the casino in gambling losses he incurred playing with the high rollers. Sammy and Frank always attracted the high rollers, with whom they were expected to play. While Sammy had to repay his gambling losses, Frank was given a free ride. At the baccarat tables, Frank received markers—or casino credit—which often reached into six figures. He was allowed to keep his winnings, but his losses were never repaid.

Sammy, who never knew about Frank's arrangement, liked the idea of being "one of them." He felt powerful, respected, and protected, just like Frank. If he had a problem, he had "friends" who would take care of it. But Sammy was always reminded that the benefit of being mobbed up went both ways. When a high-ranking mobster in Chicago wanted Sammy to perform at his daughter's wedding, Sammy was summoned. And when someone wanted to attach Sammy's name to a new business, Sammy did it without question, oblivious to the true nature of the venture, which often was to defraud its investors. When the venture crashed, Sammy remained ignorant and chalked it up to bad luck. And when a mobster wanted Sammy to perform, just like Frank did with the Westchester Premier Theater, Sammy was there, like he was in July 1974 to open the new Front Row Theater in Cleveland. Among the Front Row's investors was his new friend, Jackie Presser.

Given Sammy's high value, a "handler" was assigned to watch Sammy and take control over any situation that may develop, such as an overdose or car accident or sexual assault or even a murder. The mob didn't care what Sammy did, just so long as they could clean it up and protect their investment, who packed in the crowds as the skim flowed. They also kept Sammy happy, docile, and controllable by contributing

to a cocaine habit that became so severe, by 1980 even the FBI knew about it from wiretaps and interviews with confidential informants.

The Justice Department began investigating organized crime's influence over Las Vegas in 1974 and placed wiretaps inside several Las Vegas casinos. For years the FBI patiently collected evidence, and in 1981 a federal grand jury in Kansas City indicted over a dozen top organized-crime figures, including the head of the Kansas City family, on charges of conspiring to gain control of several Las Vegas casinos and skim money from gambling, restaurants, gift shops, concessions, and parking. The subsequent federal prosecutions, including another one involving credit card fraud in Chicago, resulted in numerous convictions and finally ended the mob's control over the Las Vegas casinos. The skim was dead, as was Sammy's relationship with Sy.

Publicly, their breakup was blamed on an aging star with tax problems, whose drawing power had diminished. But privately, Sy knew that Sammy's downward spiral came hand in hand with investigations by the Nevada Gaming Commission and the FBI. Ending the skim all but put a stop to Sammy's big paydays and Sy was soon forced out. Shirley Rhodes was named Sammy's manager, while John Climaco's role over Sammy's affairs increased after Richard Wayman died in 1983.

While representing Sammy, Climaco continued to represent Jackie Presser, who developed a close personal relationship with President Ronald Reagan and served on Reagan's 1981 transition team. When Presser was elected Teamsters president in 1984, he appointed Climaco the Teamsters chief legal counsel. Presser, who had for years dodged allegations that he was inextricably tied to organized crime, was subpoenaed to testify in 1985 before the President's Commission on Organized Crime, which was investigating mob influence of the Teamsters. Former Teamsters president Roy Williams had already told the commission about Presser's extended connections to organized crime in Cleveland and elsewhere. As an example, Williams testified that Presser sought kickbacks for his help in gaining a pension loan for the Doumani brothers and Deil Gustafson in their failed bid to buy the Tropicana, which had been made under the guise of Sammy's participation.

With Climaco at his side, Presser appeared before the commission, but he refused to testify and invoked his Fifth Amendment right against self-incrimination. Presser also refused to answer the commission's questions involving his association with the Front Row Theater, on the grounds that they might incriminate him. The commission eventually determined that corruption overwhelmed the Teamsters and was part of their daily business operations, and it recommended the U.S. government seek court supervision of the union.

In 1988 the Justice Department filed suit to oust Presser and other senior Teamsters leaders, claiming that the union had made a "devil's pact" with organized crime. Prosecutors sought a court-appointed trustee to oversee new elections for the union, which counted over 1.7 million members. The suit, filed by Rudolph Giuliani, the U.S. attorney in Manhattan, alleged that organized-crime figures deprived union members of their rights through a "campaign of fear." Among the defendants were Presser, his executive board, leaders of six organized-crime families, and several of their associates. Climaco had tried to negotiate a deal with Giuliani before the suit was filed, promising to clean up the union, but Giuliani wouldn't budge. The morning after the suit was filed, Climaco angrily denied the charges during interviews opposite Giuliani on the morning news shows, including NBC's *Today* show and ABC's *Good Morning America*.

"It's pure myth that this organization is in any way influenced or controlled by organized crime," Climaco said.

Presser, who was awaiting trial from a separate 1986 criminal indictment alleging that he padded the payroll with ghost employees for his local union in Cleveland, was stricken with brain cancer and died of a heart attack in July 1988. Following Presser's death, the Teamsters quickly ordered Climaco to clean out his Washington, DC, office. He returned to Cleveland and turned his attention to his law firm, and to Sammy, who had embarked on a world tour with Frank Sinatra and Liza Minnelli.

It was Climaco who supported yet another business idea for Sammy, a new food product line called "Sammy's Best," manufactured by Sam-

my's new company, SDJ Food Corporation, which was headquartered in Cleveland. But Sammy knew from experience his real participation in "Sammy's Best" was his name, and he didn't even bother to attend the press conference announcing the new venture, which Climaco hosted in Cleveland in March 1989, touting Sammy's own "Basin St. Barbeque Sauce." Once again, just like Sammy's myriad other businesses and ventures, investors supplied the financing, the business was introduced, and the venture soon dropped off the face of the earth.

And so would Sammy.

In May 1990, he was terminally ill and near death; everything gone, or soon would be. All he had left was his name, which he bequeathed to Altovise on his deathbed.

Sy, who was elegant in his manner and speech and resembling something out of a 1950s Hollywood yearbook, remained friends with Sammy until the very end. But he was deeply bitter over his own fate and that of his former partner.

"I gave up my career for Sammy," said Sy.

Following their split, Sy lived in near ignominy, his biggest deal pitching movie rights for the story of Joe Hunt, a convicted murderer and leader of the infamous rich kids Billionaire Boys' Club.

Now, Sy tried to bury his ill will and sad fate during his nightly walks, when he remembered the good times with Sammy. But it was hard to erase the memories of those he believed led Sammy to his downfall.

CHAPTER
21

Gary Smith needed a host.

The television variety show producer had just signed Jerry Lewis, Juliet Prowse, comedian Charlie Callas, and a young actor named Barry Bostwick to appear in a show called The Klowns. *Inspired by the success of the 1960s program* The Monkees, *Gary and his partner, Dwight Hemion, conceived a show featuring four singing clowns in full makeup. The show was a tie-in to the Ringling Bros. and Barnum & Bailey Circus and set to air on ABC on November 15, 1970. Only Gary needed a host, and he knew whom he wanted. But it had been five years since he last spoke with Sammy Davis Jr. It was at a dinner in New York in September 1965 and Gary and Sammy met at Jilly's Place on West 52nd Street. Sammy sought a quiet, fairly private place to talk about his new variety show and his idea for Gary to produce.*

Only thirty years old, Gary was rising quickly and carving a successful career in the television industry. He began working as an assistant on The Jackie Gleason Show *and now he was the producer of* Hullabaloo, *a weekly musical variety program that featured an eclectic ensemble of musicians and bands, from The Rolling Stones and Sonny and Cher to The Supremes and Dionne Warwick. It aired on NBC and was hip, fun, and cool, with a group of young dancers accompanying many of the performing artists. Each program featured a special host, and Gary wanted Sammy to host a show. Both were represented by the William*

Morris Agency, but they had never met. Sammy was performing on Broadway in Golden Boy *and Gary decided to buy a ticket. He marveled at Sammy's performance, and visited Sammy in his dressing room afterward. Gary's pitch was that* Hullabaloo *was a successful show with all young people performing. Sammy was nearing forty, but the idea of hosting a show with people about half his age was appealing.*

"I'll do it, I love the show," he said.

But Sammy had one request. He wanted Gary to book a young female singer named Lola Falana.

"Who is she?" said Gary.

"Someone I know who'll knock you out. She's great," said Sammy.

The Hullabaloo *show aired in February 1965 and Gary smiled from ear to ear. Despite the age difference, Sammy was in his element, shaking and dancing and singing. He enjoyed it so much he hosted the show again in April, and in September, which featured performances by Diana Ross and Mary Wilson. Following Sammy's September appearance, Gary's agent called him to say that Sammy wanted to have dinner. Sammy was getting his own show on NBC,* The Sammy Davis Jr. Show, *and Sammy wanted Gary to produce.*

When they met, they took a table in the back, and Sammy talked excitedly about his vision for the show, with a premiere that included Elizabeth Taylor and Richard Burton as guests.

"I think I can get them," said Sammy.

Sammy also wanted to open the show with "Nothing Can Stop Me Now," and hire his good friend George Rhodes as the musical director.

Sammy was animated, his hands waving in the air as his gold chains bounced between the open shirt collar and off his small chest.

"So, what do you think?" said Sammy.

Gary paused for a moment. His three experiences with Sammy on Hullabaloo *couldn't have been better. Sammy was a profes-*

sional who arrived on time, worked hard during rehearsals, and easily mingled with his younger guests. But Gary also knew that Sammy had an enormous ego, and telling someone with an ego the size of Manhattan that he didn't share the same vision would have to be done with great delicacy and tact.

"Well," said Gary. "I don't want to bullshit you. I think America needs to rediscover Sammy Davis Jr. They know who you are, but I wouldn't open with 'Nothing Can Stop Me Now.'"

Gary also told him he would tone down the jewelry.

"It's not about showing off but I'd want people to see a Sammy they can walk up to on the street," said Gary. "The minute somebody comes on television and says, 'Look at me, aren't you lucky I'm coming into your living room, I am the greatest performer there is,' then you're not giving that audience a chance to root for you."

Gary also suggested that using George Rhodes as musical conductor could be a disaster.

"He's your concert conductor, which is different from doing a television show, where you're getting cues in your ear and have guests to deal with and have to know every intro and commercial break. I love George, but I don't think he's ever done that," said Gary.

Sammy listened closely to Gary's input. After finishing their dinner, they hugged and said good-bye. The next day Gary received a phone call informing him that Sammy went back to the William Morris Agency and told them he didn't agree with Gary's ideas and couldn't work with him. Gary was devastated. He knew he did the right thing going with his gut, but he also knew that Sammy felt he was right. Sammy had been performing since he was a toddler and he usually followed his own heart when it came to his career. And to Sammy, it was all about being BIG, and that included having the greatest superstars appear on his show, like Elizabeth Taylor and Richard Burton, and wearing all the jewelry and flash. The bigger he was, the more powerful he became, and that, Sammy believed, was what he was all about. And that would transcend to his television program.

Unfortunately, America didn't agree. When The Sammy Davis Jr. Show *debuted on Friday, January 7, 1966, at 8:30 P.M., it was awful. Guests such as Mel Tormé and Peter Lawford, combined with singing, comedy, and variety bits, couldn't salvage the show, which lasted only nine more episodes before it was canceled in April.*

Gary didn't take any comfort in the bitter demise of The Sammy Davis Jr. Show, *and the two men wouldn't talk again until 1970, when Gary approached Sammy about hosting* The Klowns. *Gary, like the rest of Hollywood, was painfully aware that Sammy's career had all but vanished. Following the cancellation of his television show, Sammy took* Golden Boy *to London. But aside from his live touring and guest appearances on NBC's* Laugh-In, *Sammy had entered middle age a near has-been. So he was surprised, and pleased, when he received the call from Gary asking if he would host* The Klowns.

"Are you kidding!" said Sammy, who jumped at the chance to be on stage with his friend Jerry Lewis.

Sammy was so grateful for the opportunity that, following the taping, he personally thanked Gary before the live audience and ABC brass. Sammy was still giddy the following day, when he arrived to record his vocal tracks for the show. But when he walked into the studio and surveyed the nearly thirty accompanying musicians, he angrily turned around and sought out Gary.

"Follow me," said Sammy sternly.

The two men walked into a recording booth.

"I'm leaving," said Sammy.

"What are you talking about?" said Gary.

"I walk in here and see the musicians and there's no black players."

"What?" said Gary. "I don't look at the list, Sammy. I don't even think about that. We just get the best musicians that are available."

"Are you telling me you couldn't find any good black musicians?"

"No, no," said Gary. "I don't think like that. I don't count the numbers, it's not something in my thoughts."

"Well," said Sammy. "This is unacceptable to me and I'm leaving."

Sammy opened the door and walked out of the room and past the small group of people waiting in the control room.

Gary's wife, Maxine, watched as Sammy angrily exited the studio, and she pulled Gary aside.

"What happened?" she said.

Gary relayed the discussion, but didn't know what to do. The vocals were being dubbed over the taped performance, and without the recordings, there was no show.

"I had no idea he felt that way," said Gary. "Can you go out to talk to him?"

Maxine walked outside and saw Sammy leaning against a car in the parking lot. She knew Sammy from Hullabaloo, and she walked over and calmly asked Sammy to reconsider.

"You know Gary," said Maxine. "He'd never intentionally insult you. He loves you, and this is a wonderful show. Please don't do this."

Sammy explained his position. This was an important issue to him. He was with Dr. Martin Luther King Jr. in Washington, D.C., and in Selma, and the new black leaders, including Andrew Young and Jesse Jackson, were pressuring him to take a more active role and get closer to the black community. So he agreed to marry Altovise, a black woman, and he felt he needed to press his beliefs whenever possible, even when performing a simple recording for a television show. But Sammy also knew he needed to get his career back on track. So when Maxine approached him to reconsider, her warmth and gentle demeanor melted Sammy's rage. He smiled, took a drag from his cigarette, flicked it away, and said, "Okay, let's go."

———————

A rmy Archerd's *Variety* column on March 5, 1999, led off with the news about the Gary Smith/David Wolper mini-series television project, and also touched on the years it took to resolve the IRS debt, and the time Altovise spent in rehab and working minimum-wage jobs. The column also quoted Sonny, who said he had researched Sammy's career and discovered he was a tragic victim who had quickly been forgotten.

"So many people had raped and pillaged this man," said Sonny. "The challenge is to give a rebirth to his legacy as the greatest single all-around talent of this century."

As Sammy's sole heir to his estate, Altovise could live modestly, perpetuating Sammy's legacy while moving on with her own life. But Altovise wouldn't have it, and instead of basking in the glow of the great accomplishment of the upcoming Rhino box set, she continued to press Sonny to find new deals and new money. She urged Sonny to fly to Las Vegas and Los Angeles to meet with an assortment of individuals who had one bad idea after another. She also demanded that Sonny fly to Memphis to meet with Priscilla Presley to discuss opening a Sammy Davis Jr. museum. Altovise was looking at dollar signs while Sonny was trying to rebuild Sammy's name, and his intention was to find something that would capitalize on the box set, like finalizing a movie or Broadway musical, or even a documentary. But Altovise had other ideas, and she took it upon herself to agree to sell Sammy's life story to Daphna Edwards, an inexperienced television producer. Unbeknown to Sonny, Edwards pitched the Sammy Davis Jr. television movie to the various networks at the same time Gary Smith was preparing to make his pitch. When Sonny confronted Altovise, she claimed that Edwards was an old friend and they talked about doing a Sammy movie as far back as 1991, but no contracts had been signed. Altovise also admitted to plans with Edwards for a book on Sammy's life and a coffee table book of photos. She also said Edwards loaned her over $15,000.

The resulting confusion over the conflicting claims of who actually owned the rights needed to produce a film led ABC, NBC, and CBS to pass on the project. It was Tracey Davis who tipped Sonny off

that something was amiss when she learned that NBC had passed on the movie following a meeting with Altovise and Edwards. Furious, Tracey called Altovise directly, but Altovise denied the meeting ever took place. Whatever goodwill remained from the family meeting at May Britt's apartment vanished. Sonny, still hoping to salvage a television movie, sought to extricate Altovise from Edwards, offering to repay the $15,000 loan. But Edwards claimed that she and an associate had already worked to set up the Sammy Davis project with the networks and demanded a producer's credit and another $30,000. Sonny could feel a movie deal slipping away, and he could see and hear and feel Altovise breaking away from his counsel—and his friendship.

Yes I Can!: The Sammy Davis Jr. Story was finally released by Rhino and Warner Bros. on November 9, 1999. The four-CD, best-of box set featured ninety-one Sammy Davis Jr. songs, all digitally remastered, tracing Sammy's entire career from "Smile, Darn Ya, Smile" in 1949 through "Life Is a Woman" in 1978. The set included sixty-nine studio recordings and a full disc of Sammy performing live on stage at the Sands casino, singing Broadway standards, doing impersonations, and thrilling his audience. The packaging was impressive and featured a photo of a smiling Sammy standing in front of the Sands, dressed in a white jacket and matching pants, with a red turtleneck shirt and black shoes, his name splashed in large blue letters on the Copa Room marquee. Inside, along with the four CDs, was a carefully crafted rectangular booklet filled with liner notes, discography, and track listing, and tributes written by composer Leslie Bricusse and Gerald Early, an English professor from Washington University in St. Louis. Most impressive, aside from the actual music, were the photos, dozens of which covered the six decades of Sammy's life.

Rhino Records, Ron Weisman, and Sonny had taken great care in producing the box set. It was a project of love, and the first major project since Sammy's death that truly celebrated his talent. After nine years, Sammy was rediscovered, thanks chiefly to resolving what had been a publishing nightmare. So many companies, other than Sammy, owned

his recordings, and getting their permission had proved nearly as arduous as finding the masters that Sammy did own. In the end, the hard work was worth it. The project was completed, the public was thrilled, and the reviews were spectacular. Sammy was alive again, as people talked about him, wrote about him, and listened to him.

Sonny had spent much of the year working with Weisner on the project, negotiating rights to various songs, finding the right people to write tributes, helping choose the songs, and selecting the best photos. But one photo that stuck out like a sore thumb was near the very end of the ninety-six-page booklet. It was a two-page color photo of Altovise posing on a chaise, dressed in an evening gown, her cleavage visible, under the famous photo of Sammy in white face when he was three years old. Sonny had talked Weisner into giving Altovise a producer's credit, saying it would help in her continued recovery. But Altovise wanted more and insisted on the photo. Weisner grudgingly agreed.

The box set was released just months before Sammy was scheduled to be honored by the Charles H. Wright Museum of African-American History in Detroit. In July 1999, the museum announced that Sammy would receive the 2000 Ford Freedom Award, which was awarded posthumously to an individual who had dedicated their life to improving the African-American community and the world at large. The award ceremony was a two-day event held at the museum in Detroit in February 2000 and culminated with a lavish dinner where the recipient was commemorated with a brass nameplate placed in the museum rotunda. Sammy's children Tracey, Mark, and Jeff were invited and would join Altovise and Sonny, who was ecstatic. The Ford Freedom Award was a great honor and yet another sign that Sammy's legacy had indeed been resuscitated. When he called Altovise with the news, she too was excited. Sonny said he'd have Ann Hoehne make all the arrangements, including the flights and hotel, and they'd arrive together. Altovise said no, explaining that she was staying in Los Angeles and would meet Sonny there.

The black-tie dinner was held on February 17, 2000, and ticket prices ranged from $1,000 to $15,000. Gregory Hines was named the

Ford Freedom Award Scholar and was scheduled to perform in honor of Sammy and bring him to life in dance and song and a speech about his old friend.

When Sonny arrived, he saw Mark and Jeff Davis sitting at the main table up front. Tracey refused to attend, reminding everyone of the painful meeting at May's condo and that she wanted nothing to do with Altovise.

"I'm not going anywhere near that," Tracey had said of the event.

Sonny traded hugs with Mark and Jeff, and then he looked around.

"Where's Altovise?" Sonny said.

No sooner was the question asked than Altovise arrived arm in arm with a light-skinned black man with slicked-back hair. He was short, around Sammy's height, and Altovise introduced Sonny, Mark, and Jeff to her friend, Tony Francis. Altovise told everyone that Tony was an old friend she knew when she was with Sammy.

Sonny could smell the liquor on Altovise's breath as Tony glad-handed Mark and Jeff and anyone else he could grab and say hello to. Tony took Sonny's hand and gave him a hug while Altovise beamed.

"I've heard so much about you," Tony said.

Tony sat between Sonny and Altovise and peppered Sonny with questions about Sammy, his business dealings, and the estate. The more Tony talked, the angrier Sonny became. Who was this guy?

"Just be cool," he told himself as Altovise introduced Tony to Gregory Hines, museum officials, and other well-wishers.

The award presentation following the dinner started off well, with tributes to Sammy and his lifetime pursuit to break down color barriers. Altovise was given a standing ovation when she strode to the podium to deliver her brief speech, and when she finished, she basked in the glow of another ovation. But as Altovise returned to the table and the applause waned, Tony suddenly stood up and yelled out to the audience that he wanted to perform an impromptu tribute to Sammy.

Sonny, Mark, and Jeff watched incredulously as Tony jumped on the stage, cued the band, and belted out the first few words to "Mr. Bojangles." Then he danced and tried to mimic Sammy's great tapping

skills, but it was a terrible impersonation, and Sonny squirmed in his seat while Mark and Jeff got up from their chairs and walked to the back of the hall. Sonny watched them go and then followed them, and together they watched as Tony completed his "act" to mild applause and returned to Altovise, who gave him a long, loving, approving embrace.

"Holy shit, this is so embarrassing," said Mark.

The brothers said good-bye to Sonny and angrily left for their hotel while Sonny remained in the rear, watching as the ceremony concluded and Altovise and Tony left arm in arm for their room.

In 2000 Sonny filed a lawsuit against Universal Music Group and PolyGram Records, claiming they reneged on several contracts they had with Sammy in the 1970s.

The suit alleged that MGM-Verve Records failed to pay Sammy royalties on thirty-five of his songs over a twenty-three-year period and also failed to return the masters to Sammy, which Sonny claimed they were contractually obligated to do. The recordings were for MGM-Verve, which was later bought by PolyGram, which was taken over by Universal.

"This is one of the most abusive and outrageous examples of record companies defrauding an artist of royalties and attempting to keep valuable master recordings that were the property of Sammy Davis Jr.," said Sonny in his suit.

Aside from the lawsuit, Sonny worked with Gary Smith to sell Sammy's television film to a network. NBC expressed interest, as did ABC. But no contracts had been signed and nothing was cemented. Altovise continued to press Sonny for more deals, and she responded to Sonny's usual calls for patience with coldness and indignation. Altovise either refused to believe or couldn't understand that her husband, who grossed millions when he was alive, had limited income potential in death. Sonny counseled Altovise to find a job and begin a new life, but his advice was dismissed. It would have mattered, but Sonny had other, more important issues to deal with.

Sonny and his wife, Patricia, decided to separate. She had come to

Pennsylvania from Hong Kong and expected to build a life with Sonny, but he had poured so much of his time and effort into Altovise and the Sammy estate it left little time to nurture a young marriage. Patricia also thought Altovise was using Sonny, and she told him so during heated arguments. But Sonny just couldn't hear her. He was on a mission, and that mission had a purpose. And the focus and determination that made him a successful attorney and investigator played havoc with his personal life.

Sonny also had to deal with his parents. The Hillside had suffered financially for several years and was in turmoil, and the burden became too great to bear for the Judge and Mama. They decided they wanted out and pressured Sonny to buy the resort outright. Sonny was put on the spot, but said no. So the Judge put the Hillside up for sale and watched and listened as potential buyers came and went, people who kicked the tires, spouting "black pride" speeches about the importance of the Hillside but in reality were looking to get a deal on 109 acres they could turn into some strip mall. Sonny decided to take matters into his own hands. He went to the bank and learned that his father was behind on the mortgage payments. The Judge had borrowed $2.2 million in 1988 to renovate the Hillside, and twelve years later the debt was down to $1.2 million. But the mortgage, which began with monthly-interest-only payments of $9,000 the first two years, had risen to $15,000 per month with the addition of principal. As business suffered and revenues dropped, the Judge sent what he could, sometimes $8,000, more some months, less others. The bank officer said something had to be done, immediately, to bring the account current or else they would have to begin foreclosure proceedings. Sonny knew his parents would be devastated if they were threatened with foreclosure, and he didn't want them to suffer that embarrassment.

"Don't tell my parents," said Sonny, "and I'll work out something."

Sonny was given access to the mortgage files, and he was flabbergasted by the terms of the original loan. Sonny knew about the double-digit interest rate, which was at least two points higher than the favorable rates at the time. But he didn't know that in addition to put-

ting up the Hillside and the property as collateral, his parents had to use their home and pensions as additional securities for the loan. Sonny was appalled. The bank had tied his parents up completely, and he immediately thought of the Judge and his growing resentment, which spilled over the years into painful soliloquies.

"What more do I have to do? I fought for my country. I was good to my family. I have a business. I was a judge. I do everything right, but I'm still not equal," said the Judge.

Sonny secretly negotiated for three months with the bank, which agreed to a payoff of $850,000 to settle the mortgage. Sonny borrowed $1 million from another bank, paid off the Hillside note, and with the extra money he paid the Hillside's other outstanding bills. He also gained the release of his parents' home and pensions. The Hillside now belonged to Sonny.

Mama was happy that her son would continue their legacy, but for the Judge it was a difficult transition. The Hillside was his life, and since Sonny was still his son, the Judge refused to accept the fact that he was no longer the owner. The Hillside was still his, he thought, a place where he welcomed Al Sharpton and the sons of Jesse Jackson and Martin Luther King Jr. and the National Association of Black Journalists. Sonny took over the Hillside out of love for his parents, but given the hell he received from the Judge, he wondered why he did it at all.

The problems with his personal life and the Hillside overshadowed his dealings with Altovise, who had all but abandoned him, checking in only to ask for money and to see if any new venture was on the horizon. Sonny did have some incredible news on December 12, 2000.

Following the release of the Rhino box set, Sonny and Ron Weisner talked at length about Sammy's lengthy recording career and the fact he had never won a Grammy Award, the music industry's highest honor. Given the wonderful reviews and immediate success of the box set, Weisner called the Grammy committee and suggested that Sammy be given a posthumous award for Lifetime Achievement. The committee took the suggestion under consideration, and weeks passed without a word. Finally, Weisner learned that the Grammy trustees had indeed

voted to award Sammy a posthumous Lifetime Achievement Award, and when he called to break the news, Sonny was beside himself, jumping up and down in the Hillside office.

The Judge didn't know what to make of his son.

"You don't understand, Judge. We got Sammy a Grammy!" Sonny yelled.

Sonny immediately called Altovise, who was with her mother in Queens. She appeared sincerely happy with the news, and she thanked Sonny for his efforts. Following their brief conversation, Sonny called Tracey Davis, who cried, as did Mark and Jeff, who were all overcome with joy. It was the first time ever that Sammy was officially acknowledged as a great singer. Coming off the Ford Freedom Award, this was yet another special moment for Sammy, and Tracey, Mark, and Jeff all thanked Sonny for his efforts.

"We'll all go to the awards show together," said Sonny.

Their strained relationship notwithstanding, Sonny still believed that Altovise needed a confidence boost and, with this great honor, he hoped she'd finally see his vision for her future, and for Sammy's legacy. Sonny made sure that Altovise received a formal invitation to attend the ceremony, which was scheduled for February 21, 2001, at the Staples Center in Los Angeles. Grammy officials had to be notified in advance who each honoree would be taking as a guest, and Sonny figured he'd attend with Altovise while Weisner would get additional tickets for Sammy's children. The evening promised to be spectacular. Others receiving Lifetime Achievement Awards included the Beach Boys, Tony Bennett, Bob Marley, and The Who. Among those nominated for awards were U2, Madonna, 'N Sync, Beck, Eminem, Paul Simon, Faith Hill, Britney Spears, and Sting.

But as the ceremony drew closer, Sonny, Tracey, Mark, and Jeff had yet to receive their tickets, and Sonny called Weisner to inquire about the ticket situation.

"Listen, I was just going to call you," said Weisner. "Altovise submitted her ticket request and she's taking some guy named Tony Francis. He's going to be her escort."

Weisner heard nothing but dead air.

"Sonny, you there?"

"Yeah Ron, I'm here," said Sonny.

The news took the air out of his lungs.

"I don't think I'm going to make it," said Sonny.

"Nonsense," said Weisner. "Listen, don't worry about it. I've got tickets for us. I'll see you out here."

The ceremony was a painful blur. Altovise walked the red carpet with Tony Francis, and when she accepted the Grammy on behalf of Sammy, she thanked a host of people, without a single mention of Sonny. Aside from a "Hello," she never spoke to Sonny, who sat with Ron Weisner, Jeff Davis, and Jeff's girlfriend. Neither Tracey nor Mark could get tickets, and Tracey was furious. This was one event she wanted to attend.

"But we're his kids!" she screamed.

Sonny said there wasn't anything he could do about it. And despite his work leading up to the ceremony, he never even saw the Grammy Award.

The bittersweet Grammy experience left Sonny in a daze, and the reality of his situation with Altovise had finally sunk in, long after others had not only warned him what would happen, but predicted he'd end up on Altovise's scrap heap of lawyers. Norman Lear warned him, as did Tracey and Mark and Finkelstein and Cosby and even his estranged wife, Patricia. Sonny had poured his heart into representing Sammy's estate, so much so that his general belief in the goodness of people blinded him to the realities of Hollywood, and even life. He became reflective and studied his own motives. Why would he go so long with a single client who paid little money? Did he simply get caught up in what he thought was a just cause, a good fight, as he did when he dedicated himself to the E. F. Hutton investigation? Couldn't he see past that? Or was it something else? Tracey Davis never thought Sonny was in it for the money. But she did think that Sonny considered representing Sammy's estate as a feather in the cap of his burgeoning entertainment

law practice. Sonny couldn't buy that. Tracey didn't know him, and he knew himself too well. Hell, he was the only son of Mama and the Judge, and those weren't values they taught or appreciated.

Sonny knew it came down to injustice. The more he had learned about Sammy Davis Jr., the more he knew he had to fight for the memory, and legacy, of a great black icon. He also knew that his own final insult—the coup de grâce—would come soon. And he didn't wait long.

Two days after the Grammy ceremony, the phone rang in his hotel room, and it was Altovise. She wanted Sonny to meet some people, Brian and Barrett LaRoda. She said they were brothers who managed Stevie Wonder and were nephews of Tony Francis, and they wanted Sonny to sit down with them. She wouldn't say why.

"We'll come by your hotel in the morning and you can follow us in your car," said Altovise.

The following morning, a gold Rolls-Royce pulled up to the front of the hotel. Inside were Altovise, Tony Francis, and their driver. The back passenger window rolled down, and Tony yelled out to Sonny to follow them. Sonny thought the scene would be comical if it weren't so serious, with Altovise pulling up in the tackiest of all vehicles, with a guy that looked like and thought he was Sammy, and some Klingon behind the wheel. But he grudgingly followed the gaudy car, and after driving for twenty minutes, they finally stopped in front of an office building. Sonny watched as Altovise emerged, wearing a fur coat, and locked arms with Tony. Together, they walked inside the building, with Tony waving for Sonny to follow. Once inside, Sonny was led into an office where Altovise, Tony, and half a dozen other people sat on one side of a long conference table facing an empty chair on the other side of the table. Sonny knew the chair was reserved for him.

Barrett LaRoda began the awkward conversation with a mention of his representation of Stevie Wonder. He praised Sonny for his work settling the IRS debt, and complimented him on the subsequent Rhino deal.

"You did a terrific job," said Barrett. "But we can do better."

Barrett said that his group had connections within the entertainment world that would propel Altovise and Sammy's estate into the stratosphere. He didn't offer any examples of what deals he had in place, or even general ideas. Barrett told Sonny that he could stay on as Altovise's attorney, but as far as managing her career and Sammy's estate, they would take over.

When Barrett finished, there was a long pause. Sonny considered a measured response, but he couldn't control his emotions.

"Let me ask you something, where the fuck were you seven years ago when she had nothing?" said Sonny.

"We know you did a great job," said Barrett. "You're a great lawyer."

"That's not what I'm talking about," said Sonny, who leaned over the table and looked directly into Barrett's eyes.

"Now you want to get involved, after I secured all her rights, after I settled the debt, after I restored Sammy's legacy?" said Sonny, his voice rising in anger. "Where were you when the IRS was coming after her and she was throwing up and she needed money and shelter and time to heal? Where were you when my mother cared for her and gave her love and treated her like a daughter? Where the fuck were you?"

Sonny turned toward Altovise, but there were no words. There was nothing he could say. Altovise remained quiet as she sat in her ridiculous fur next to Francis, the Sammy Davis impersonator, insensitive to all the time, money, heartache, and tears spent on her.

"You know what? I don't give a fuck," said Sonny.

"You're out anyway. You're no longer representing her," said Barrett.

Sonny walked outside to his car and looked over at the gold Rolls-Royce idling on the street. He shook his head and drove back to his hotel. That night he boarded a flight for New York, and by morning he was home at the Hillside.

CHAPTER

22

Three black limousines pulled up to an apartment complex in Washington, DC, and Brian Dellow jumped out of the lead car, wearing a black tuxedo, his hands filled with jewelry, a shaving kit, and a gun.

Waiting for Brian was Ralph Wunder, the owner of the limousine company, who received a frantic call from Brian just minutes earlier, asking if the group could stop by to drop something off.

"Ralph, don't you live a couple of blocks from the Kennedy Center?" said Brian. "Sammy's packing a gun and we found out we have to pass through metal detectors and have to drop off some stuff."

Ralph exited the lobby and walked to the car to meet Brian. In his hands were jewelry, including gaudy gold nuggets, diamond rings, and a gold watch given to Sammy by Frank Sinatra. Along with the jewelry exchange came Sammy's shaving kit, which contained a flask filled with Orange Crush soda and rum.

"I thought he stopped drinking?" Ralph whispered.

"He did," said Brian, winking his eye.

Ralph also took the handgun.

"Sammy's always packing," said Brian.

The limos were soon on their way, and the entourage was escorted into the White House for their meeting with President Ronald Reagan. Sammy was being honored as a recipient of a 1987 Kennedy Center Honor, which recognized him for his lifetime of contributions to American culture. Other 1987 honorees included

Bette Davis, Perry Como, violinist Nathan Milstein, and choreographer Alwin Nikolais.

The actual award was given by the president to the five honorees. There were no speeches or comments, but the group and their guests were served a celebratory dinner with the president. The following night, Sammy and Altovise and the other honorees were seated at the Kennedy Center with the president and first lady, Nancy Reagan, for a program that featured performers including Lucille Ball, Don Ameche, Ray Charles, and Jimmy Stewart. Newsman Walter Cronkite served as master of ceremonies.

Sammy's after-show celebration party was held at the Ritz-Carlton, and the banquet hall was closed and filled with Sammy's friends. It was a festive, happy evening, one of few in recent times. Altovise looked striking and, as usual in public, personable and the perfect complement to her famous husband. Despite their troubles, after seventeen years of marriage she knew how to play the role and she played it well, holding hands with Jimmy Stewart and wrapping her arms around Liza Minnelli.

Sammy couldn't have been happier.

Several hard years deflated his giant ego and had humbled him somewhat. He had never won an Oscar, or an Emmy, or even a Grammy, but receiving a Kennedy Center Honor topped all three. He was duly proud of his accomplishment, and he smiled and laughed as the night wore on and turned to early morning. By six A.M. the party had wound down and only a few hardy souls remained, among them Sammy, Vic Damone, Diahann Carroll, Brian Dellow, and Ralph Wunder, who joined the group after the show.

Sammy, Vic, and Diahann decided to sing together to end the night, and when they finished one song, they started another. Brian and Ralph watched as the threesome turned to impressions, with Diahann yelling, "Sammy, do Cagney," and Sammy obliging with a side-splitting impersonation of the great James Cagney. He then switched to impersonations of George Raft, Jimmy Stewart, and Marlon Brando. The one-upmanship continued when they each

*decided to take turns singing solo, with Diahann starting a song
and then handing it over to Vic, who sang a bit before turning it
over to Sammy, who proceeded to take over the near-empty room,
combining his singing and still incredible dancing skills. Vic and
Diahann watched in awe, along with Brian and Ralph, as Sam-
my's incredible talent exploded before them.*

*Even at sixty-two years of age Sammy was spectacular, and it
didn't matter that he had an audience of four or forty thousand.
Sammy was doing what he had trained for and excelled at for
nearly six decades, and the sweat that collected on his brow and the
smile that spread on his face spoke of the pure joy of a man who, at
this one special moment in his life, was very happy and at peace in
his environment. He was, after all, an entertainer.*

OCTOBER 2005

Sonny placed the last file into the last box, covered it, and put it
inside the bedroom closet and on top of the other boxes. There
was more to see again, including photos of Sammy from yester-
year, pictures that were never published and viewed only by a select few.
But Sonny didn't bother. He had seen enough. Reviewing all the files
forced him to recall more than he ever wanted to.

It was early evening, the sun had long disappeared, and Sonny sat on
his mother's bed, alone in her room and in his thoughts. He closed his
eyes and tried to hear her voice and feel her warmth again. He thought
back to 2001. It was just a few months after the Grammy Awards and the
final parting with Altovise that Sonny and the Judge learned that Mama
had lung cancer. She'd been coughing throughout the summer. Mama
never smoked, and several trips to the doctor produced one benign di-
agnosis after another. But the coughing wouldn't stop, and when they
realized it was cancer, in August 2001, it was too late. Mama lasted only
a few months and died on January 30, 2002. She was eighty.

A wake was held at the Lanterman & Allen funeral home in East

Stroudsburg, and again at the Concord Baptist Church in Brooklyn, and hundreds came to pay their respects. Sonny remembered the wake in Brooklyn. Old friends from throughout New York overwhelmed Sonny, who sought a quiet moment away from the mourners. He stood outside the funeral home in cold, nighttime air when he noticed a woman down the block walking toward the funeral home. Sonny recognized the walk, and as the woman slowly emerged from the darkness and into the yellow glare of a streetlight, he saw that it was Altovise.

Sonny was stunned. After all that happened just months earlier, here was Altovise, in Brooklyn, coming to pay her respects. Mama always wanted Sonny to have a sister, and she treated Altovise like a daughter. They'd sit under the cherry blossoms and talk for hours, holding hands, or Mama would invite Altovise to the Hillside's Sunday gospel hour, where she held hands with other guests and listened as the Judge gave one of his sermons. Afterward, they'd all depart for the dining room for dinner, and Altovise would tell stories of her life with Sammy.

Altovise got a lot of love from Mama, and here she was, giving some of it back.

She walked up to Sonny and gave him a hug.

"Hi, Sonny," she said.

There were no apologies or talk of Sammy or even the faintest smell of liquor. This was about Mama, and Sonny let go of his anger and warmly returned the greeting.

"Come with me," he said, leading her inside the funeral home, where he introduced his visitors to Altovise Davis.

Mama's death was one of several personal tragedies for Sonny. Shelby Starner, his former singing protégée, died in June 2003. Her debut album, *In the Shadows,* was released in 1999 to critical acclaim but failed to gain commercial success. She reentered the studio with members of the Red Hot Chili Peppers, but her follow-up album was never released and she sought to severe her ties to Warner Bros. in 2000. Soon after, she was treated for bulimia and, following two years of treatment, she passed away. She was nineteen.

Mama's passing cast a pall on the Hillside. For nearly fifty years she was its heart, soul, and conscience, and her smile and tenderness were sorely missed by its guests, Sonny, and especially the Judge, who never recovered from her loss. Following Mama's death, the Judge became even more irrational, and deeply resented Sonny's new direction for the Hillside as a multicultural retreat. Father and son, as they so often did throughout their lives, argued bitterly, with the Judge trying desperately to hold on to the resort's black roots. But it was Sonny who owned and controlled the Hillside, and he remained steadfast.

During the summer of 2005, the Judge was toiling around the Hillside and hit his head in a bathroom. The doctors feared clots, and he was placed on blood-thinners, but he suffered a massive stroke. The Judge recovered enough by October to join the Sunday gospel hour, but he appeared sluggish, and Sonny took him to Pocono Medical Center the next day, where a brain scan revealed a blood clot and hemorrhaging.

Sonny took his father to Lehigh Valley Hospital in Allentown, where the Judge was admitted and placed under observation. He remained there for a week and his condition appeared to improve. Sonny stayed by his side but left one morning for a meeting at the Hillside. When he returned that afternoon, the Judge was sluggish again, his face was swollen, and he couldn't breathe. Sonny alerted the nursing staff, and within minutes there were twenty people rushing into the Judge's hospital room. Doctors tried to intubate the Judge while Sonny held his hand, talking to his father about the Hillside and the big group coming in for the weekend. The Judge's condition worsened but the doctors told Sonny to remain in the room and keep talking to his father, who was lapsing into a coma.

"Don't let him go out," a doctor yelled.

The Judge remained semi-alert, his eyes responding to everything Sonny said. So Sonny talked about his future plans for the Hillside, but promised to get his father's permission first. Sonny also told him he planned on getting a set of golf clubs and promised he would take lessons.

"See, Judge. Then you and I can play, just like you always wanted," said Sonny.

The Judge's body lurched as the medical crew tried to jam a tube down his throat. But his airway passage was swollen, and another doctor said he was going to perform an emergency tracheotomy. There was no time for anesthesia and the doctor took a scalpel and began slicing a line in the Judge's neck. Blood spewed as his body tightened and arched violently, and he held even tighter to Sonny's hand. With every movement of the scalpel the Judge squeezed harder, and Sonny could feel the Judge's incredible strength.

"They're just helping you breathe, Dad. Everything will be all right," said Sonny.

The procedure took the better part of an hour and the tube was finally inserted into the trachea and the Judge was stabilized. But Sonny never spoke with him again. The Judge slipped into a coma and Sonny stayed with him for ten days and nights. The Judge died on October 22 at 9:07 A.M. He was eighty-four.

The Judge was gone, along with Mama, and Sonny now carried all their problems, their burdens, and their rich history. The Murrays spent a lifetime building something that was special to so many people, and even with its dire financial problems, Sonny knew deep in his heart it was a legacy that simply had to continue. He looked around the bedroom again and he studied the photo of himself standing next to the Judge, with the painting of Mama in the background. Sonny and the Judge each wore suits, and they looked like the quintessential successful American family, rich in tradition and accomplishment. Sonny knew that given their success, no one could say otherwise.

He slowly rose from the bed, reached over for the photo, picked it up, and kissed it gently. Sonny then lifted the framed photo of himself playing golf with the Judge. He blew off the dust from the front, placed the frame prominently on the shelf before exiting the room, and returned to the Hillside knowing he had struggled, saved, fought for, and lost one great black legacy. And after contemplating his future during a long, sad day, Sonny decided he wasn't about to lose another.

The glow that emanated from the success of the 1999 Rhino box set and the 2001 Grammy Award has long since faded, and today Sammy Davis Jr.'s legacy is once again mired in failure and controversy.

Soon after firing Sonny Murray in 2001, Altovise appointed Tony Francis as executive director of the Sammy Davis Jr. Foundation. She also named Barrett LaRoda to manage the foundation and to oversee day-to-day management of the Sammy Davis Jr. estate.

But from 2001 to 2007, the LaRoda Group did little with Sammy's legacy. Their few projects included an agreement in 2002 with an Australian gaming group to create a Sammy Davis Jr. online virtual casino game and a Sammy Davis Jr. slot machine. LaRoda also took part in producing *Mr. Bojangles, the Ultimate Entertainer,* which debuted at Connecticut's Foxwoods Casino in 2006 and was the third incarnation of a Sammy live show. LaRoda secured two other deals, one using Sammy's image in a television commercial for the Applebee's restaurant chain and another for a Sammy Davis Jr. bobble-head doll.

Altovise Gore Davis continues her battle with alcohol addiction. According to LaRoda, Altovise was admitted to a Narconon substance abuse treatment facility in California in 2004, where she remained for nine months. Following her release, LaRoda said Altovise remained in California and rented a two-bedroom apartment in Reseda, a neighborhood in Los Angeles. But her new residency caught the attention of the

California tax authorities. The $1.9 million state franchise tax owed by Sammy and Altovise for the fraudulent tax shelters still remained owed. Sonny negotiated with the state years earlier but couldn't reach an agreement, and he advised Altovise to maintain her residency outside of California. Ignoring Sonny's advice, Altovise moved to California and a lien was slapped on her income. In addition, the IRS also filed a lien on Altovise after she failed to live up to the 1997 settlement. Under the Federal Income Collateral Agreement, Altovise was required to file tax returns each year and make 40 percent payments on income above $100,000 until 2003. The details remain murky, but after firing Sonny in 2001, Altovise didn't file the appropriate returns, and the IRS nullified the agreement. Sonny said he told LaRoda's attorney, Londell McMillan, about Altovise's tax status, but LaRoda said during an interview in November 2007 that he never knew about Altovise's previous tax problems, especially the IRS settlement, and he accepted no responsibility for her failure to honor the agreement. LaRoda also said he was surprised when he learned of the issues surrounding the IRS and the California tax, which by 2007 had risen to $2.9 million.

With tax problems resurfacing, Altovise signed over her rights to Sammy's name and likeness to a newly formed company, Sammy Davis Jr. Enterprises, which is a partnership between Altovise, LaRoda, and Francis. The agreement, said LaRoda, is irrevocable and gives him, Francis, and Altovise each 33 percent of Sammy's name and likeness. Following the formation of SDJE, LaRoda said he entered into a licensing deal with author Burt Boyar.

Since returning from Spain in 1997, Burt continued to pursue a variety of Sammy projects, and he met LaRoda twice a month at the Bel Air Hotel in 2005 to discuss possible opportunities to exploit Sammy's name and legacy. According to LaRoda, Burt agreed to pay "licensing" fees to SDJE for the rights to four projects, including a photo book, a documentary, use of the 150 hours of taped interviews with Sammy for a CD set, and Sammy's image for a Cadillac commercial.

In March 2007, Burt's book *Photo by Sammy Davis Jr.* was published. The critically praised collection of Sammy photos from the

1950s to 1980s received national attention, and Burt was interviewed on a variety of programs, including *Good Morning America.*

Following the publication of the photo book, Burt and LaRoda entered into negotiations with film producers Craig Zadan and Neil Meron of Storyline Entertainment for a film biopic on Sammy's life for New Line Pictures, based on Sammy's book *Yes I Can.* But negotiations reached a standstill after Burt sought producer credits and $300,000 for himself and two friends, and LaRoda sought producer credits for himself and Altovise, and payment of $1 million.

When Tracey Davis learned of the pending movie deal, she contacted Sammy's old friend and former publicist David Steinberg. Steinberg intervened and reminded all parties that Sammy's children still owned 25 percent of *Yes I Can,* and no movie optioning the rights to the book could move forward without their participation.

Negotiations resumed, this time with the children involved, but once again they hit a wall. According to LaRoda, his attorney Londell McMillan, who also represented Altovise in the deal, made subsequent usual demands for bonus money and also requested that Altovise be hired to choreograph the film. Zadan and Meron, who produced the Oscar-winning *Chicago,* balked.

With the movie deal quickly falling apart, Burt Boyar interceded in August 2007 and convinced Altovise to fire the LaRodas and McMillan. But Burt neglected to consider that Altovise had signed her rights to Sammy's estate over to Sammy Davis Jr. Enterprises, and since LaRoda and Francis were her partners, they would remain part of any deal.

Burt said he moved Altovise to a Beverly Hills apartment in the fall of 2007. He claimed that under LaRodas' management, she led a sad existence in a cockroach-infested apartment. Burt said Altovise didn't have a refrigerator and was forced to buy ice at a local 7-Eleven to keep her food cold. She was also penniless, he said, and collected cans and bottles from the street for the nickel return.

LaRoda denied Burt's assertions, saying Altovise had lived comfortably, but he did admit that since his "firing" in August 2007, relations with Altovise were estranged.

During the summer of 2007, attempts were made to interview Altovise through LaRoda, who said she declined because she "didn't want to revisit that part of her life."

Other attempts were made through Burt Boyar in August 2007 and November 2007, but he said she was "too fragile" to sit down for an interview. Burt later said that he was working on a book with Altovise about her life with Sammy.

In January 2008, Burt and Altovise filed a federal lawsuit against LaRoda, Tony Francis, and the LaRoda Group, claiming they exaggerated their business credentials and duped her into signing away two-thirds of Sammy's estate. LaRoda and Francis denied the claim.

Watching all this with contempt was Tracey Davis.

"Every time we get to a certain place, it all goes to pot," said Tracey in November 2007. "Here we are, seventeen years after my dad died, and his estate is still being mismanaged into oblivion. It's horrible."

Tracey never reconciled with Altovise. One meeting did take place in 2002, but it went badly after Tracey learned that Quincy Jones again optioned the rights to *Yes I Can* for a Broadway musical for an undisclosed amount. Tracey said the LaRoda Group sent $1,500 each to her and her brother Mark, whose check bounced. After ten years of options, Quincy never moved forward with the musical and the option finally expired.

Tracey left California in 2004 and worked for Universal Studios in Orlando, Florida, before moving to Nashville, Tennessee, in 2005, where she continued her career as an advertising executive producer while raising her four children. Tracey returned to California in November 2007 and planned to file suit against Burt Boyar over his *Photo by Sammy Davis Jr.* book. Many of the pictures included in the book were of Tracey and her brothers, and Tracey claimed Burt infringed her rights by using her image without her permission. In addition, after scouring the book, Mark Davis made an interesting observation: the photos were from the vast collection discovered by Sonny Murray inside the Bekins warehouse in 1998. Burt claimed publicly that he found the photos, and included a blurb in the back of the book thanking Altovise

for the use of the collection. Altovise did not receive any author credit or a copyright, and Tracey, upon learning of Altovise's renewed tax problems, saw the book as nothing more than an effort by Burt, Altovise, and the LaRodas to deceive the IRS.

Burt declined to comment on the photos, saying he "didn't want to get Altovise in trouble." But Burt argued that the pictures, once found, belonged to Altovise, since she—not his children—was the heir to Sammy's residual estate. Burt also said he received a small, $15,000 advance for the book, which took him a year to complete with captions and stories.

"It became a labor of love. Sammy made me. Writing *Yes I Can* became the biggest moment of my life," said Burt, who also had harsh words for Sammy's children, saying they were "only interested in money and not interested in furthering their father's legacy. They're horrible."

The tension between Sammy's children, Altovise, and Burt Boyar eventually affected May Britt, who tried her best to remain above the fray but was pressured by Burt to convince her children to cooperate with the New Line film. May had finally married again. In 1993, three years after Sammy's death, she wed Lennart Ringquist, a former entertainment executive. She has since lived a happy, quiet life near Los Angeles.

Mark Davis has successfully remained in recovery from his addictions. He found a new love, works a full-time job at a warehouse, and is studying animation.

Jeff Davis lives quietly near Palm Springs with his wife and mother-in-law.

Manny Davis, who was adopted by Sammy and Altovise in 1988, has remained separated from the family and from Altovise. Manny served in the U.S. Army, and his whereabouts are unknown.

Sy Marsh passed away in 2005. His son, Seth, said during an interview in November 2007 that his father remained bitter until his death over the loss of his home due to the investment in the fraudulent tax shelters, but that he always loved Sammy, even after their breakup, and they remained friends until Sammy's death. He was eighty-six.

Mort Viner, Dean Martin's agent, died of a heart attack in 2003 while playing tennis. He was seventy-two.

Altovise's friend Donald Rumsfeld was appointed U.S. secretary of defense by President George W. Bush on January 20, 2001. One of the architects of Operation Iraqi Freedom in 2003, Rumsfeld resigned his post in December 2006.

Vasilios "Bill" Choulos, the attorney who once represented Jack Ruby, died of emphysema in 2003. His son George, an attorney in San Francisco, denied his father ever had possession of Sammy's glass eye. George also said that Joel David Kaplan, the man his father helped escape from a Mexican prison in 1971, was a CIA agent.

Sam Giancana, the Chicago mob boss, was deported from Mexico in 1974. After returning to Chicago, he was shot and killed in his basement in June 1975, on the eve of his scheduled testimony before a U.S. Senate Intelligence Committee about his alleged role in a CIA plot to kill Cuban president Fidel Castro.

Dino Meminger, Sammy's "road son," shot and wounded his estranged wife and killed a man accompanying her in Ithaca, New York, in January 2004 before turning the gun on himself. He was forty-seven.

Murphy Bennett, Sammy's longtime road manager, died of cancer in April 1993. He left behind five children, nine grandchildren, and a great-grandson.

Fortunatas "Fip" Ricard, Sammy's trumpeter, died in May 1996. He was seventy-two.

Joe Jackson, Sammy's movie "stand-in" and record cataloger, lives in retirement in Los Angeles.

Richard Ferko, the attorney hired by Altovise in 1990 continues to practice law in Los Angeles. He is still owed over $200,000 for his work representing Altovise.

Brian Dellow, Sammy's chief of security, eventually parted with Quincy Jones and currently serves as the security manager for a major West Coast business. He also oversaw security for the Jerry Lewis Telethon.

Eliot Weisman is one of the nation's premier concert promoters and talent managers. His clients include Liza Minnelli, Steve Lawrence, Eydie Gorme, Don Rickles, and Ben Vereen, among others.

Shirley Rhodes underwent heart transplant surgery in the 1990s and lives in Los Angeles. During an interview in October 2007, Rhodes declined to discuss Sammy's will or the insurance money she received after Sammy died. Rhodes asked over and over again why anyone would be interested in "dredging up" Sammy's life.

"Leave the man alone. He's dead," said Rhodes.

Rhodes deferred all questions about the handling of Sammy's estate to John Climaco, whom she described as a "great friend."

Following his release as coexecutor of the Sammy Davis Jr. estate in 1997, Climaco continued to be a power broker in Cleveland. His law firm served as counsel to several major projects there, including Jacobs Field, Gund Arena, and the Rock & Roll Hall of Fame and Museum.

Climaco was also named lead or colead attorney in several major class-action federal lawsuits, including asbestos and tobacco litigation. In 2000, Climaco received the Ellis Island Medal of Honor, which is awarded to immigrants and their ancestors who have distinguished themselves for their outstanding contributions to America. Previous medal-winners include presidents George H. W. Bush, Bill Clinton, and Gerald Ford, several senators, congressmen, statesmen, and Nobel Prize winners.

Climaco's political reach extended far beyond Ohio. He was a fundraiser for Democratic senator John Kerry's failed presidential run in 2004.

No charges or claims against Climaco or Rhodes were ever made in connection with their roles as coexecutors of the Sammy Davis Jr. estate or regarding Transamerican Entertainment, and they deny any wrongdoing or allegations of mismanagement. Climaco also said, during an interview in January 2008, that he never personally received any money from Transamerican Entertainment insurance policies.

Calvin Douglas lives in the same home on the grounds of the Hillside Inn. He still hears from Altovise, who calls him once or twice a year.

Albert "Sonny" Murray Jr. currently remains the owner and proprietor of the Hillside Inn. Sonny was never able to fulfill the wishes of

Yves Piaget and bring Sammy's family together. After he was dismissed by Altovise in 2001, Sonny contemplated filing suit against Altovise but didn't, despite an unpaid legal bill that exceeded $800,000. Sonny turned his attention to producing films and writing screenplays. In 2006, he was appointed a federal mediator for the U.S. District Court in the Middle District of Pennsylvania.

Sonny spent several difficult years keeping the Hillside Inn open. Despite efforts to diversify, the clientele remained mostly black and Sonny continued to offer discounts to church and youth groups from the New York, New Jersey, and Philadelphia area. But with each passing year the Hillside fell deeper into debt.

Following the Judge's death in 2005, Sonny put the Hillside up for sale while searching for alternative uses for the property. He began preliminary discussions with Wynton Marsalis to open a jazz camp in cooperation with New York's Lincoln Center, and received a grant from the state of Pennsylvania to explore opening a charter school at the Hillside.

After a decade of losses, the Hillside Inn was the beneficiary of resurgence in 2007 and enjoyed its best summer season in years. Visitors flocked each weekend like they did so many years before, and the unexpected revenues allowed Sonny to pay off a few bills.

By January 2008, Sonny was readying to open the Hillside for its fifty-third year in operation.

In May 2008, Sonny was yet again pressed into the controversy surrounding the Sammy Davis Jr. estate after receiving a call from Tracey Davis, who asked Sonny to review a copy of a trust formed by Sammy in March 1963. The long-lost document, found in December 2007 by May Britt, directed 70 percent of Sammy's interest in any books, films, compositions, or other representation or portrayal based on his life to his children. It was signed by Sammy, his then-attorney Joe Borenstein, May Britt, and, as witnesses, Murphy Bennett and Shirley Rhodes. The discovery of the trust again led to questions surrounding Sammy's estate and those around him, particularly Shirley Rhodes, who as a witness to the trust knew of its existence.

Sonny, who never knew of the trust, reviewed it at Tracey's request and believed it to be legal and binding. Sonny was also convinced that had he known of the trust years earlier, Altovise's interest would have been minimal, while Sammy's children would have had majority control of their father's legacy.

ACKNOWLEDGMENTS

This important book became a reality thanks to the help of a number of people. Kathleen Parrish, an author and former reporter at the *Morning Call,* read the original book proposal, offered suggestions and enthusiastic encouragement at a time when I needed it. I'm grateful to Tim Darragh, the investigations editor at the *Morning Call,* who gave the book a careful read and offered valuable edits and suggestions. Ed Kumiega, an assistant U.S. attorney in Oklahoma City, helped me navigate through some federal and investigatory issues. I met Ed in 2003, while researching *A Beautiful Child,* and we remained in touch ever since. Tracey Davis helped in many ways. Initially resistant, Tracey opened up after our first conversation and her help was invaluable.

Thanks to Dawn Davis and her wonderful team at Amistad/ HarperCollins for their enthusiastic support of this project.

I'm forever grateful to my literary agent, Steve Hanselman of Level-Five Media, for his support, guidance, and always wise counsel. Julia Serebrinsky, the vice president of editorial at LevelFive Media (and Steve's wife), was instrumental in helping with the original book proposal, and I thank her for giving the final manuscript a careful read.

Of course, there wouldn't have been a book without Albert "Sonny" Murray. He's a good man with a good heart, who carries a heavy burden, and I will always be indebted to him for sharing this difficult story with me.

And finally, my love and thanks to my wife, Donna. As is the case with these book projects, she held down the home front while I was away. Even when I was home, my mind was usually elsewhere during the year and a half it took to research and write this book. But Donna, as always, understood.

SOURCES

The story that unfolded in these pages could not have been told without the help of the following people:

Calvin Douglas was gracious and generous in giving me his time to convey his many experiences. He was vital to this story, and his razor-sharp mind belied his age. Corene Watson, a sister of Judge Albert Murray, was helpful in relaying the history of the Hillside, the Judge, and Mama Murray, along with Nelly Quevedo, the Hillside's general manager.

During trips to Los Angeles for interviews in July and August 2007, I was helped immensely by a number of people, particularly Sammy's friend and security chief Brian Dellow. Brian had never granted an interview before, and he only agreed to talk to me thanks to several phone calls from others. His memory was keen and his love and affection for Sammy clearly evident.

During that same visit to L.A. in July 2007, I interviewed Richard Ferko, Jay Shapiro, Joe Jackson, Herb Sturman, Mark and Tracey Davis, and their mother, May Britt. Mark and I spent a day together talking about his father over lunch, and then toured through Beverly Hills to visit the various addresses Mark and his parents and siblings had called home. I met his mother, May, briefly. She offered a welcoming handshake and reminded me of my own mother, warm and nurturing. I spoke to May again months later over the phone. She preferred to remember Sammy for his gentleness and generosity. She truly loved Sammy. And I believe, after all was said and done, Sammy truly loved May. I first spoke to Tracey Davis in May 2007. She became an invaluable source, who provided crucial information, helped direct me to others who knew answers to questions she couldn't answer, and was someone I'd

simply call to bounce questions. We finally met in L.A. over dinner at one of her father's old haunts, Dan Tana's restaurant, and we continued to talk over the phone right through the completion of the book.

It was during my visit to L.A. in August 2007 that I interviewed Burt Boyar, Gary Smith, Hilliard Elkins, and David Steinberg. I met Burt at his penthouse and we talked for several hours. We later spoke several times over the phone. I have known Gary since 2003 and spent a day with him going over his Sammy photos and footage from the *Hullabaloo* days. Gary's personal stories about Sammy were interesting and insightful. David Steinberg's stories were hilarious. Like Brian Dellow, David had refused for years to grant interviews about Sammy, but we spoke at length over two days. It was David who told me the stories about the Chinese food and Princess Grace, and he also shared information on some of the shadier people involved in Sammy's life. By the time we were finished, he urged me to remember that Sammy had a heart of gold and lived a life many of us could never understand. Most important, said David, Sammy thoroughly enjoyed himself.

I tried to remember that while writing this book.

Shirley Rhodes declined numerous requests to meet with me in person. It was only through the urging of David Steinberg that Shirley finally agreed to talk via a phone interview. I also interviewed John Climaco, briefly in late 2007 and at length in January 2008. It was Ed Kumiega, an assistant U.S. attorney in Oklahoma City, that led me to former FBI agents involved in the investigations that led to the demise of the mob's control over the casinos in Las Vegas. I can't identify them, but their information about Sammy, Frank Sinatra, and organized crime was crucial. Dennis Gomes also proved invaluable. Dennis was the lead investigator with the Nevada Gaming Commission in the 1970s, who headed the probes that eventually led to the successful federal prosecutions in the 1980s. His work was the basis for Martin Scorsese's 1995 film *Casino*. Dennis later went on to become president of the Tropicana and Trump Taj Mahal in Atlantic City, and the Golden Nugget in Las Vegas. I also spoke with Nick Akerman, the former assistant U.S. attorney in New York, who prosecuted the Westchester Premier Theater case.

Additional interviewees included Barrett LaRoda; Robert Uguc-
cioni, executive director of the Pocono Mountains Vacation Bureau;
Seth Marsh (Sy's son); George Choulos (Bill's son); Ralph Wunder; and
author Martin Yant.

Albert "Sonny" Murray was, of course, instrumental. I met Sonny
in 1996, when I was covering the death of a ten-year-old girl, which
he had been hired by the local county to investigate. He later told me
about his representation of the Sammy Davis Jr. estate and the IRS
settlement, which I reported in 1997. Over the years we would meet for
an occasional breakfast in Stroudsburg. In August 2006, after years of
prodding, Sonny finally agreed to talk to me about the Hillside and his
Sammy experience.

In addition to the aforementioned interviews, I also pored through
thousands of pages of court documents, along with articles, books, and
other research material. I finished the manuscript in January 2008.

Court Documents

*Sammy Davis Jr. and Altovise Davis, et al., v. Commissioner of Internal Rev-
enue,* United States Tax Court, 1989

Last Will and Testament of Sammy Davis Jr., 1990

*Fierstein & Sturman Law Corporation v. Shirley Rhodes and John Climaco
as executors of the estate of Sammy Davis Jr., Deceased,* Court of Appeal
State of California, Second Appellate District Division

*United States of America v. John Peter Cerone, Milton John Rockman, Joseph
John Aiuppa, Angelo LaPietra, Joseph Lombardo,* United States Court
of Appeals for the Eight Circuit, 10/8/87

Offer in Compromise, Internal Revenue Service, The Estate of Sammy
Davis Jr. 4/97

Estate of Sammy Davis Jr., First and Final Account and Report of Execu-
tor and Petitions for Settlement of Account, 8/92

Reports

E. F. Hutton Mail and Wire Fraud Case, Hearings before the Subcommittee on Crime of the Committee on the Judiciary House of Representatives, June 19, July 19, August 1, 1985, Part 1; October 3, 31, December 6 and 11, 1985, Part 2

White Collar Crime (E. F. Hutton), Hearings Before the Subcommittee on Crime of the Committee on the Judiciary House of Representatives, April 17 and May 8, 1986

President's Commission on Organized Crime, Report to the President and the Attorney General, 1985

The Edge: Organized Crime, Business, and Labor Unions, 1986

Committee on the Judiciary Subcommittee on Crime, Testimony by Clark B. Hall, FBI (retired), 7/24/96

Articles

"Whirlaway," *Time*, 8/18/71

"President of a Financially Troubled Theater in Westchester Resigns," *New York Times*, 11/13/77

"Stars May Testify in Mob-Theater Trial," *Washington Post*, 10/17/78

"Defense Summing Up at Theater Trial," *New York Times*, 1/5/79

"Conviction Upheld in Theater Swindle," *New York Times*, 4/13/80

"Grand Jury Investigating Singer's Ties to Skimming Scheme," *Associated Press*, 7/15/80

"The Invisible Enterprise," *Forbes*, 10/13/80

"U.S. Jury Continuing Inquiry on Sinatra," *New York Times*, 1/11/81

"New Teamster Leader Grilled by Senate Committee," *Associated Press*, 6/7/83

"Teamsters Chief Says He's Probing 'Hanky-Panky' in Locals," *Associated Press*, 6/7/83

"Shaking the Mob's Grip," *Time*, 10/24/83

"Prosecutors Recommend Prosecuting Presser, Report Says," *Chicago Tribune*, 6/21/84

"Stinging the Sex Rings," *Time*, 9/10/84

"Jailed Underboss Says Mob Haggled Over Teamster Boss," *Chicago Tribune*, 9/29/85

"Officials Say U.S. Plans Indictment of Teamster Chief," *New York Times*, 5/10/86

"Teamsters Boss, FBI Agent, Two Others Indicted," *Associated Press*, 5/17/86

"Mob Figures Chose Teamsters' Chief, Government Says," *New York Times*, 11/25/86

"U.S. Confirms Presser Was Informant for FBI," *Associated Press*, 12/3/86

"Document Says Presser Helped FBI Since '70s," *United Press International*, 11/26/87

"Pension-Fund Leader Who Stemmed Corruption in Biggest Fight," *Chicago Tribune*, 2/28/88

"Feds: Mob and Teamsters 'An American Scandal,'" *Associated Press*, 6/28/88

"Teamster Leaders Deny Mafia Controls Union," *Associated Press*, 6/28/88

"U.S. Sues Teamsters, Citing Mob Influence," *Newsday*, 6/29/88

"Prosecutors Seek to Take Teamsters 'Back from the Mafia,'" *Associated Press*, 6/29/88

"Teamsters President Jackie Presser Dead After Cancer Battle," *Associated Press*, 7/10/88

"Presser Remembered as Corrupt by Some, Great by Others," *Associated Press*, 7/11/88

"Sammy Davis Jr. Name to Headline Grocery Shelves Next Month," *PR Newswire*, 3/21/89

"6 Men Are Convicted in a Loan Scheme at a Bank in Queens," *New York Times*, 4/5/90

"Friends Mourn Sammy Davis Jr., Eulogized as 'The Only of a Kind,'" *New York Times*, 5/18/90

Tribute, *Time*, 5/28/90

"Sammy Davis Jr., Tribute," *Rolling Stone,* 6/28/90

"Ex–S&L Chief Gets Jail for Fraud," *New York Newsday,* 8/16/90

"Without Her Sweet Candy Man, Altovise Davis Bears a Widow's Burden—a Ruinous Tax Bill," *People,* 10/1/90

"Taxes; Shelters Need Check for Leaks," *Commercial Appeal (Memphis),* 10/8/90

"Sammy for Sale," *Los Angeles Times,* 9/18/91

"Sammy Davis Auction a Sad Affair to Some," *Los Angeles Times,* 9/23/91

"Sammy's Troubled Legacy," *People,* 10/7/91

"Sammy Davis' Mementos Raises $439,000 at Auction," *Jet,* 10/7/91

"Altovise Davis Struggles to Cope with Debt Left by Sammy Davis Jr.," *Jet,* 10/18/91

"Locker Full of Sammy Davis Items Discovered," *Los Angeles Times,* 12/14/91

"IRS Seizes Davis Items Hidden in Rental Storage Unit in Burbank, Calif.," *Jet,* 12/23/91

"Sammy Davis Jr.'s Secret FBI Fan Club," *Washington Post,* 4/26/92

"Verdict Is 2nd-Degree Murder in Death of Jilly Rizzo; Drunken Driver Faces 15-to-Life," *Press-Enterprise,* 7/24/93

"Counsel with Clout; John Climaco Succeeds on Grit, Connections," *Cleveland Plain Dealer,* 8/22/93

"AKA Frank Sinatra," *Washington Post,* 3/7/99

Transcript, *Larry King Live* interview with Altovise Davis, CNN, 5/27/02

"Presidential Campaign Comes to Northeast Ohio; Obama Draws Crowd, Raises Money," *Cleveland Plain Dealer,* 2/27/07

Books

Yes I Can: The Story of Sammy Davis Jr., by Sammy Davis Jr., Burt and Jane Boyar, New York: Farrar, Straus and Giroux, 1965

Hollywood in a Suitcase, by Sammy Davis Jr., New York: William Morrow & Company, 1980

Why Me?: The Sammy Davis Jr. Story, by Sammy Davis Jr., Burt and Jane Boyar, New York: Farrar, Straus and Giroux, 1989

Mobbed Up: Jackie Presser's High Wire Life in the Teamsters, The Mafia, and the FBI, by James Neff, 1989

Rotten to the Core 2: More Crime, Sex and Corruption in Johnny Appleseed's Hometown, by Martin Yant, Columbus, OH: Public Eye Publications, 1994

Sammy Davis Jr., My Father, by Tracey Davis with Dolores A. Barclay, Los Angeles: General Publishing Group, 1996

The Sammy Davis Jr. Reader: The Life and Times of the Last Great American Hipster—From Vaudeville to Vegas—as Seen Through the Eyes of His Public, edited with an introduction by Gerald Early, New York: Farrar, Straus and Giroux, 2001

Gonna Do Great Things: The Life of Sammy Davis Jr., by Gary Fishgall, New York: Scribner, 2003

In Black and White: The Life of Sammy Davis Jr., by Wil Haygood, New York: Billboard Books, 2003

INDEX